Masterpieces of World Ceramics in the Victoria and Albert Museum

Edited by Reino Liefkes and Hilary Young

With contributions by Terry Bloxham, Yueh-Siang Chang, Judith Crouch, Catherine David, Patricia Ferguson, Alun Graves, John Guy, Anna Jackson, Beth McKillop, Christopher Maxwell, Hanneke Ramakers, Mariam Rosser-Owen, Sonia Solicari, Tim Stanley, Ming Wilson

Photography by Mike Kitcatt

V&A Publishing

Acknowledgements

We owe a great debt of gratitude to Mike Kitcatt of the V&A's photographic studio, who took all new photographs for the book. We would also like to thank our colleagues Ken Jackson for his tireless help with all aspects of the photography programme, and Sonia Solicari for her considerable organizational skills. Several objects were specially conserved prior to photography by Vicky Oakley, Fi Jordan, Juanita Navarro, Hanneke Ramakers, and Julia Barton, work facilitated in part by Christopher Maxwell. Dr A. Jeffrey Spencer, Dr Dyfri Williams, Alexandra Villing, and Colin McEwan, all of the British Museum, gave invaluable advice on ancient and South American pottery, and Rupert Faulkner of the V&A's Asian Department advised on Japanese ceramics. The book owes its excellent design to Grita Rose-Innes of Rose-Innes Associates, and was copy-edited with close attention to detail by Lesley Levene. Finally, we would like to thank Mary Butler, Mark Eastment and colleagues at V&A Publishing, notably Anjali Bulley, who oversaw and co-ordinated all our efforts and exercised great patience with the editors during the completion of the book.

First published by V&A Publishing, 2008
V&A Publishing
Victoria and Albert Museum
South Kensington
London SW7 2RL

Distributed in North America by Harry N. Abrams, Inc., New York

The moral right of the authors has been asserted.

Hardback edition
ISBN 9781 851 775279
Library of Congress Control Number 2007935523

10 9 8 7 6 5 4 3 2 1
2012 2011 2010 2009 2008

Designed by Rose-Innes Associates

Front jacket illustration: Vase, France, p.123
Back jacket illustration: Architectural ornament, China, p.98
Frontispiece: Vase, France, p.134
p.135: © Succession Picasso/DACS, London 2008

Printed in China

V&A Publishing
Victoria and Albert Museum
South Kensington
London SW7 2RL
www.vam.ac.uk

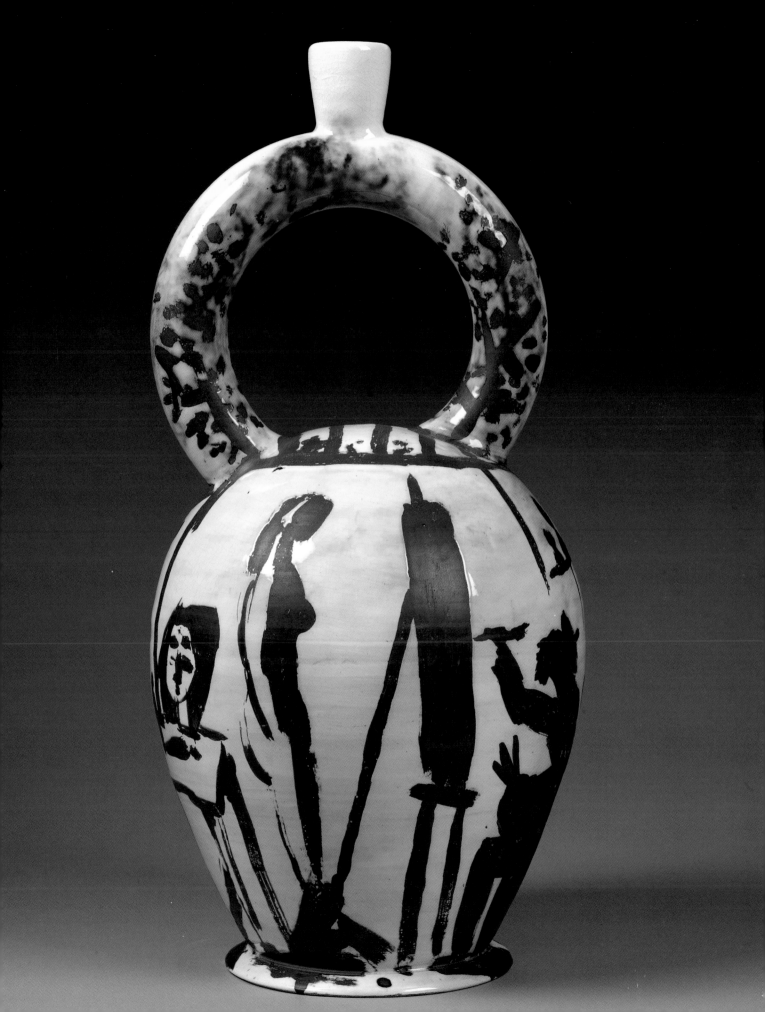

Historical Timeline

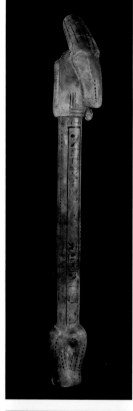

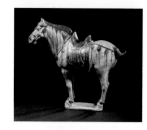

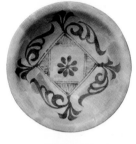

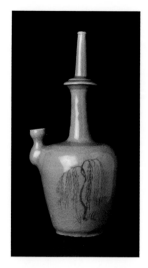

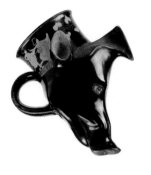

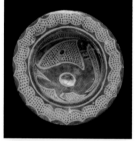

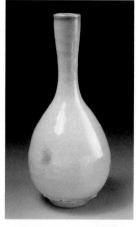

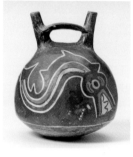

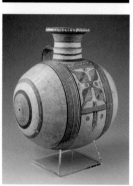

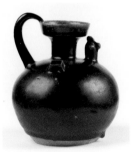

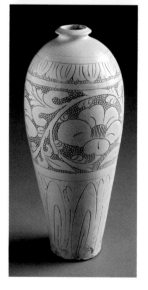

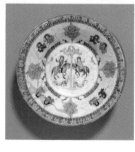

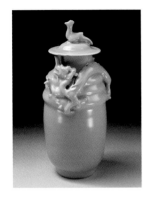

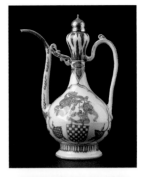

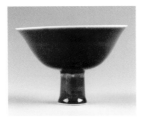

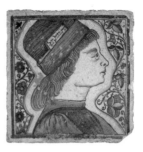

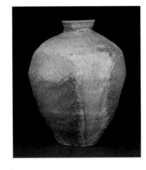

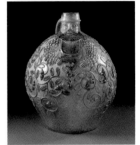

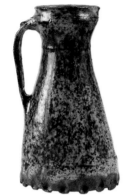

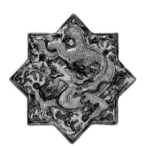

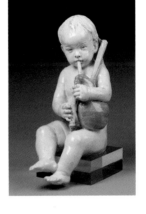

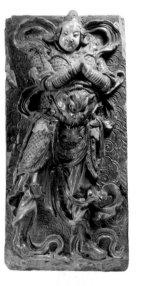

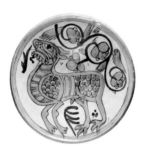

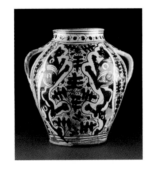

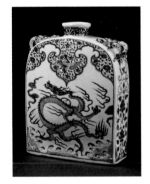

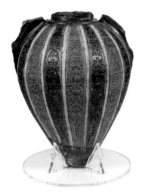

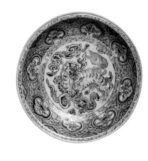

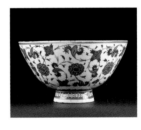

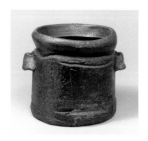

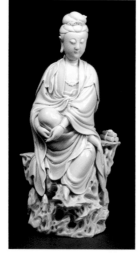

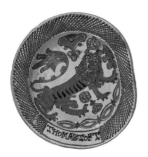

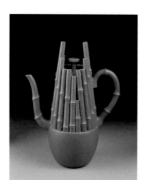

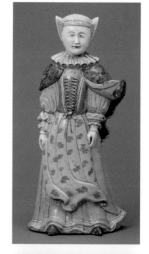

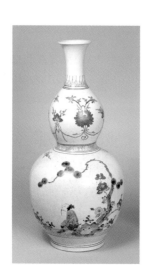

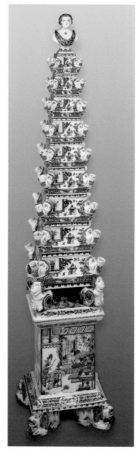

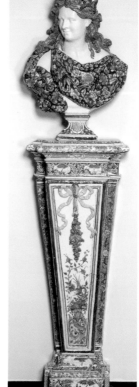

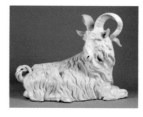

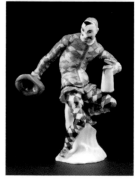

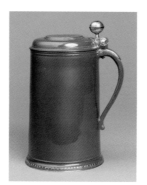

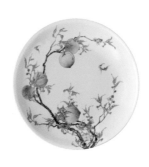

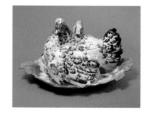

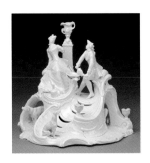

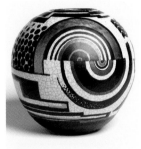
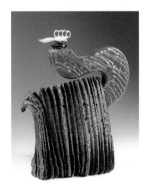
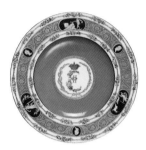
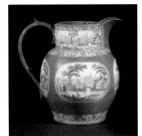
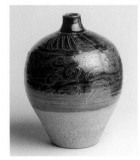
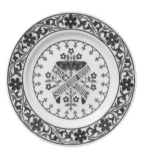
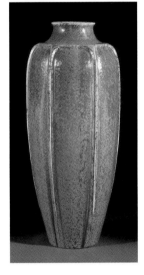
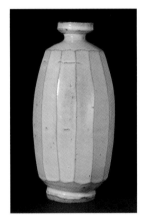
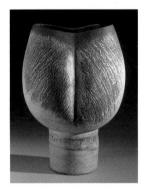

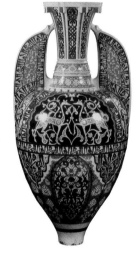

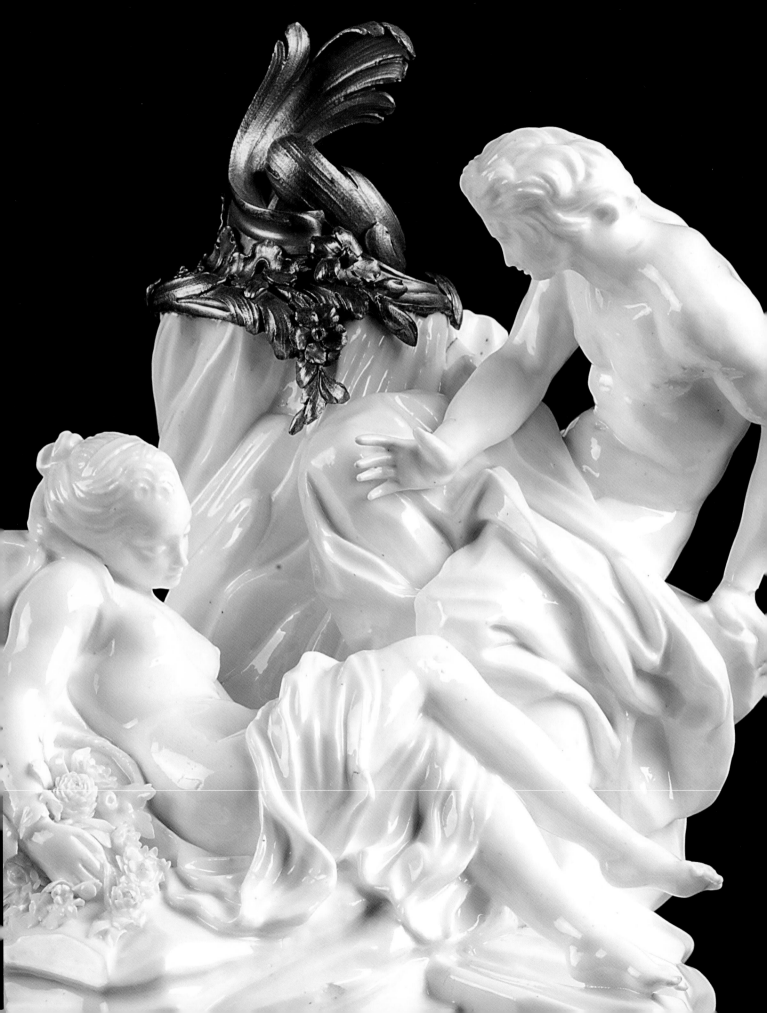

Introduction

From the earliest times, people have dug up the clay from under their feet and shaped it with their thumbs, or a stick or stone, to fashion sculptural images and simple hollow vessels. With the acquisition of the skill to control fire, it was a logical step to put such vessels onto the flames to cook or heat their contents, leading to the discovery that intense heat could transform clay into a material of great durability. From this point onwards, exploration of the practical possibilities of the material went hand in hand with development of its aesthetic potential, the discovery of glazes, making vessels impervious to liquids, being the next major leap forward. One of the earliest art forms, pottery is also near-universal, occurring in settled cultures across the globe wherever clay can be dug from the ground.

This book illustrates some of the finest examples of the potter's art in the Victoria and Albert Museum. Originally the V&A was founded as a museum of manufactures, to display both historic and contemporary artefacts as examples for students of design and for the benefit of British industries. From the start, ceramics formed a substantial part of the collections. Many contemporary pieces were acquired at the international exhibitions of the later nineteenth century. The Museum also started to buy historic ceramics, mostly of the Renaissance period, from a number of the great private collections of the time; but the collections were transformed by the arrival of a number of major gifts and bequests. In 1910 George Salting bequeathed his vast collection to the Museum: this was particularly rich in Asian ceramics, but it also included a large quantity of Italian and French Renaissance pottery, Dutch Delftware and many other types. Curiously, British ceramics were rather poorly represented until 1884, when Lady Charlotte Schreiber donated her vast collection of over 1,500 English ceramics to the Museum. In 1901 a rationalization of national museums led to over 4,000 ceramics collected by the Museum of Practical Geology being transferred to the V&A. Since then, many smaller gifts and bequests, augmented by innumerable strategic purchases, have greatly increased the Museum's holdings, which now comprise the largest, most comprehensive and richest collection of East Asian, Middle Eastern and post-medieval European ceramics in the world.

As the collections were, from the onset, intended to exemplify the best in ceramic design of periods, ancient civilizations were represented, as were ceramics from the indigenous cultures of South America, but such holdings have remained very small. Sub-Saharan African pottery has never been collected, and Indian ceramics have remained

Figure group known as 'L'Heure du Berger' ('The Shepherd's Hour'), but perhaps representing Zephyrus and Flora (detail, see p.100)

absent largely because the subcontinent lacked a strong ceramic tradition, reflecting the nature of its clay deposits and religious and cultural prohibitions.

In selecting objects for inclusion in this book we were not only influenced by their visual impact and aesthetic quality, but tried also to represent major developments in ceramic technology, style and usage. Furthermore, we wanted to explore the crucial role of international trade in the transmission of manufacturing techniques, styles and designs from one part of the globe to another. For, with the exception of South American pottery, which until the fifteenth century developed in isolation from the rest of the world, all ceramic traditions are to some extent interconnected, with that of China being undoubtedly the most influential. Chinese porcelain, for example, was admired across the globe, and was the stimulus for a whole string of innovations in neighbouring Asian countries, South-East Asia, the Middle East and Europe. Some of the most important of the strands cutting across and linking the world's ceramic traditions are introduced briefly below.

Ceramic specialists have developed a complex terminology for classifying materials and techniques, but in essence − for those in the West at least − there are two broad categories, pottery and porcelain, each of which has two or three main subdivisions. Porcelain is white and usually translucent when thinly potted and is resonant when struck. Real or 'hard-paste' porcelain of the Chinese type generally contains porcelain stone, either alone or in combination with china clay (kaolin); it is fired at high kiln temperatures, at which the material vitrifies (turning dense and glass-like) and becomes impervious to liquids. Lacking knowledge of the Chinese materials and processes, but keen to rival the beauty of its wares, some early European factories developed imitation porcelains known as soft pastes: these contain white-firing clays and a variety of other ingredients. Pottery, on the other hand, is rarely translucent. The term embraces both earthenwares, which are fired at comparatively low kiln temperatures and require a glaze to make them impervious to liquids, and stonewares, which are made from clays that vitrify at the high temperatures at which they are fired but are frequently glazed for aesthetic or practical reasons. Fritware is a further type of pottery, and, like certain soft-paste porcelains, is made from a combination of quartz, white-firing clay and powdered glass. The Chinese do not draw the same distinction between pottery and porcelain as Westerners, but consider their fine stonewares and porcelains, both of which are high-fired and may have raw materials in common, a single category. Porcelain, with its fine

structure, is particularly suitable to thinly potted and finely decorated wares, whereas earthenwares, and especially stonewares, can be much coarser and have often lent themselves to a rougher and bolder aesthetic. These and other ceramic terms are further discussed in the Glossary (see pp.142–3).

The Contribution of China

China has contributed more to the worldwide development of ceramics than any other country and, in the opinion of some, its wares of the Song and Ming dynasties set a standard of artistic excellence that has never been surpassed. The world's first wheel-thrown pottery was made in China in the fourth millennium BC, and the combination of suitable clays and sophisticated kiln design enabled the production of the world's first high-fired ceramics as early as the fifteenth to fourteenth century BC. These stonewares

Interior of a warehouse with East India trade goods
Tempera on panel (originally a fan leaf). Probably Netherlands, c.1680–1700. 26.3 x 43.6cm. Given by Sir William Lawrence, Bt., P.35–1926

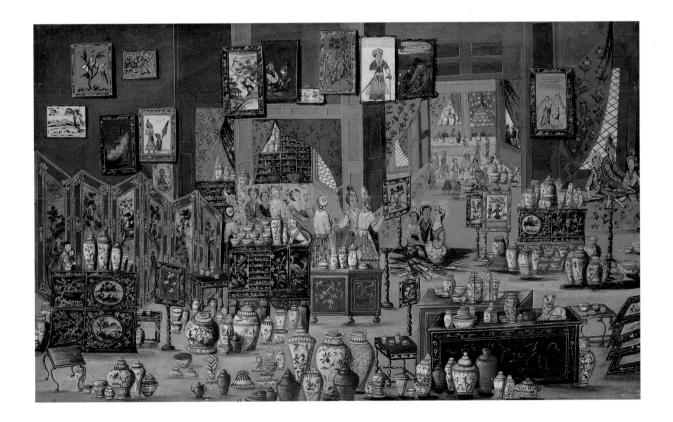

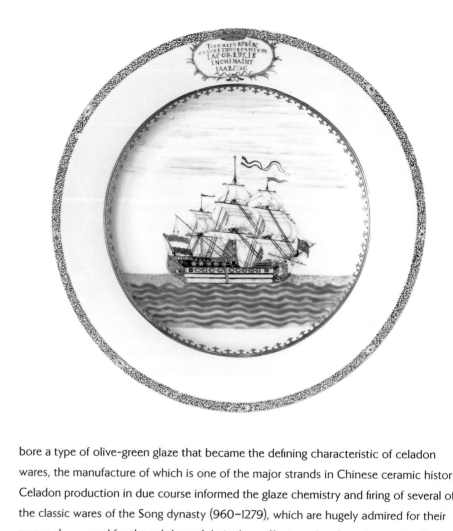

Plate painted with a Dutch East India Company ship and made for its captain
Porcelain painted in enamels and gilt. Jingdezhen, China, 1756. 32cm diameter. Given by His Majesty King George V, C.376-1926

bore a type of olive-green glaze that became the defining characteristic of celadon wares, the manufacture of which is one of the major strands in Chinese ceramic history. Celadon production in due course informed the glaze chemistry and firing of several of the classic wares of the Song dynasty (960–1279), which are hugely admired for their serene shapes and for the subtlety of their glaze effects and surface decoration. Low-fired earthenwares with glazes fluxed with lead and stained green or brown had been produced in quantity in the Western Han Dynasty (206 BC–AD 9) and for centuries were particularly associated with funerary ceramics. Porcelains were made in small quantities from the seventh century, but their production was long overshadowed by the fine stonewares of the Tang (618–906) and Song dynasties. The earliest blue-and-white porcelains were made at Jingdezhen in the first half of the fourteenth century, largely for export to the Middle East, but from the Ming period (1368–1644) they were produced also for the home market and imperial use. Jingdezhen expanded to become the largest kiln site in the world and came to dominate the Chinese production. From this point onwards Chinese innovations were focused on surface decoration for porcelain (including painting in enamels and monochrome glaze effects) rather than on new ceramic bodies. The quality of painting on Jingdezhen porcelain of the Ming and Qing (1644–1911) dynasties was often superb, and was admired and greatly coveted across the globe.

These tremendous successes were based, in part, on the country's copious supplies of raw materials of very high quality — notably porcelain stone and kaolin and other clays — together with the availability of fuel to fire the kilns. Production was highly organized from early on, with much specialization and subdivision of labour. Jingdezhen probably saw the first mass production of assembly-line manufactured goods made in any material anywhere in the world. At its height, the scale of production at Jingdezhen was almost unimaginable, dwarfing all rivals in other countries: in 1712 there were said to be 3,000 'porcelain furnaces' in the city; and in 1606 it was reported that the imperial kilns required 10,000 daily workers to fulfil orders of ceramics for court and official use alone. Export markets had been an important source of revenue for Chinese kilns from the ninth century. Potters developed shapes and patterns designed to meet the specific requirements of overseas markets, which included Japan, Korea, South-East Asia, India, Africa, the Middle East and, from the sixteenth century, Europe and thereafter North America.

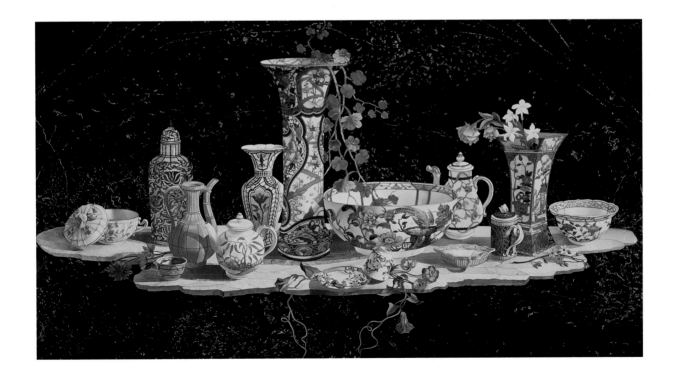

Still life with Asian and Italian (Doccia) porcelain from the collections of the Grand Dukes of Tuscany
Pietre dure mosaic on Egyptian nephrite. Florence, Italy, *c.*1797, after an oil painting by Antonio Cioci. Pitti Palace, Florence

Design for a fireplace
Etching and engraving after
Daniel Marot (1661–1752),
from *New Chimneys made in
Holland and other Provinces*
(The Hague, Netherlands,
1703). E.2873–1905

In neighbouring countries that shared the geology and clays of China, these exports inspired close imitation and emulation, leading to the foundation of distinctive national traditions in the manufacture of porcelain and fine stoneware in Korea and Japan (notably inlaid celadons in the former, blackwares in the latter and fine porcelains in both), and to some extent also in Vietnam, Thailand and Cambodia.

Cross-pollination between Chinese, Middle Eastern and European Traditions

Further afield than East and South-East Asia, Chinese imports had a similar galvanizing effect on ceramic production, inspiring both imitation in local earthenware clays and the introduction of radically new materials and techniques. Trade in ceramics between China, the Middle East and Europe led to cross-pollination between the potting traditions of these lands, and the resultant strands of influence criss-cross the globe. Until its course was permanently altered by Chinese imports, ceramic production in both the Middle East and Europe had been dominated by earthenwares with clear or stained lead glazes. Manufacture of lead-glazed pottery of this type began in Europe in imperial Roman times (at roughly the same time as in China), survived the collapse of the empire in Constantinople, and was revived in both medieval Europe and the Middle East, where it continues in some regions today.

One of the most important of the strands leading from China – initially at least – begins with the late eighth-century Iraqi discovery that a clear lead glaze could be turned white, in imitation of imported Chinese wares, by the addition of tin oxide. This white ground was found to be eminently suitable for painting with a blue pigment derived from cobalt, giving rise to the world's first blue-and-white ceramics. These predate the very earliest Chinese blue-painted porcelains by more than 500 years. From the ninth century, Middle Eastern potters used this white glaze as a ground for lustre decoration (a technique from contemporary Islamic glassmaking), which was subsequently used as an adjunct to painting in colours.

Both lustre painting and tin-glazing were widely practised in Spain during and following the years of Islamic rule, marking the beginning of the great European tin-glazed pottery tradition. Spanish lustre-decorated pottery was exported in considerable quantities to late medieval Italy – at the time the most advanced economy for luxury goods in Europe – where it was greatly admired and imitated. From Italy knowledge of the tin-glaze process percolated throughout western Europe, where it dominated fine

ceramic production until the eighteenth century, when tough, inexpensive earthenwares from Staffordshire finally drove it out of the market. The resultant pottery became known by a variety of terms: maiolica in Italy; *faïence* in France, Germany and Scandinavia; and Delft or delftware in the Netherlands, Britain and Ireland. Italian Renaissance maiolica is celebrated for its polychrome figure decoration, and much eighteenth-century French and German *faïence* was made in imitation of contemporary European porcelain, but a great deal of Dutch and English Delftware was inspired by Chinese blue-and-white, which had been familiar in Europe – as a costly and exotic import – from the sixteenth century.

The desire to emulate the seemingly miraculous brilliant whiteness of imported Chinese wares has been a strong thread in ceramic history since the late eighth century, when it inspired Iraqi potters to invent tin-glazing, and continued into the tenth and eleventh centuries, when it led Middle Eastern potters to develop the first fritwares. The focus of many later attempts at emulation, in both the Middle East and Europe, were the blue-painted export wares of Jingdezhen, which were imitated, for example, in Safavid Iran and seventeenth-century Delft. Both Dutch Delftware and Iranian fritwares were commercial products made in large quantities for home and export markets, but such was the fascination with Chinese porcelain that elsewhere it was often the private passion of princes and rulers that fuelled attempts to reproduce it and unlock its secrets.

For example, inspired by Ming blue-and-white and working under the patronage of Sultan Mehmet II (1451–81), the potters of Iznik in Ottoman Turkey created some of the most accomplished ceramics made anywhere in the Islamic world. In late sixteenth-century Florence, the Grand Duke of Tuscany was personally very closely involved in developing the first European soft-paste porcelains ('Medici porcelain', which is technically related to Middle Eastern fritwares and was possibly influenced by Iznik technology). Soft pastes were again made in late seventeenth- and eighteenth-century France (much of it under royal or ducal patronage, as at Sèvres and Chantilly) and England; but it was not until 1709 that Europeans discovered the materials and processes for making porcelain of the East Asian type. This momentous advance was made at Meissen, a factory founded by Augustus the Strong, Elector of Saxony and King of Poland. Augustus eventually came to own more than 24,000 Asian ceramics, and ordered even greater quantities from his own manufactory. Within a few years, however, industrial spies had taken Meissen's trade secrets to Vienna and Venice. Eventually

they became common knowledge throughout Europe, where porcelain factories were frequently founded by monarchs and the aristocracy as a matter of competitive prestige. It is an extraordinary fact that − although they have a history in China stretching back to the Bronze Age − prior to these developments the only high-fired ceramics made in Europe had been the salt-glazed stonewares of the Rhineland and Britain, and minute quantities of red stonewares inspired by Chinese redwares from Yixing.

Industry and Art

Britain had been the leading economy of the Industrial Revolution. Its ceramic industry was at the forefront of developments in mass production, with hundreds of factories − both large and small − manufacturing on a scale unprecedented in Europe and supplying a wide range of ceramics to both home and export markets.

Britain was also one of the first countries to witness a public debate about the declining standards of design and craftsmanship resulting from industrialization. Under the inspiring leadership of Prince Albert, an enlightened government introduced a number of measures, including the establishment of schools of art and design, and the foundation of the first museum dedicated to the decorative arts in 1852, the Museum of Ornamental Art (later the Victoria and Albert Museum). Both established a blueprint subsequently followed abroad.

In 1851, London hosted the Great Exhibition, a huge international event attracting three million visitors. The exhibition was a showcase for all nations to present their best achievements in science, technology and art as well as natural produce. This was the first in a series of similar international and national exhibitions organized throughout the world. In many countries these excited a debate about contemporary style in relation to notions of national identity.

With museums and art schools providing unprecedented access to historic artefacts, designers could pick and choose from a seemingly endless vocabulary of historic styles. Artists drew their inspiration from classical antiquity, from such earlier European styles as Gothic, Renaissance and rococo, and from the art of distant lands, especially Asia and the Middle East. With great confidence, they also strove to improve on their sources of inspiration, making their products bigger and better. Large factories such as Minton's in Britain and Sèvres in France sought collaborations with architects and professional designers to improve the quality of their most prestigious products.

The turn of the century brought a new, self-conscious élan, with historic revivals giving way to a fresh start, a new style or 'Art Nouveau'. This predominantly urban style found its inspiration mainly in nature, but also in Asian art and craft. The rich and intense monochrome glazes of eighteenth-century Chinese court ceramics became the inspiration for the earliest 'artist potters' in France in the 1870s. Working in small independent studios, such makers deliberately moved away from the polished perfection of industrial production. They strongly valued personal engagement with the material and the exploration of the 'unpredictable' qualities of high-firing monochrome glazes or salt glaze. They returned to archetypal ceramic vessel types – such as simple storage jars – and preferred rough stoneware above the finesse of delicate porcelain.

Of all the pioneer artist potters, perhaps the most influential has been Bernard Leach. After a prolonged stay in Japan, he established a small independent studio in St Ives in Cornwall in 1920. In addition to finding inspiration in early Chinese and Korean ceramics, Leach was looking for the essence of indigenous craft traditions, which he found in the 'noble simplicity' of English medieval pottery and slipwares. Leach did much to elevate pottery to an art form that could be assessed following aesthetic criteria. Through his writings he provided a model for a new generation of craft potters, whose functional wares provided an alternative to the products of industry.

The history of twentieth-century industrially produced ceramics is defined by shifting attitudes towards modernism, and the fine balance between style and functionality. Some of the most avant-garde designs of the early twentieth century, conceived in the aftermath of the Soviet revolution, were intended as propaganda and to signify a radical break with the bourgeois past. Ironically, these were largely decorative designs that were applied to blanks made by the Russian Imperial Porcelain Factory, giving them emphatically elitist associations. In Scandinavia, socially inspired industrialists and designers aimed at providing aesthetically sound tablewares to all but the very poorest. They embraced the machine as a necessary tool to achieve this utopian vision, but most tablewares were still largely produced by hand. Despite receiving critical acclaim for some of their designs, these were popular with the intellectual elite rather than with the country's workers, who preferred cheap copies of traditional, luxurious tableware.

The urge to achieve a strong modernist style, often based on geometrical shapes and primary colours, sometimes led to the functionality of the design being compromised. In other cases, modernism became little more than an additional

decorative finish, overlaying a more or less conventional shape, the resultant wares often finding a greater popular appeal than hard-line modernist designs. Some well-established European manufacturers, such as the Nymphenburg and Meissen porcelain factories in Germany and Wedgwood in Britain, sought to embrace a more restrained view of modernism during the 1910s and 1920s, attempting to revitalize their products and give a contemporary relevance to their inherently traditional luxury brand. It was in the USA, during the late 1930s, that functionalist design first reached a much wider public, when new organic shapes added greater dynamism to undecorated functional tableware. This tradition was continued after the Second World War, when refugees such as Eva Zeisel added new impetus to a rapidly developing consumer industry.

The duality between individual 'artist' makers and mass production of more or less 'designed' wares was a continuing theme throughout the twentieth century. Most artist potters saw themselves as firmly rooted in a long ceramic history and their work can often be seen, in one form or another, as a response to earlier potting traditions. Often, decisions around which tradition to adhere to led to interesting polemics. Even when, during the latter part of the twentieth century, studio pottery became increasingly conceptual and more sculptural in scope, the introduction of postmodernist notions of quotation and subversion redirected potters to examine the history of their own craft.

Throughout its existence, the Museum has been a tremendous source of inspiration to ceramic makers, enabling them to set themselves against a long and truly international tradition. Looking through the pages of this book, one is struck by a sense of continuity, a sense that throughout the ages, wherever potters have explored the creative potential of the basic resources available to them − wet clay, the heat of the furnace and, above all, their own bare hands − they form part of an immense global tradition, stretching from Neolithic China and ancient Egypt to present-day artists and craftsmen working all around the world.

'Alhambra Vase'
(detail, see p.114)

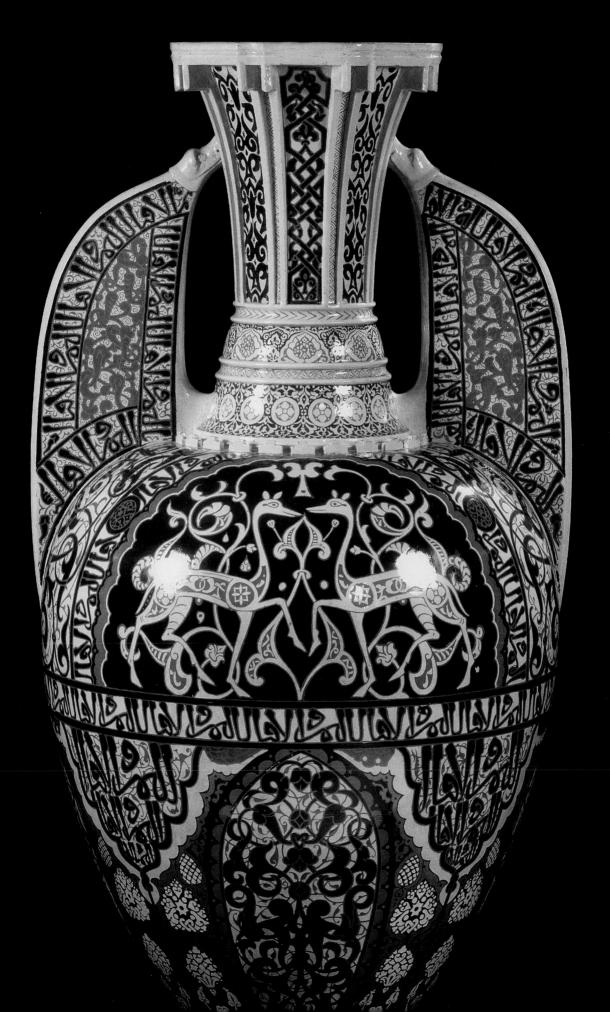

Ewer

The great importance of this piece is that it is made from kaolin-rich clays, the same raw material used for porcelain, and had it been fired to a higher temperature it could be described as porcellaneous or as 'proto-porcelain'. However, the firing range of Neolithic kilns seldom exceeded 1,050°C, which means that the ewer was fired at much the same temperature as Neolithic earthenwares, and the body has remained porous rather than become vitrified during firing.

The common raw material for Neolithic Chinese ceramics is loess, a wind-borne dust derived from igneous rocks (rocks formed from molten magma or lava), not kaolin-rich clay. This is because in northern China the latter was usually found beneath the loess and hence was more difficult to obtain. Kaolin clays were deposited earlier than loess: some 260 million years old, they were laid down when huge carboniferous forests flourished in north China. The mud on which these forests grew was of kaolin-rich sediments, washed by the rain from distant rocky highlands.

Made 1,000 years before writing was invented in China, there is no textual source to explain the function of this distinctive vessel. Its form, with three bag-shaped legs, strap handle and spout, suggests it was a ewer in which water was boiled. The use of kaolin clays by the aboriginal potter could have been sheer coincidence, or it may have been deliberate, as the material had a superior resistance to the thermal shock that occurred, for example, when liquids were heated over a fire. MW

Jar

This large jar is of a type used for storage and in burials, as examples have been found containing remains of food and children's bones. Like many Neolithic pots from Gansu province in north-western China, the upper part is boldly painted with a dynamic spiral pattern — which probably originally had some ritual or symbolic meaning — and it is made from loess, deposits of which are found throughout the northern part of the country. True loess is a wind-borne dust, derived mainly from the mechanical weathering of igneous rocks (those formed from magma or lava). Loess deposits become increasingly fine the further they are blown. Wares made from loess may be red, buff, grey or black, depending on the conditions in which they were fired, and are fine in texture.

The jar was made by the coiling method, a basic forming technique found worldwide. This involved building up the vessel from the bottom with rolls of clay, pinching and smoothing them down, thus controlling the growth of the vessel's shape. After finishing by beating and scraping, and applying the handles, the jar would have been fired in a relatively sophisticated kiln, in which the fire was separated from and situated underneath the chamber containing the pots. An updraught system carried the heat of the fire up a channel to bake the wares without damaging them. Temperatures of up to 1,020°C were already achieved at this early time. Finally, the jar was painted in earth pigments and burnished, to smooth and seal the surface. MW

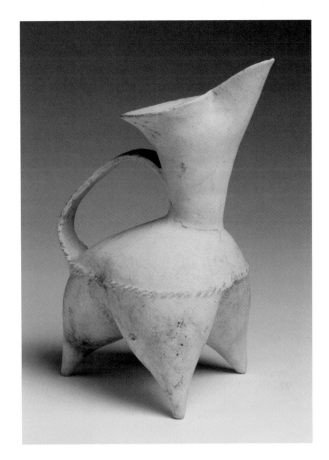

Ewer
White unglazed earthenware
China, Shandong province
About 2500 BC
Height 26cm, maximum width 16.5cm
Purchased with funds from
Mr T.T. Tsui, FE.8–2000

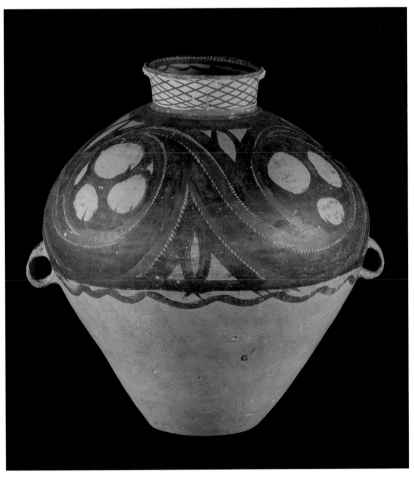

Jar
Unglazed earthenware, painted in red
and black pigments
China, Gansu province
2000–1700 BC
Height 39cm, maximum width 39cm
C.286–1938

Uas (ritual sceptre or staff)

Jar

This extraordinary object is the largest known example of ancient Egyptian faience. The term 'faience' here refers to an unusual glazed ceramic material composed of crushed quartz which is best suited to moulding or hand-modelling (though, confusingly, the same name is also used for French tin-glazed earthenware). Invented in Egypt or Mesopotamia, faience was first used to make beads from about 4000 BC and later for amulets, figures, vessels and tiles. Probably a by-product of stone-working rather than potting, faience was glazed long before glazes were used on other ceramic materials, on which they first appear around 1600 BC. Initially faience glazes were coloured with copper oxide to create blues and greens emulating the semi-precious stones turquoise, lapis lazuli and azurite. During the New Kingdom (1550–1069 BC), other mineral oxides were sometimes added to give different colours.

Known as a *uas* in ancient Egypt, sceptres of this type were items of temple equipment and are shown held by gods as a symbol of their might. The fragments from which this one was reconstructed were discovered in 1894 in a temple built to the god Seth by Thutmose I in the Naqada region, Upper Egypt, and the animal head probably therefore represents this god. His arms are broken off at the elbows but their acute angle suggests they might originally have held a standard or have been raised in adoration. The stem below terminates in vestigial legs. The inscription gives the full title of Amenhotep II and two of the cartouches bear his name. JC

Although found in northern Cyprus, this attractive vessel may have been made in Kourion, on the south-west coast of the island and one of the most magnificent of the twelve kingdoms into which ancient Cyprus was divided. It dates from a time when artistic influences on the native Cypriot potting tradition were diverse, owing to the island's key position between the Greek and Near Eastern nations. Between about 1500 and 1050 BC, Mycenaean colonists arrived from mainland Greece bringing their own pots, the decorative features of which became part of the native repertoire. Between about 1050 and 750 BC, Phoenicians (Canaanite seafarers, traders and colonists from what is now Lebanon) added their potting and decorative styles to the Cypriot mix. During the period when this piece was made, much of Cyprus surrendered to Assyrian control (709 BC). The quatrefoil motif may have a Near Eastern origin.

Such vessels were used for storing wine or water. The size and fine decoration of this example suggest that it would have been owned by a socially elevated family for domestic use or funerary feasts. It is from a large group of ancient pottery bought from Lieutenant Kitchener, RE, Director of Survey in Cyprus, who was later to achieve fame for his iconic 1914 First World War recruitment poster. JC

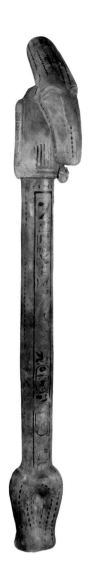

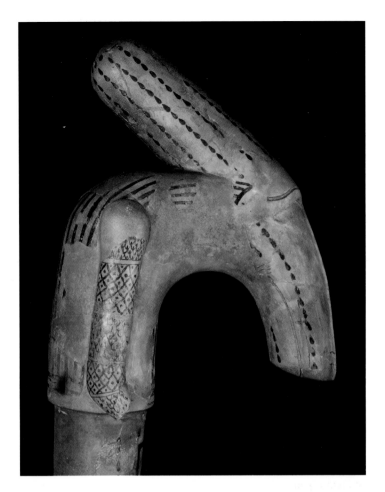

Uas (ritual sceptre or staff)
Turquoise-glazed composition or faience
Egypt
New Kingdom: 18th Dynasty, about 1425 BC
With inscription concerning Amenhotep II
(reigned 1427–1400 BC)
Height 215.9cm, width 25cm, depth 48.2cm
Given by H.M. Kennard, Esq. (through Prof.
Flinders Petrie, University College, London),
437–1895

Jar
Earthenware, wheel-thrown and painted
in black and red on a buff-coloured slip
Cyprus, perhaps Kourion
About 750–600 BC
Found at Gastria, Cyprus
Height 32.1cm, length 30cm,
maximum width 24.8cm
222–1883

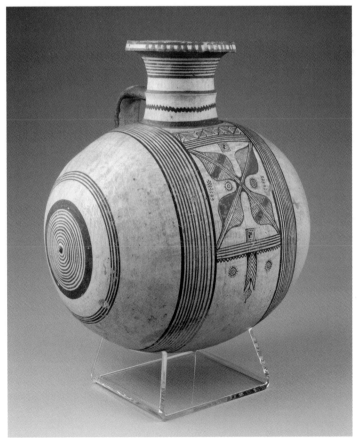

Rhyton (drinking cup)

Ancient Greek pottery is notable for its finely painted figure decoration in glossy black slip. On early pieces the painting was in the 'black figure' technique, in which the silhouettes of the figures themselves were painted, with details incised or added in other colours. Around 530 BC, this began to be superseded by the 'red figure' technique used here, in which the silhouettes were left unpainted, allowing the red of the fired clay of the body to show through; the spaces around them were painted in, and facial features and other details were delineated in slip. The colour contrast relied on very careful manipulation of the oxygen levels inside the kiln, in order to fire the clay to an orange-red and the slip to a glossy black. Most red and black figure pottery was thrown on a fast kick-wheel, but the boar's head of this cup is moulded. The shape would have appealed to members of the wealthy classes, who regularly hunted boars for sport. The painted decoration shows companions of the wine god Dionysus, reflecting the rhyton's function as a cup for wine.

Athens was the most powerful of the Greek city states at the time that this cup was made. Pottery had been made in Greece for millennia, but the Athens region, Attica, took a lead from the tenth century BC, introducing figure painting around 770 BC. Much Greek pottery was exported, as with this piece, which was found in Italy. It was probably made by Sotades, a highly skilled Athenian potter of the 460s BC who specialized in vessels of unusual form. JC

Storage jar

Made of high-fired stoneware, and with an olive-green glaze, this jar is a precursor of the celebrated celadon wares of the Song and later dynasties. It was made in Zhejiang province, which lies south of the Nanshan–Qinling divide. Vital for an understanding of Chinese ceramics, this takes its name from two mountain ranges separating the loess plateau of north China from rice-growing southern China. Provinces north of this line are classified as 'northern China', have different raw materials from those in the south and their wares were fired in kilns of different design.

Archaeological evidence indicates that the first Chinese ceramics were produced in southern China in about 9000 BC – at least 1,000 years before the earliest northern wares. Southern potters used superficial deposits of locally abundant refractory clays. These are by definition resistant to heat and therefore needed a higher temperature to mature, and in about 1500 BC true vitrified stoneware – fired at 1,150–1,200°C – made its first appearance in Zhejiang.

The first Chinese glazes were discovered by chance, when incandescent wood ash in the draught of a high-temperature kiln reacted with the clay of the wares. Potters were quick to make use of this natural reaction by deliberately applying wood ash to the raw clay, and, as on later celadons, here they exploit the deepening of the colour where the glaze pools. The three ridges on the shoulders prevented the molten glaze from running at full heat, but have the added advantage of evoking work in cast bronze. MW

Rhyton (drinking cup)
Earthenware, painted in black slip
Greece, Athens
Probably made by the potter Sotades
About 460 BC
Found in Capua, Campania, Italy
Length 23.8cm (rim to snout),
maximum width 22.5cm
669–1864

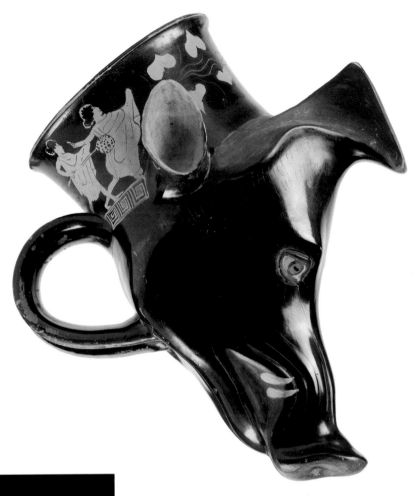

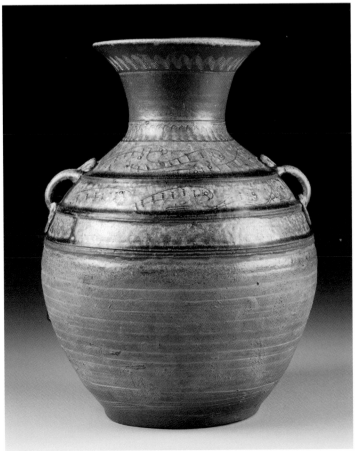

Storage jar
Stoneware, with incised and combed
decoration and olive-green glaze
China, Zhejiang province
Western Han dynasty (206 BC–AD 8)
Height 32cm, diameter 21.4cm
C.138–1913

Tomb figure of a dog

The Chinese tradition of sumptuous burials led to a great variety of ceramic figures of wild and domesticated animals being interred with the deceased in tombs. These animals, together with architectural models such as watch towers and water wells, provide a rich insight into daily life under the Han dynasty (206 BC–AD 220).

This figure is made of loess (see p.20), which has fired to the reddish colour visible in places where the glaze has flaked off. The fine texture and low shrinkage rate of loess made it a favourite raw material for northern Chinese pottery. However, it melts at a comparatively low temperature, so if a glaze was required this needed to have an even lower melting point. The potters therefore used glazes with a high lead content, which had the advantage of producing brilliant colours with warm tones. Modern ceramic historians have been intrigued by this development, as high-lead glazes were also used by Roman potters, and one theory, still unsubstantiated, is that the Chinese were influenced by the Romans.

Unless properly prepared, high-lead glazes can poison both makers and users of pots alike. Copper oxide, used to create the green colour, was particularly dangerous as it upset the chemical stability of the glaze and caused the poisonous lead to leach out. The silvery iridescence on this dog is partly the result of the unstable glaze, but has been exacerbated by burial conditions and is a characteristic feature of Han dynasty green mortuary wares. MW

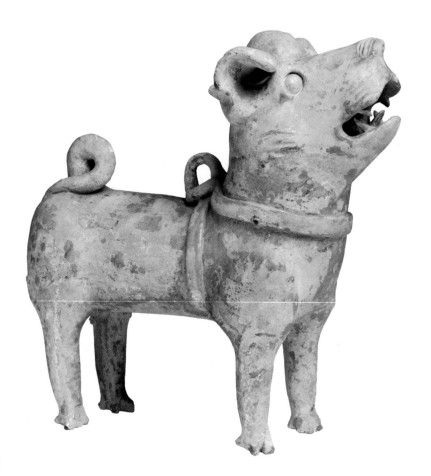

Tomb figure of a dog
Earthenware, with green glaze
North China
Eastern Han dynasty (AD 25–220)
Height 34.5cm, length 34cm,
maximum depth 14cm
C.167–1914

Bowl

By the first century AD, earthenware finished with a slip that fired to a distinctive glossy red was the tableware of choice all over the Roman world. This was popular because its tough surface made it impermeable and easy to clean. It was also more straightforward to mass-produce than the earlier wares decorated with black slip, made in the Greek tradition, which required specific firing conditions. These red slip wares were inexpensive, as they were made in vast quantities at centres throughout the empire – from Rome to Carthage and from Lyons to Asia Minor – wherever there was a source of appropriate fine clays.

The Italian plain ware that preceded this general type was known from Roman times as Arretine, Arezzo potters being the first to use red slip for a range of simple cups and dishes in the first century BC. Elaborate relief-moulding, sometimes derived directly from embossed metal vessels, was later used to embellish a wider variety of shapes. Here, the bowl is moulded with gladiators fighting, alternating with the motif of a figure presenting an emperor with a palm. The names of individual potters or workshop owners were often stamped into the clay before firing. Relief-moulded ware is properly known as *terra sigillata* (pottery decorated with motifs or scenes), but this has become a generic term for any red slip ware. As the production of red slip ware increased in central, southern and eastern Gaul (largely in present-day France and parts of Germany), less was made in Italy for export. Production of Gaulish *sigillata* ceased in the third century AD. JC

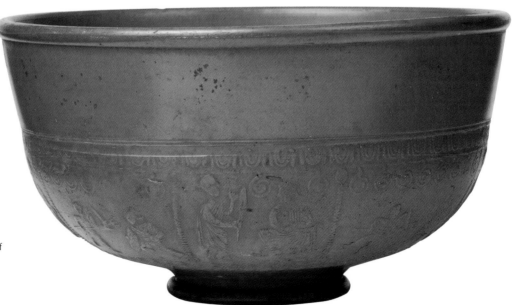

Bowl
Unglazed earthenware,
moulded in relief
Germany, Trier
About AD 150–200
Found in Cologne
Height 14cm, diameter 26cm
Transferred from the Museum of
Practical Geology, 1921–1901

Pouring vessel

This piece is a splendid example of the Nasca pottery of Peru, which, in both artistic and technological terms, is among the finest of any of the early civilizations of the Americas. Nasca potters perfected a method of painting with coloured slips, replacing unfired resinous pigments, which resulted in a delicacy of painting unrivalled in other slipware traditions. They used metal oxides in their clay to create as many as 15 different hues and formed their wares by a combination of coiling and hand-modelling (the potter's wheel, like glazes, being unknown in South America prior to the arrival of Europeans). Before firing, the painted pots were burnished with a pebble, or another smooth hard object, in order to polish the surfaces, reduce porosity and strengthen the vessel.

Painted pottery bowls and jars were widely used by the Nasca in domestic contexts, but these 'double spout and bridge bottles' may have been primarily for ceremonial use and for burial. The second spout was to facilitate pouring by allowing the passage of air. This example is painted with the supernatural killer whale from Nasca myth. The beast represented or embodied the power of the ocean, just as the condor symbolized the air and feline creatures represented the land (as these forces of nature controlled the fishing and agriculture on which Nasca survival depended). The bold simple style of the decoration is a characteristic of early Nasca pottery, the later wares having more colourful designs of greater complexity. **HR**

Ewer

Although not hailed as a 'classic' ware by ceramic connoisseurs, 'blackware' from Deqing, where this ewer was made, represents an important milestone in the history of Chinese ceramics, for it was from this early southern stoneware that the famous dark-glazed tea bowls of the Song dynasty evolved.

Having accumulated centuries of experience making green-glazed stoneware (see p.24), potters in Deqing, Zhejiang province, tried a new line of products in the fourth century. These were daily utensils such as ewers and bottles, covered with either black or dark brown glazes. Technologically, these black and brown glazes were not difficult to make – all that was required was a higher content of iron. This could be achieved either by using an iron-rich clay in the glaze or by adding concentrated iron oxide to the ash glaze used for greenware.

Dark-glazed ceramics were probably first made in imitation of lacquer, but the matt glaze lacked the glossy appearance of painted lacquer. They were produced in smaller quantities than the popular green-glazed wares. The southern kilns, including Deqing, introduced several imaginatively modelled shapes, with 'chicken-headed' ewers like this piece, frog-shaped pots and tiger-shaped urinals displaying a naïve charm not seen before. **MW**

Pouring vessel
Earthenware, painted with
coloured slips and burnished
Peru, Nasca culture
AD 100–400
Height 19.5cm, diameter 16.5cm
Given by Lady Steel-Maitland,
C.15–1941

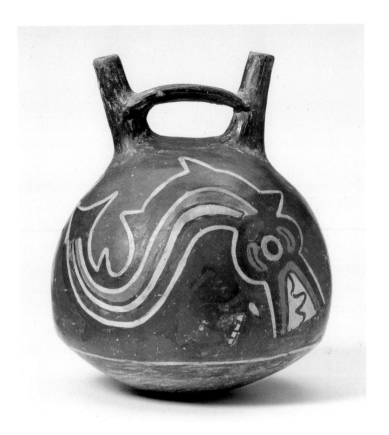

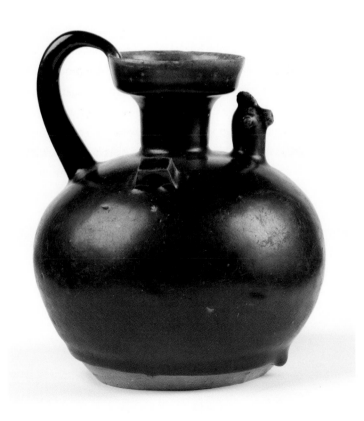

Ewer
Stoneware, with black glaze
China, Deqing kilns, Zhejiang province
Eastern Jin dynasty (AD 317–420)
Height 17.5cm, diameter 14cm
FE.9–1972

Pedestal stand

After about AD 300, the introduction of the potter's wheel and high-firing kilns enabled Korean potters to produce thin-bodied, complex ceramic vessels in an astonishing variety of shapes. These variations in part reflect the emergence of a number of different states within the Korean peninsula. Tall pedestal vessels were characteristic of the states of Kaya and Silla, in the south-east region, and seem to have been used in funerals. Enormous numbers have been excavated from royal tombs in and around the Silla capital, Kyŏngju, along with storage jars and eating utensils. After Buddhism reached southern Korea, burial practices changed and the need for large supplies of utensils for use in the afterlife disappeared. By about AD 650, simple covered urns were produced to contain the cremated remains of believers.

Silla's tombs (about 57 BC–AD 668) usually consisted of a chamber protected by a layer of large stones, a design that guarded against robbers and ensured the survival until modern times of plentiful examples of ancient ceramics. Sculptural pieces exist in the form of ducks, horse riders, boats and chariots. More rarely, small human and animal figurines were attached to the neck of a vessel. Here, the decoration comprises incised geometric patterns and raised horizontal bands on the vessel walls, above two rows of triangular piercing on the upper section of the A-shaped base. Probably, the pedestal stand supported a round-bottomed container which has since been lost. Similar forms are found in early Japanese pottery, demonstrating the cultural connections that have long existed between the two countries. BM

Stem cup

This white-bodied, white-glazed stem cup has remarkably thin walls. It was made at a time when silver tableware was fashionable and the shape of the cup, especially the bulging ring above the splayed foot, shows strong influence of contemporary silverware. It would have blended in harmoniously with silver vessels, but would have been considerably cheaper.

Although green-glazed and black-glazed stonewares were first produced in southern China, it was north China that made the first high-fired whiteware. Kaolin-rich white-firing clays had been used as early as the twenty-fifth century BC, and it remains unknown why it took northern kilns nearly three millennia to rediscover the material. The quest for aesthetically pleasing vessels rather than basic utensils must have been the main force driving potters to search for white-firing materials. No doubt they learned the technology of high-temperature firing from the more experienced potters of southern China. The first high-fired whiteware emerged in northern China in the sixth century, the earliest datable piece of white stoneware being found in a tomb of AD 575.

The Tang dynasty (AD 618–907) was an era when Chinese lifestyle was very cosmopolitan. Foreign goods were imported from the 'Western Regions', a vague term used to refer to places beyond the western frontiers of China. Chinese people were not averse to trying out foreign food and drinks, including wine made from grapes (rather than the native rice wine). This white cup, a novelty at the time, would have been a perfect vessel from which to drink the dark red wine. MW

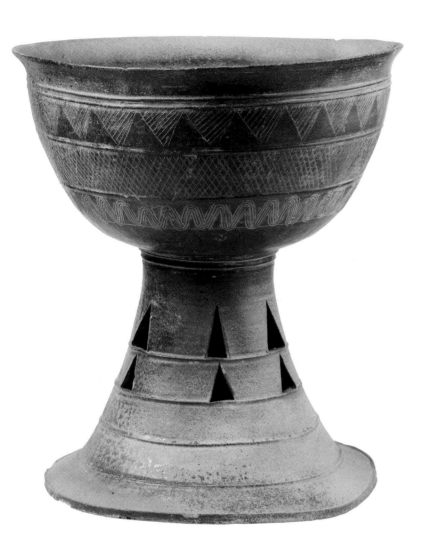

Pedestal stand
Unglazed stoneware
Korea
AD 400–600
Height 36cm
FE.58–1993

Stem cup
Stoneware, with white glaze
North China
Tang dynasty, 7th century AD
Height 7.5cm, diameter 7.5cm
Mrs B.Z. Seligman Bequest,
C.138–1965

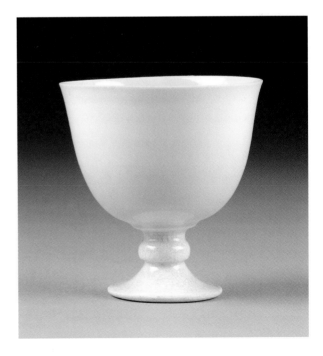

Tomb figure of a horse

The brown glaze running down the neck of this powerfully sculpted and amazingly lifelike horse suggests that it is of the 'blood-sweating' type, bred in the Ferghana valley, in what is now Uzbekistan, and brought to China along the Silk Road. It is a magnificent example of Tang *sancai*, which can be translated literally as 'three-colour' ware. In fact, such wares frequently feature more than the three colours implied in the name – in this case ivory, green and two shades of brown. Blue and amber are also common, and occasionally, though infrequently, all five can be seen on a single piece. Some *sancai* wares were exported to the Middle East and similar effects were also achieved by Middle Eastern potters.

Tang *sancai* horses were made for burial with the dead, a tradition that can be traced to the third century BC, when a large number of terracotta warriors and horses were made for the tomb of the First Emperor, Qin Shihuangdi. Following the excavation of his royal mausoleum, the construction method of the horses has been thoroughly studied, revealing that the head, neck and body were made separately using two-part moulds. These were then joined together and solid moulded legs were inserted into holes in the body. Smaller parts such as eyes, ears, lower jaws and tail would be attached and the entire model smoothed over. Tang horses were probably made in a similar manner. This *sancai* horse differs from its Qin predecessors in having more details, such as the saddle and trappings, and hence more finishing by hand would have been necessary. MW

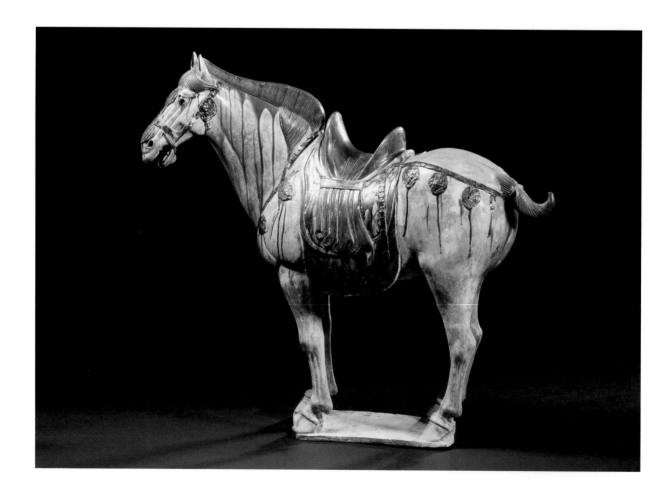

Bowl

Around AD 750, Chinese ceramics began to be imported into the Middle East in large quantities. This was the result of new long-haul trade routes between Iraq and China, plied chiefly by Middle Eastern merchants. A main entrepot for this trade in Iraq was the port of Basra, described by the Arab geographer al-Muqaddasi as 'a port of the sea, an emporium of the land'.

It was at Basra, too, that the first local imitations of these Chinese imports were made. Particularly admired were the high-fired, pure white stonewares made in Hebei province in northern China. The kaolin clay that gave the Chinese originals their bright white body did not exist in Iraq, and the potters of Basra used locally available earthenware clays, which produced a distinctive yellow body. They invented a way of masking it by mixing tin oxide into the lead-based glaze. Particles of tin oxide remained in suspension during firing and recrystallized on cooling, making the glaze appear white and opaque. This was the origin of the tin-glaze technique, which spread throughout the Islamic empire and eventually to Europe.

The white surface of the glaze provided a 'blank canvas', which Iraqi potters saw as a vehicle for decoration. They painted designs in cobalt blue, using a mineral available locally, and thereby created the world's first blue-and-white ceramics. The design on this bowl, of a diamond with leaves springing from the tips, was a popular one. It is even seen on contemporary Chinese wares, which must have been made for export to the new Middle Eastern market. The shape of this bowl also copies Chinese imports. MRO

Bowl
Tin-glazed earthenware, painted
in cobalt blue
Iraq, probably Basra
AD 800–900
Restored from excavated fragments
Height 6.5cm,
maximum diameter 20.8cm
Circ.175–1926

Tomb figure of a horse
Earthenware, with *sancai* glaze
North China
Tang dynasty, 8th century AD
Height 75cm, length 83cm
Mrs Robert Solomon Gift, C.50–1964

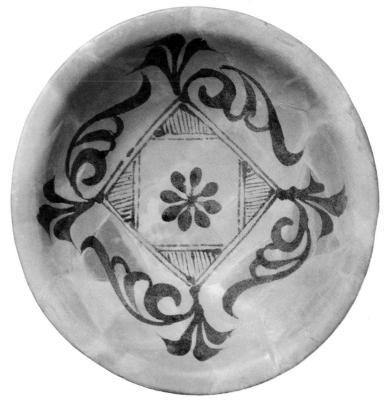

Bowl

Middle Eastern potters were hugely inventive in the ninth century: in addition to inventing tin-glazing and creating the first blue-and-white wares (see p.33), they also invented the technique of decorating ceramics with metallic pigments known as lustre. This was an expensive technique, both in materials and in fuel, but it had wide appeal because of its successful imitation of precious metal wares. The dotted background here, for example, recalls the ring-matted textures of gold and silver dishes. Like many vessels, the form of the bowl probably followed metal prototypes, as the wide, flat rim is not a natural shape for a potter to throw on a wheel.

The depiction of human and especially animal figures became frequent in lustreware from the start of the tenth century AD, a single figure often occupying the entire decorative field. The bird on this bowl is probably a peacock, indicated by the long tuft of feathers on its head and its plump body. These birds were associated with royalty and were often depicted in early Islamic court art.

Iraqi lustrewares were exported throughout the Islamic empire and have been found as far west as Spain and as far east as India. Lustre became one of the most popular means of decorating Islamic ceramics and was used at different times in Egypt, Syria, Iran and Spain, from where it was transmitted to Italy. The technique may have been the monopoly of certain potters who themselves carried the knowledge from place to place. MRO

Storage jar

This slender jar is an example of Cizhou ware, a term embracing a range of high-fired stonewares made in several regions of northern China. The distinguishing feature is the white or cream-coloured slip (a thin layer of diluted clay) covering the body, on which a variety of decorative techniques were employed. Cizhou potters were highly creative, using carving, incising, combing, inlaying, stamping, underglaze painting and overglaze enamelling to decorate their wares. Very often two or more of these techniques were combined to decorate a single object. Here, the design of camellia flowers on a scrolling leafy branch was incised, but variety was achieved by setting the flowers against a ring-punched background.

A vessel of this shape has traditionally been referred to as a *meiping*, meaning literally 'prunus vase'. However, some of these 'prunus vases' are inscribed with the Chinese words 'fine wine'. Judging from the sturdy body of this piece and its heavily weighted foot, it was most probably a container for alcohol.

Cizhou wares were utilitarian at their time of production and were made in relatively large numbers. Their bold designs and spontaneous quality had strong appeal to Japanese and western connoisseurs in the twentieth century. In 1940 the influential British potter Bernard Leach acknowledged the inspiration he derived from Cizhou ware in his seminal publication *A Potter's Book* (1940; see p.134). MW

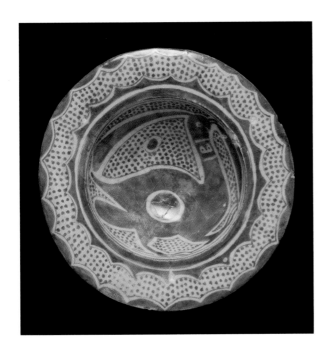

Bowl
Earthenware, with lustre painting
Iraq, probably Basra
AD 900–1000
Height 4cm, diameter 14.3cm
Given by Monsieur Georges Tabbagh,
C.1309–1924

Storage jar
Stoneware, with incised and punched
decoration, cream-coloured slip and
transparent glaze
North China, Cizhou kilns
Northern Song dynasty, 1025–50
Height 38.5cm, diameter 16cm
Purchased from the Eumorfopoulos
Collection with the assistance of
The Art Fund, the Vallentin Bequest,
Sir Percival David and the Universities
China Committee, C.31–1935

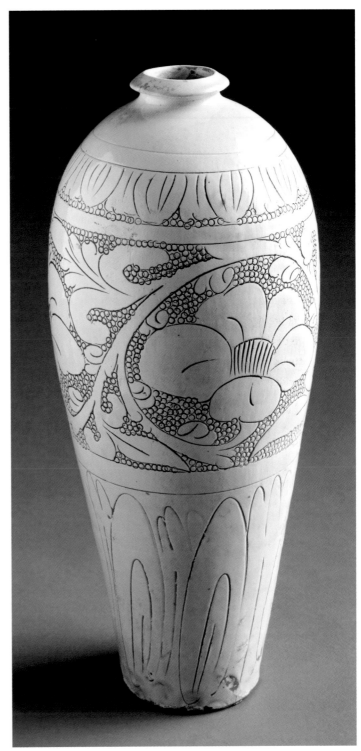

Ewer

This elegant eight-lobed ewer was made in Jingdezhen, in Jiangxi province, a town that was to dominate the entire porcelain industry in China for centuries to come.

The kilns of southern China, which had earlier excelled at making green-glazed ceramics, started to produce whitewares in the tenth century. The resultant Qingbai porcelains differ from their northern counterparts in both chemical composition and firing technique (see following entry for Northern Ding wares). They were fired in a 'dragon' kiln, so called because its narrow and upward-climbing structure resembles a dragon. Such kilns were built into the side of a hill or a man-made mound and were designed to maximize heat from the fuel, which in this case was wood. Qingbai wares were fired in a reducing atmosphere, meaning the kiln was deliberately deprived of oxygen, resulting in a distinctive glassy, cool, bluish-white glaze. In Chinese, 'Qingbai' means literally 'bluish white'.

Like earlier whitewares, the ewer was made as a substitute for a silver vessel. Other daily utensils not used for dining were also made in Qingbai porcelain, including lamps, pillows, incense burners, boxes and small jars. Qingbai ware was evidently an important export line from the eleventh to the fourteenth century, as examples have been found in Korea, Japan, South and South-East Asia, West Asia and North Africa. One of the earliest pieces of Chinese porcelain to reach Europe, the Fonthill Vase (now in the National Museum of Ireland and once owned by a fourteenth-century king of Hungary) is of Qingbai ware. MW

Storage jar

The harmonious proportions and subtle decoration of this jar are characteristic of Song dynasty ceramics. It belongs to a category of Chinese stoneware known as Ding ware, as it was made in Dingzhou, in present-day Hebei province, north of the great north–south divide (see p.24). The jar is covered with an ivory-coloured glaze, which is a distinguishing feature of Ding ware. The design of a lotus is incised and the fluency with which the motif is executed testifies to the skill of the potter. To streamline production and to reduce costs, the Ding kilns introduced moulded decoration towards the middle of the twelfth century. Latter-day ceramic collectors, however, have always valued incised decoration over moulded work.

In the eleventh century the choicest Ding wares were sent as tributes to the imperial court, as their subtle beauty suited the restrained taste of the Song dynasty emperors. After 1127 northern China came under the rule of the Nüzhen, a nomadic minority from outside the Great Wall, and Ding ware temporarily lost its 'imperial' status. However, when in 1368 China once more had an emperor of the Han race, Ding ware became prized by Chinese collectors again and was hailed as one of the 'Five Great Song Ceramics' (together with Ru, Guan, Ge and Jun). MW

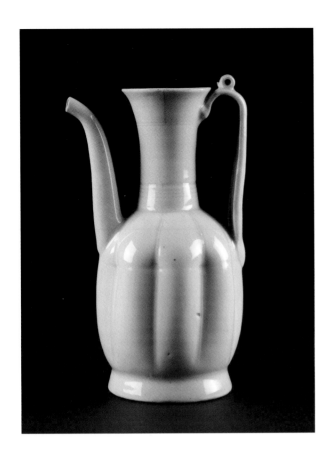

Ewer
Porcelain, with bluish-white glaze
China, Jingdezhen
Northern Song dynasty, 11th century
Height 19.7cm, width 11.7cm
H.B. Harris Bequest, C.112–1929

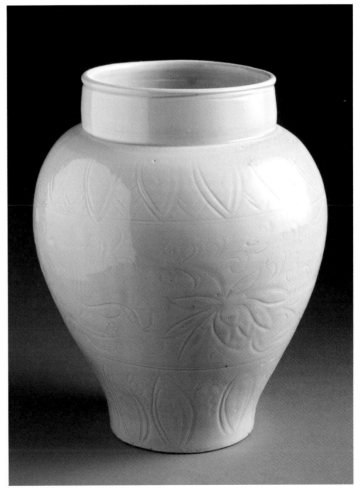

Storage jar
Stoneware, with incised decoration
and ivory-coloured glaze
China, Ding kilns, Hebei province
Northern Song dynasty,
11th–12th century
Height 29.5cm,
maximum diameter 24cm
Purchased from the Eumorfopoulos
Collection with the assistance of
The Art Fund, the Vallentin Bequest,
Sir Percival David and the Universities
China Committee, C.37–1935

Vase

This vase was made in Yaozhou, north of the divide separating northern and southern China (see p.24). It has a grey stoneware body, covered with an olive-green glaze. Modern scholars in the West traditionally refer to this type as celadon, the Chinese equivalent for this term being simply 'greenware'.

The first greenwares were made in southern China. Eventually the technology spread to the north and for a brief period in the eleventh century the Yaozhou products outshone their southern competitors, due partly to the fact that the capital city, Kaifeng, was situated much closer to the northern kilns. The geographical proximity of the Yaozhou and Ding kilns (see p.36) led to these two wares sharing many stylistic features. The decoration on Yaozhou wares, however, tends to be deeply carved rather than incised or moulded. The olive-green glaze pools in the carved areas, intensifying in colour and making the design – in this case a peony – much more apparent.

The Yaozhou kiln site was excavated by the Chinese authorities in the twentieth century, but there is currently no evidence that the wares were exported in the Song dynasty. China's neighbour Korea produced a similar green-glazed stoneware in the twelfth century, but Yaozhou ware is not thought to have been its source of inspiration. MW

Water sprinkler

The water sprinkler, also known by its Sanskrit name, *kundika*, was a popular object in Korea during the Koryŏ dynasty (AD 918–1392). With its origins in Buddhist purification ceremonies, the form reached Korea from India, the birthplace of Buddhism, via China. *Kundika* were produced in bronze as well as in ceramics with green celadon glaze; plain and patterned examples are known. The Chinese envoy Xu Jing, who visited Korea in 1123, noted that *kundika* were 'used by the nobility, government officials, Buddhist temples, and common people alike for storing water'.

The bottle has a high-shouldered body and a long neck, surmounted by a narrow spout, and there is a second, short spout, lacking its lid, which was used for filling the bottle. Covered with a crackled celadon glaze, it is decorated with a willow and waterfowl scene, reflecting a Buddhist taste for rustic tranquillity. This decoration is inlaid, a Korean speciality, using a method invented and developed by Koryŏ craftsmen during the twelfth century, possibly originally in imitation of inlaid bronze and lacquer. The motif is carved into the semi-dried clay body and the resulting grooves are then filled with a mixture of quartz, glass and clay (for the white) and mineral-rich glaze materials (for the black). After the excess has been scraped off, the piece is biscuit-fired, before being glazed and fired again. The ensuing design is clearly visible underneath the thin and highly translucent iron-bearing celadon glaze, which gives the bottle its green colour. BM

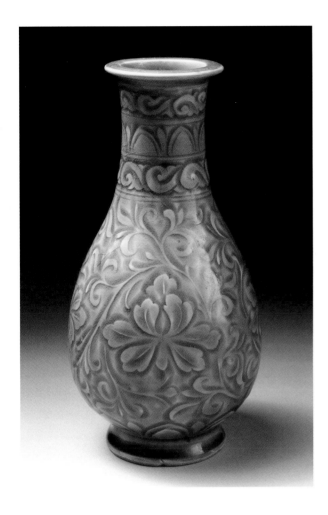

Vase
Stoneware, with carved decoration
and olive-green glaze
China, Yaozhou kilns, Shaanxi province
Northern Song dynasty, 11th–12th century
Height 24cm, maximum diameter 12cm
Purchased from the Eumorfopoulos
Collection with the assistance of
The Art Fund, the Vallentin Bequest,
Sir Percival David and the Universities
China Committee, C.810-1936

Water sprinkler
Stoneware, with celadon glaze and inlaid
decoration
Korea
Koryo period, 1150–1200
Height 35.5cm
C.743-1909

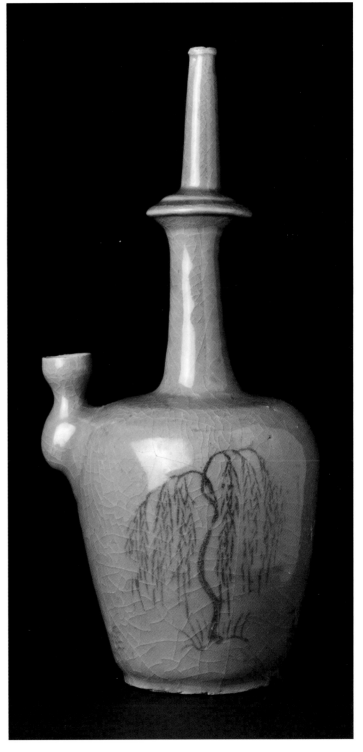

Vase

This elegant long-necked vase is an example of Jun ware, a type praised by collectors in the Ming dynasty as one of the 'Five Great Song Ceramics' (see p.36), although unlike these others, which received imperial patronage, Jun was mainly made for a general market. It has a stoneware body coarser than most Song ceramics, but above all it is the glaze that distinguishes Jun ware from its rivals. Lacking relief or painted decoration, Jun wares rely entirely on the beauty of their form and glaze for visual impact. Here the glaze is sky-blue, very thick and full of tiny pinholes visible to the naked eye. Jun glazes have a tendency to run during firing, and in this case it has run thin at the mouth of the vase, leaving the rim a mushroom hue.

Modern scientists have carried out numerous analyses of Jun glazes, establishing that the opal-blue colour arises from a process known as 'liquid-liquid phase separation' during early cooling. In layman's terms this means that the colour effects are partly optical, in much the same manner that the sky appears blue as a result of refracted light. Jun glazes are complex and their effects embrace luminosity, whiteness and opalescence, which together create a wide range of subtle tones and textures.

The single, subtle patch of purple on the vase is derived from a copper-rich pigment added for heightened visual impact. On some Jun pieces the purple splashes are applied much more boldly and exploit chance effects, making them the most dramatic of all Song dynasty wares. MW

Bowl

The potters of Kashan, in northern Iran, experimented with a wide range of decorative techniques. One that emerged fully formed in the late twelfth century, with no apparent precedent, was that of decorating ceramics with coloured enamels. This ware, now known as *minai* (from the Persian for enamel), achieved a rich polychromy in ceramics for the first time. The enamels were applied to the hard, already-fired glazed surface and fixed during a second firing, in the same manner as lustre. Vessels decorated in both techniques were signed by the Kashan master potter Abu Zaid (active 1186–1220).

Minai wares often feature highly detailed scenes and are closely related to miniature paintings of the period. It may be that the scene here, showing figures on horseback who greet each other as if meeting by chance, suggested a specific story to a twelfth-century Iranian user. The paired figures seated around the walls of the bowl have long tresses and haloes and the 'moon face', which together epitomize the Iranian ideal of beauty at that time. The ensemble conveys a general message of well-being, enhanced by the elegant inscription around the rim, which contains a litany of good wishes.

The *minai* technique died out with the Mongol invasions of the 1220s. A variant of it was developed later in the thirteenth century and used mainly on tiles, where red and white enamels and gilding were applied over a dark blue ground. This ware is known as *lajvardina*, after the Persian word for lapis lazuli, which the blue ground resembles. MRO

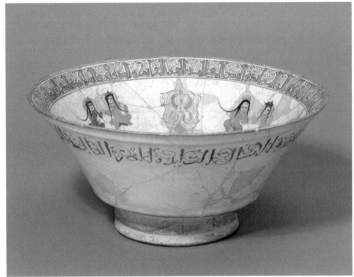

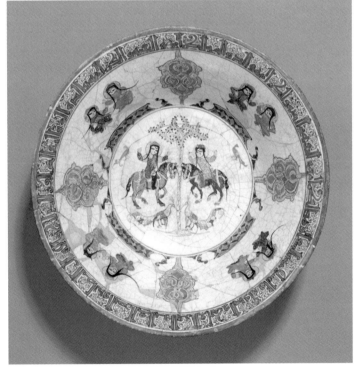

Vase
Stoneware, with sky-blue glaze
and copper splash
China, Jun kilns, Henan province
Northern Song or Jin dynasty,
12th century
Height 29.5cm, diameter 12.6cm
Sir John Addis Gift, FE.156–1975

Bowl
Fritware, painted in enamels and gilt
Iran, probably Kashan
1180–1220
Said to have been found at Rayy,
near Tehran
Height 9cm, diameter 20.7cm
Given by Col. Stephenson Clarke, CB,
C.85–1918

Dish

Around 1150, Kashan, in northern Iran, emerged as a new centre of innovation in Islamic ceramics. Its potters perfected the fritware body (also known as stonepaste), a white, high-fired ceramic made from quartz powder finely ground from sand or pebbles, mixed with small quantities of white clay and a glassy substance known as 'frit' to bind it. This was the closest Islamic potters ever came to producing porcelain.

The white fritware body provided the perfect 'blank canvas' for decoration and also proved to be a versatile material, especially suitable to moulding and carving. This led to an explosion in the range of vessel shapes and sizes, and of decorative techniques employed. Lustre was extensively used and the processes followed were described in a treatise written in 1301 by Abu'l-Qasim, a member of one of Kashan's pottery families. He says that when it has been evenly fired, 'it reflects like red gold and shines like the light of the sun'.

The design of this impressively large dish is unusual in consisting entirely of stylized plant motifs. It is one of the complete vessels recovered from a hoard of Kashan wares found at Jurjan, in north-eastern Iran. The many types of wares represented in the hoard provide important evidence for the wide range of decorative styles and vessel shapes produced at the same time in a single production centre. They must have belonged to a merchant who feared for his stock in the face of the Mongol invasions of Iran in the 1220s. He buried the hoard for safekeeping, but did not return to recover it.
MRO

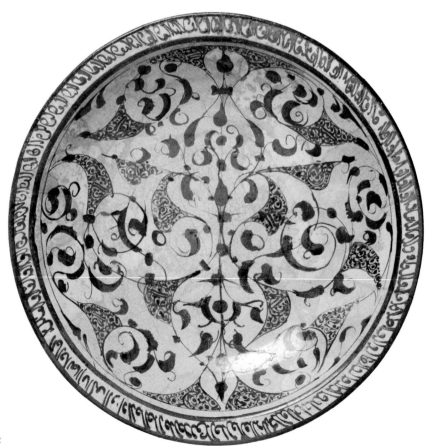

Dish
Fritware, with lustre painting
Iran, probably Kashan
About 1200
Height 8cm, diameter 35.5cm
Ades Family Collection

Ewer

Manufacture of glazed stoneware ceramics in Cambodia coincided with the rapid expansion of urbanization under the Khmer empire centred at Angkor. The earliest production centre was on Phnom Kulen, the plateau mountain to the north-east of Angkor and the site of the first of the Angkorian-period Khmer capitals, that of Jayavarman II (802–about 830). Kilns have been located on Mount Kulen in the presumed vicinity of his capital.

Glazed ceramics continued to be made in the vicinity of the capital, which was relocated several times during the Angkorian period (from the ninth to the end of the thirteenth century). Recent excavations of kiln sites in the region confirm that production was associated with both urban and ritual centres. Roof tiles abound at all sites, as well as functional wares and a number of categories of more specialized ceramic forms seemingly associated with temple life and ritual.

Vessels incorporating animal forms in their design were particularly popular in the later Angkorian period, as on this piece, which has a handle in the shape of a bird. Many of these vessels with residual animal forms have a wide neck aperture and are often encrusted with traces of lime, indicating that they were containers for the lime associated with betel chewing. This example, however, has a constricted neck and a functioning spout, and was probably a domestic pouring vessel. The vast majority of surviving brown-glazed Khmer ceramics have been excavated, often in the vicinity of temples, in those regions of north-east Thailand that once formed part of the Khmer empire. JG

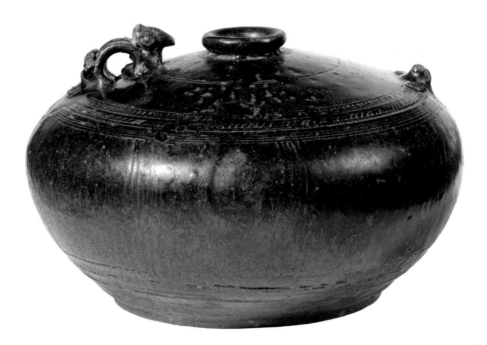

Ewer
Stoneware, with incised decoration
and iron-brown glaze
Cambodia or north-east Thailand
(Khmer empire)
About 1150–1250
Diameter 22.3cm
FE.130–1978

Tea bowl

Tea drinking underwent a drastic change in tenth-century China, as a result of which two cities in the south started making dark-glazed tea bowls. These were Jianyang and Jizhou (where this unusually large bowl was made), in Fujian and Jiangxi provinces respectively. Prior to this the Chinese drank steeped tea and men of fine taste recommended drinking from a green bowl. When powdered tea replaced leaf tea as the standard drink, black or brown tea bowls were deemed more suitable. The drinker would first pour boiling water on the powdered tea and then use a bamboo whisk to whip up a rich whitish froth, which looked very appealing against the dark glaze.

Dark-glazed tea bowls usually have thick walls so that the heat from the boiling water does not scald the drinker's hands. Though they might appear rustic at first sight, Jizhou bowls are in reality highly sophisticated products. The potters manipulated the glaze mixture and the firing and cooling processes to create a wide variety of decorative effects, including 'hare's fur', 'tortoiseshell' and 'oil spot' glazes. This is a highly successful example of the 'hare's fur' type, the glaze having fired to a warm golden colour and the pattern on the inside having a glowing appearance. The three flying phoenixes were created by the 'resist' method, a speciality of Jizhou potters. Cut-paper silhouettes shaped as phoenixes were stuck to the first layer of brown glaze, over which another glaze was applied. The paper burned away in the kiln, leaving outline impressions on the bowl. MW

Jar

This jar is a fine example of Guan ware (meaning 'official ware'), the distinguishing feature of which is its crackled glaze. Crackles occur when the glaze shrinks more than the clay body beneath, the disparity between the two rates of contraction causing the glaze to craze. In this particular case the crackles were deliberately created, as Chinese connoisseurs considered them a pleasing feature. Modern scientists have analysed the Guan glaze and concluded that Chinese potters caused the crazing by reducing the silica content of the glaze.

As its name implies, Guan ware was fired in kilns that were under the direct control of state officials. In 1126 the Song dynasty capital, Kaifeng, was captured by a fierce nomadic minority, the Nüzhen. The Song court fled to regions south of the Yangzi River and eventually set up a new capital in Hangzhou. Supplies of ceramics from northern kilns, such as Ding and Yaozhou, were no longer available. As a result, two kilns were established by imperial command, one called 'Xiuneisi' (literally 'Palace Maintenance Office') and the other 'Jiaotanxia' (literally 'Beneath the Suburb Altar'), both to produce Guan wares exclusively for court use. MW

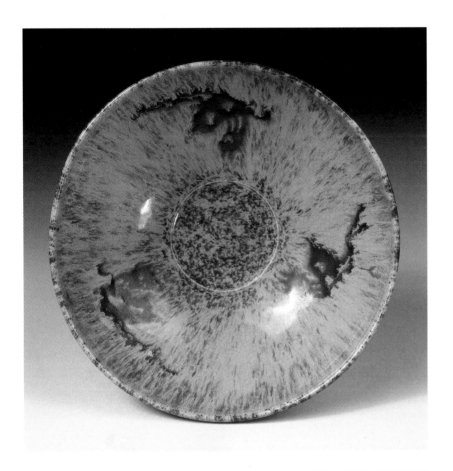

Tea bowl
Stoneware, with resist decoration
and 'hare's fur' glaze
China, Jizhou kilns, Jiangxi province
Southern Song dynasty,
12th–13th century
Diameter 16cm
Purchased from the Eumorfopoulos
Collection with the assistance of
The Art Fund, the Vallentin Bequest,
Sir Percival David and the Universities
China Committee, C.30–1935

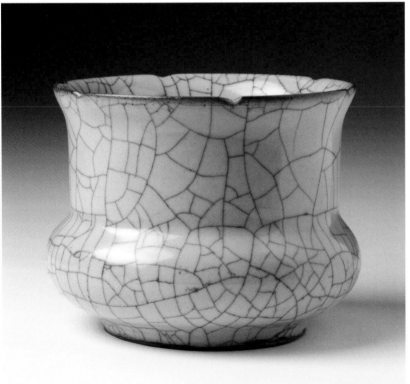

Jar
Stoneware, with crackled
pale green glaze
China, Guan kilns, Zhejiang province
Southern Song dynasty, 13th century
Height 10cm, diameter 12cm
Purchased from the Eumorfopoulos
Collection with the assistance of
The Art Fund, the Vallentin Bequest,
Sir Percival David and the Universities
China Committee, C.25–1935

Funerary jar

This jar was made to contain grain for burial in a tomb. It is of a type of celadon known as Longquan ware and is closely related to the Guan ware made some 300 kilometres away (see p.44). But while the Guan kilns were only established after the Song court moved to Hangzhou in 1126, those at Longquan had been in production since the third century. The arrival of the Song court and its affluent ministers in the south brought prosperity to Longquan, as state officials demanded a quality no less refined than Guan ware. To satisfy these important customers the potters improved their products to the extent that the best Longquan wares are almost indistinguishable from Guan pieces. Although all Longquan wares are green-glazed, the varieties of shades and textures are numerous. Their qualities were highly esteemed and Chinese writers compared the subtle variations in green to jade, to young beans and to the sky.

Longquan's success resulted not from imperial patronage but from efficient management. When the Guan kilns ceased production after the collapse of the Song dynasty in 1279, those at Longquan continued to flourish under the new rulers, the Mongols. The kilns were on average 40 metres long and had a firing capacity of up to 10,000 pieces. The volume of Longquan celadons exported overseas can be gauged from the cargo of the 'Sinan wreck', a ship sunk near Korea en route to Japan: of the 17,000 ceramics on board, more than half were Longquan wares. MW

Wall tile

The Mongol invasions of the early thirteenth century created a close link between the Middle East and China, as both regions came to be ruled by descendants of Chingiz Khan – the Ilkhanids (1256–1353) in Iran and the Yuan (1271–1368) in China. These dynasties maintained close links with each other through trade by sea, and by land across Central Asia. As a result many Chinese designs and motifs were adopted in the Middle East, the dragon, the phoenix and the lotus flower being particularly popular in Islamic art from this time onwards.

Tile production increased under the Ilkhanids. Many were made for Muslim religious buildings, notably the tombs of figures revered by the Shiites. An important secular construction was the summer palace of Takht-i Sulayman in the mountains of north-west Iran. This palace complex was built in the 1270s and was lavishly decorated with tiles in a variety of decorative techniques, many of them moulded. Their designs included scenes from the Persian national epic, the *Shahnama* or *Book of Kings*. They also included the first datable Chinese designs in Iran, in particular the dragon and the phoenix, both symbols of imperial power. This tile is very similar to others known to have come from Takht-i Sulayman and would originally have formed part of a frieze, interlocking with cross-shaped tiles. The dragon's body has been skilfully curved to adapt to the star shape. MRO

Funerary jar
Stoneware, with bluish-green glaze
China, Longquan kilns,
Zhejiang province
Southern Song dynasty, 13th century
Height 25.5cm,
maximum diameter 12cm
Purchased from the Eumorfopoulos
Collection with the assistance of
The Art Fund, the Vallentin Bequest,
Sir Percival David and the Universities
China Committee, C.28–1935

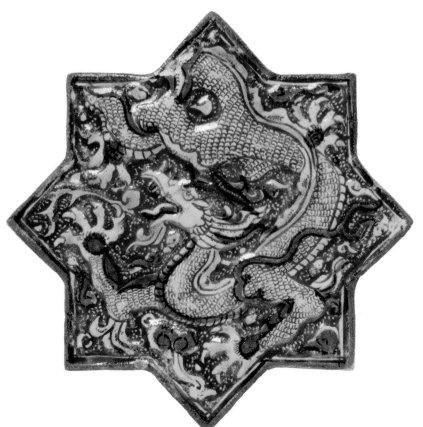

Wall tile
Fritware, moulded and painted in
colours and lustre
Iran, probably from Takht-i Sulayman
About 1270–75
Width 20.4cm, depth 1.5cm
George Salting Bequest, C.1970–1910

Flask

The design of dragons and 'cloud collars' here was painted in a blue derived from cobalt – a revolutionary innovation at the time that this flask was made. Known as 'blue and white' in the West, such wares are undoubtedly the most familiar, influential and widely imitated of all Chinese ceramics. At the time of writing, a Yuan dynasty blue-and-white jar is the most expensive ceramic item ever sold at auction, reaching a 'hammer price' of £14 million.

It was no coincidence that the success story of Chinese blue and white should begin while China was under Mongol rule, when the country was highly receptive to ideas from abroad. As early as the ninth century, Chinese potters had briefly experimented with painting in cobalt blue. The impetus for its revival in the fourteenth century probably came from the Middle East, which was the main source for the cobalt used in China during these years, and was also a hugely important export market for Yuan and later porcelains. It was via trade with the Middle East that most early blue-and-white porcelains reached Europe until Portuguese seafarers found their way to China in the sixteenth century. In China the early use of blue and white was probably restricted to the Mongol court and the more affluent Chinese. Production expanded after the Mongols were overthrown in 1368 and in the second half of the fifteenth century a native supply of cobalt was found. Chinese blue and white has enjoyed uninterrupted popularity from that time until the present day. MW

Wall tiles

These two tiles are most unusual in technique, because the design is not stamped into the surface and then inlaid with clay of contrasting colour, as with most decorative tiles from medieval England. Rather, it was cut through a light-coloured slip laid onto a red earthenware rectangular tablet, and the whole of the background was then removed and the details incised. This technique allows considerable refinement in composition and delineation, but was not suitable for large-scale production or for hard-wearing floor tiles. The tiles are apparently part of a group from Tring parish church in Hertfordshire, the designs for which were based on a series of manuscript illuminations for the Apocryphal Gospels of the Childhood of Christ. The V&A tiles, each of which is divided into two square compartments, show (left to right): Christ resurrecting three children who had died while playing with him; Christ at a well; three men remonstrating with Joseph (relating to a story about a boy who died while imitating Christ sliding down a sunbeam); and Christ with three boys kneeling before him.

The style of the drawing on the tiles suggests an English or possibly Norman French origin. Certainly, there are examples of incised ceramic tomb slabs in Normandy; however, incised slipware decoration was also popular on pottery made in East Anglia (in the south-east of England) during the fourteenth century. TB

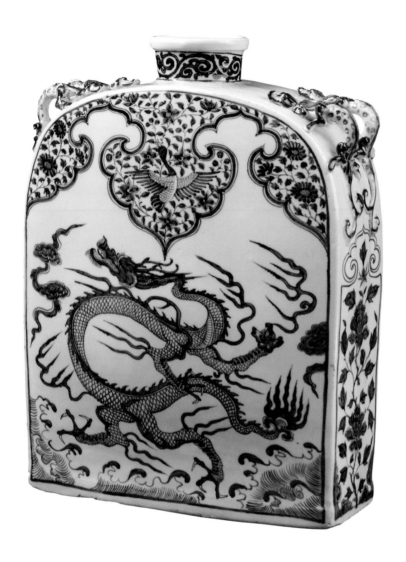

Flask
Porcelain, painted in underglaze blue
China, Jingdezhen
Yuan dynasty, 1300–1368
Height 37cm, width 28cm, depth 9cm
Purchased from the Eumorfopoulos
Collection with the assistance of
The Art Fund, the Vallentin Bequest,
Sir Percival David and the Universities
China Committee, C.47–1935

Wall tiles
Red earthenware, with white slip,
incised decoration and lead glaze
England or France (Normandy)
About 1330
Height 19.5cm, length 39.5cm
C.470&C.469–1927

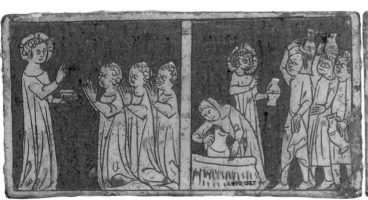
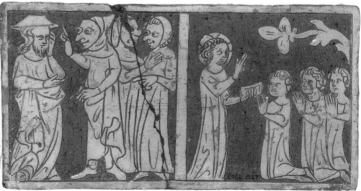

Jug

With its bold and functional shape and simple but highly effective decoration, this jug is a characteristic example of fine domestic medieval English pottery.

It is of a type known as Mill Green Ware, Mill Green in Essex being a potting centre that supplied the London market, and parts of Kent and Essex, between about 1270 and 1350. Mill Green jugs are thinly potted and characterized by a coating of white slip and speckled green glaze, and their thin potting and careful decoration suggest that they were intended for fine dining. The white slip, which extends over the larger part of the vessel's form, was added for decorative effect and has been incised to reveal the red earthenware body below (a simple means of achieving contrasting colour). The central portion of the jug was then sprinkled with coloured glaze, rendering it less permeable to liquids, although here the glaze was only sparsely applied, apparently primarily for decoration. The green stain was achieved by adding copper filings to a 'galena' (lead sulphide) glaze. The base of the jug appears to have been separately made and then 'pinched' into place. The deep pinch-marks are a strong decorative feature, but also strengthened this vulnerable point, made it easier to stack unfired, glazed pots upside down in the kiln and reduced surface contact between pots during firing.

English medieval pots of this type were greatly admired by early studio potters such as Bernard Leach, who praised their nobility and 'severe dignity of form'. TB

Dish

This boldly decorated dish was produced in a part of Spain ruled by the Christian kings of Aragon. Yet, in technique and design, it reflects the presence of Muslim power in Spain from the eighth to the fifteenth century.

Contact between Muslims and Christians in Spain was only intermittently a clash of irreconcilables. For long periods, they lived side by side – together with Jews – under rulers of either affiliation, and cultural exchange was intense. In this way, the Muslim habit of eating from ceramics was transmitted to the Christian courts of northern Spain. After their expansion into the Muslim territories to the south, the kings of Aragon continued to foster the ceramics industry there, employing both Muslim and Christian potters. So successful did Spain's pottery industry become that, by the fourteenth century, when this dish was made, the country was a major source of the luxury ceramics used in the Middle East and parts of western Europe.

Paterna in Valencia specialized in ceramics of this type, with designs that overlap the perceived divide between Islamic art and the Gothic style in Europe. The scrollwork and the deer-like beast can be traced back to the decorative artefacts of earlier periods, notably those produced in North Africa and Egypt under the Fatimid caliphate (919–1171), which was the most powerful Mediterranean political entity of its time. Similar motifs continued in use outside the Fatimid caliphate, in Norman Sicily and southern Italy, and in Spain. They found favour, too, in northern Europe, where they became a component of the Gothic style. TS

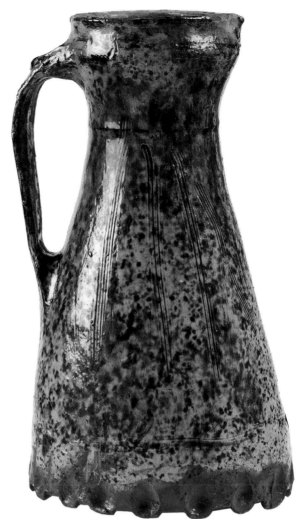

Jug
Red earthenware, with white slip
and green glaze
England, Mill Green, Essex
Early 14th century
Height 28.2cm, width 17cm,
maximum diameter 15.9cm
C.184–1926

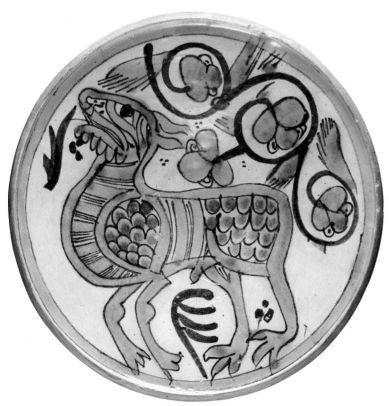

Dish
Tin-glazed earthenware, painted
in manganese and copper oxides
Spain, Paterna
About 1325–50
Restored from excavated fragments
Diameter 24.2cm
C.21–1931

Storage jar

The *tinaja*, a type of large storage vessel, was produced in Islamic Spain from the twelfth century. They were either partly covered with a green glaze, or left completely unglazed, which helped to keep the contents cool. This example has a hole close to the base to take a wooden stopper or tap, but this was probably a later addition, as most other *tinajas* lack this feature. With their narrow bases, these jars would have had special stands or been sat in holes cut into the floor, and the contents would be reached with a ladle or scoop. Some examples are decorated with vine leaves, suggesting they were for storing wine, and others were possibly for olive oil.

The greater part of the handles and the neck of this piece are missing and its surface is worn, but it is obvious nevertheless that the jar was once a prestigious object. The rich decoration of the body is divided into vertical bands that are glazed white, dark green and turquoise green. The incised decoration consists of abstracted floral patterns similar to those on stucco, stone- and wood-carvings from the Alhambra at Granada, the palace complex of the Nasrid kings (1238–1492), the last Muslim dynasty to rule in Spain. The basic shape and some of the jar's decorative motifs are close to those of the so-called 'Alhambra Vases', a group of magnificent jars made in Málaga and decorated in lustre, which may once have stood in niches in the palace (see also p.114). **RL**

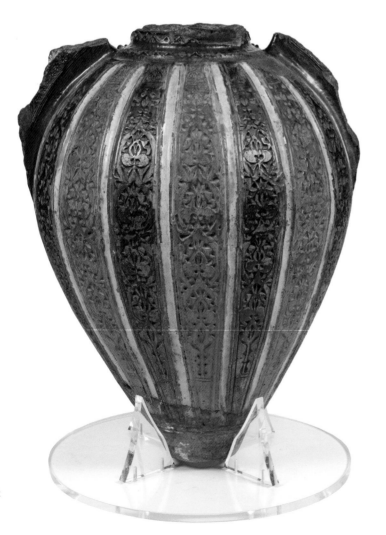

Storage jar
Tin-glazed earthenware, with incised and stamped decoration
Spain, Granada (Nasrid kingdom)
About 1375–1425
Height 95cm, width 69.6cm
125–1897

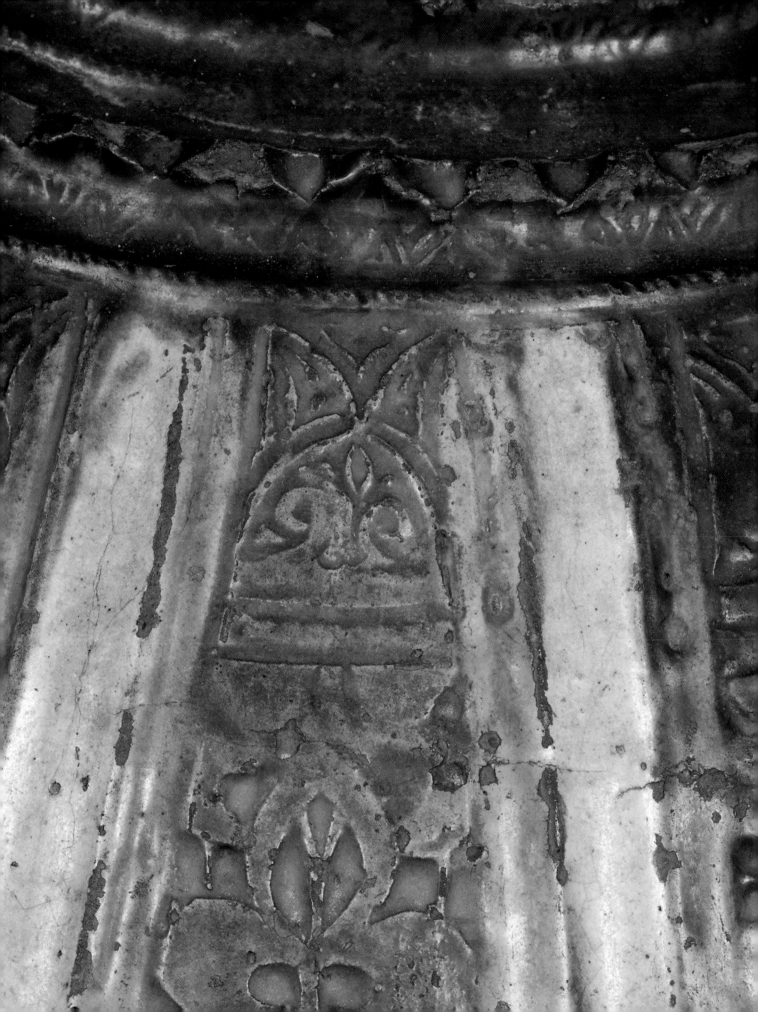

Stem cup

The red glaze of this wine cup is derived from copper, a mineral that is highly fugitive as a red colorant. The glaze has fired to a beautiful even red, except at the rim, where the colour has bled away from the sharp edge.

In the fourteenth century, Jingdezhen potters had attempted underglaze painting in much the same manner as contemporary work in cobalt blue (see p.48). The results, however, were not always successful, some pieces misfiring to a dark grey instead of the intended bright red. It was not until the reign of the Ming Emperor Yongle that potters finally mastered the technique of firing an even colour. Imperial intervention was the main reason for the breakthrough. Yongle, who had recently established the capital in Beijing, wanted monochrome vessels placed at the altars where he performed sacrifices – blue for Heaven, yellow for Earth, red for the Sun and white for the Moon. Red had a special significance, as the surname of the emperor was 'Zhu', which means 'red'.

Expertise in firing copper red was lost after 1435: those very few red-glazed vessels produced soon after this date have a rather unattractive liver colour, and we know that the emperor was petitioned to cancel orders for red-glazed vessels because 'all attempts ended in failure'. Copper-red glazes reappeared in the eighteenth century, when they were a reinvention rather than a revival, as the composition of this later glaze is very different from its Ming predecessor. MW

Jar

In contrast to the porcelains made for export to the West, with their polished finesse (see pp.77 and 80), this jar possesses a rugged beauty long-prized in native Japanese aesthetics.

The jar was made in the first half of the fifteenth century in Shigaraki, an important pottery centre not far from Kyoto. As is the case with many Shigaraki wares, its surface is reminiscent of a lunar landscape: cracks and pockmarks are the result of partially melted particles of white quartz and feldspar in the clay, while the burning out of organic matter in the firing process has left deep craters in other areas. The body is a subdued reddish-orange. Ash from the wood fuel has formed a natural green glaze on the shoulders, which has gathered and run into a distinctive streak down the front of the jar. Three ridges in its silhouette are evidence of the coiling method by which it was made. The broken mouth hints at its utilitarian past and adds to its austere beauty. Jars such as this had a variety of uses, from manure vats to burial containers.

Although the jar is clearly too large to have served in such a context, other Shigaraki wares were among the first native ceramics to be used in the Japanese tea ceremony, where they were combined with hitherto admired varieties of Chinese ceramics such as 'hare's fur' tea bowls (see p.44). This fusing of Chinese and Japanese tastes, which occurred during the ascendancy of the tea master Murata Shukō (died 1502), marked a radical step forward in the development of tea aesthetics. CD

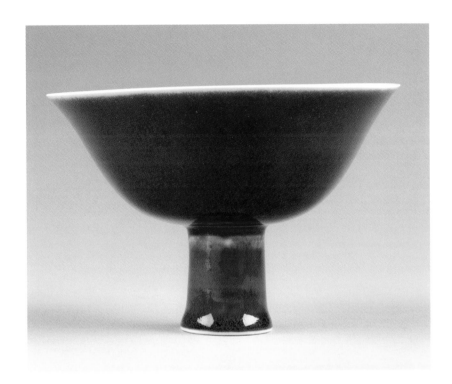

Stem cup
Porcelain, with red glaze
China, Jingdezhen
Ming dynasty, Yongle reign period
(1403–24)
Height 10.7cm, diameter 15.5cm
W.G. Gulland Gift, 168A–1905

Jar
Stoneware, with natural ash glaze
Japan, Shigaraki kilns
About 1400–1450
Mark: shallow, oblong-shaped
impression on base
Height 49.5cm, diameter 41.5cm
FE.20–1984

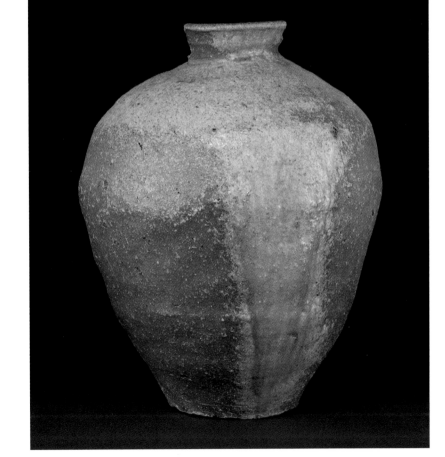

Drug jar

Italian merchants of the fourteenth and fifteenth centuries imported large quantities of fine ceramics from Valencia in Spain. These Spanish pots had a bright white tin glaze that provided an excellent background for contrasting painting in blue and lustre, and their quality was far superior to pottery made locally, which until around 1400 was predominantly decorated in green and brown (see following entry and p.50).

Inspired by these imports, from about 1400 Italian and especially Tuscan potters used a much thicker, whiter tin glaze, onto which they painted designs in a thickly applied and intense cobalt blue, often in combination with manganese purple outlines. The tin oxide used in the glaze was expensive, however, as it was imported, and so was confined to the most visible surfaces: the interior of this jar, for instance, has only a lead glaze.

The late Gothic motifs on the jar – notably the rampant heraldic leopards and the oak leaves that surround them – are much bolder and less linear in treatment than on other contemporary Italian ceramics. The animals have been placed in a compartment that closely follows their contours, a feature that can be traced back to Iraqi pottery of the ninth century.

Intended for storing drugs, this large jar was probably made for a hospital pharmacy in or around Florence. When lined up in rows on shelves, these drug jars had a powerful decorative effect. The two small handles make it easier to lift the jar, but might also have been used to fasten a cover to keep its contents fresh. RL

Bowl and cover

Arabs occupied parts of Spain in the period between AD 711 and 1492. They introduced Middle Eastern ceramic techniques, including tin-glazing and lustre decoration. Over time, the Muslim potters of Spain developed a distinctive lustre-decorated pottery that was greatly admired all over Europe. This was characterized by dense, all-over designs painted in metallic lustre and blue, and often featured repeating calligraphic or geometric patterns, built up of interweaving forms and stylized floral motifs. Vastly superior to any other type of ceramics made in Europe, Spanish lustre pottery was exported to Italy and other countries, mostly by Italian merchants. Málaga near Granada was the leading centre of production until the fourteenth century, but during the fifteenth century some potters moved further north to Murcia and Valencia, where Manises became an important centre.

The precise function of this magnificent and very large bowl is unclear. It was probably intended as a serving or cooling vessel, though the fact that it has survived intact for hundreds of years suggests that it was probably never used. The decoration is strongly Islamic in character and the underside of the cover features a very unusual lion mask at the centre. A shipment by a leading Italian exporter of Spanish pottery, ordered from the Valencian potter Asmet Zuleima in 1407, lists 199 pieces of lustre ceramics, including 'three large bowls, their covers painted out- and in-side'. RL

Drug jar
Tin-glazed earthenware, painted
in cobalt and manganese
Italy, probably Florentine area
About 1420–50
Mark: a ladder motif at the base
below each handle
Height 36.3cm, width 32.8cm
2562-1856

Bowl and cover
(with interior view of bowl)
Tin-glazed earthenware, painted
in cobalt and lustre
Spain, probably Manises, Valencia
About 1440–60
Height 54.8cm, diameter 46.8cm
7659&A-1862

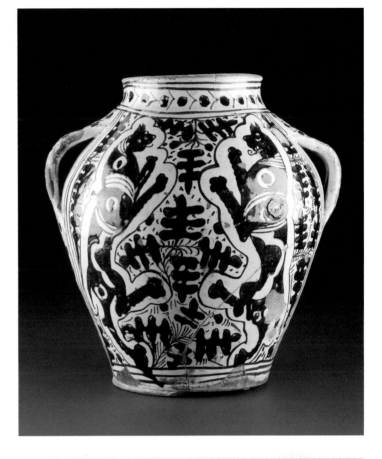

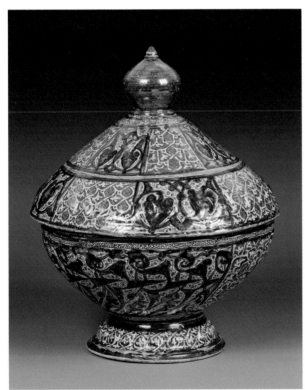

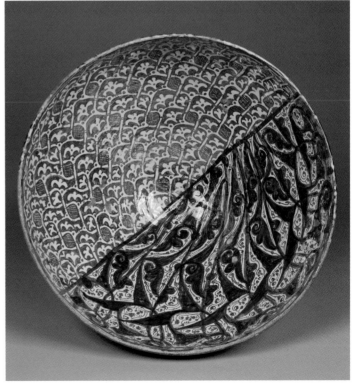

Dish

In the course of the fourteenth century the emerging kingdom of Sukhothai in north-central Thailand began producing glazed stoneware ceramics in cross-draught kilns, which in all probability owe a debt to the ceramic technology of southern China. This 'new technology' represented a major advance over the lower-temperature kilns that preceded them and allowed a new wave of creative innovation in ceramic-making. The new Sukhothai wares included iron-painted designs, often featuring fish motifs and sometimes set in a lotus pond, as seen here.

Kilns have been excavated immediately north of the city wall at Turiang, near the temple of Wat Pra Pai Luang, and it may be that much of the initial stimulus for glazed ceramic production came from the Buddhist monasteries and the urban centre of Sukhothai, which became the founding capital of the Thai kingdom. Certainly much of the Sukhothai production was given over to the manufacture of architectural ceramics. Finds from shipwreck cargoes in the Gulf of Thailand and the South China Sea demonstrate that the kilns of Sukhothai, along with those of the sister city of Si Satchanalai, were also devoted to the mass production of glazed wares for the export markets of South-East Asia. This dish, which has an Indonesian provenance, bears witness to this trade. JG

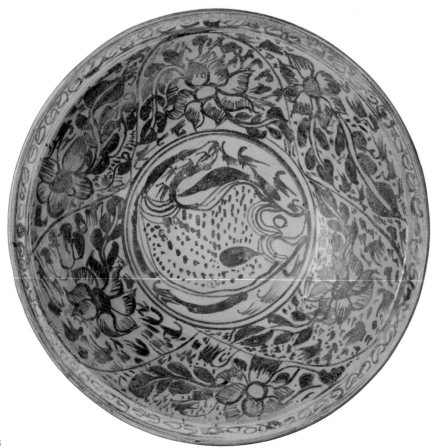

Dish
Stoneware, painted with underglaze iron
Thailand, Sukhothai
About 1450–1500
Diameter 32.3cm
Given by John and Helen Espir,
IS.55–2002

Dish

The kilns of northern Vietnam produced a range of high-fired stoneware ceramics. At their height in the latter half of the fifteenth century, these rivalled the Chinese wares of Jingdezhen. Two strong styles had emerged over the preceding couple of centuries: an indigenous style, reflecting forms and functions associated with Vietnamese lifestyles, and a style following, to varying degrees, Chinese models. The latter were produced largely for South-East Asian and West Asian export markets, where they were traded in competition with Chinese wares. In some more distant markets they may also have been traded to less discerning clients as Chinese wares.

Vietnamese potters were quick to respond to shifts in demand and readily emulated Chinese forms and decorative motifs. The shape of this broad serving dish, for instance, was originally produced in Chinese porcelain for use in communal dining in the Middle East (see p.78), and the painted design − of a Buddhist lion among clouds surrounded by trefoil panels − is likewise Chinese in origin. The close emulation of Chinese ceramics suggests that some of the potters may have been expatriate Chinese, who are known to have settled in Vietnam to escape social disturbances and restrictions on foreign trade at home. Many dishes of this type have been excavated from residential sites in west Java and central Thailand, and enamelled wares featured prominently among those recovered from the Chu Lao Cham cargo (offshore from Cham Island, Hoi An), shipwrecked off the coast of central Vietnam in the late fifteenth century. JG

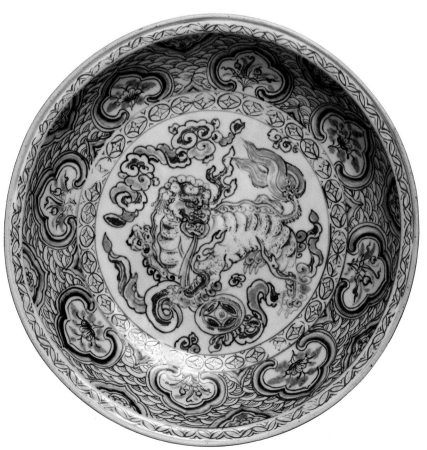

Dish
Stoneware, painted in underglaze
blue, enamels and gilt
Vietnam, Hai D'uong region
About 1480−1500
Diameter 35.8cm
FE.10−1987

Floor tile

The Italian Renaissance was one of the most brilliant chapters in the history of tile-making. It was a time of technical achievement, when tile painters attained astonishing levels of subtlety and refinement, fully exploiting the increasing range of colours.

Spanish influence had been decisive on the birth of an Italian painted tin-glazed (maiolica) tile industry. Large quantities of Valencian tiles reached Naples after it fell under Spanish control in 1442 and within a decade local craftsmen began creating tiled floors following Valencian prototypes. The potential of this new medium as a colourful alternative to cheaper polished brick flooring or expensive marble inlays was soon recognized throughout Italy. The pavement commissioned for the Convent of San Paolo in Parma, for which this tile was made around 1480, is perhaps the most striking early example. The large square tiles are boldly painted in Renaissance style, with profile portraits of young men and women in smart contemporary dress and with allegorical emblems alluding to courtly love. This tile bears a lifelike portrait of a youth named 'Zovano', or John, according to the note in his cap, which also alludes to his betrothal. The superb quality of its painting is reflected in the huge sum of £118 the Museum paid for it in 1890.

During the late fifteenth century, Italian maiolica potters had begun to compete successfully with imports of luxury Valencian pottery, and the production centres of north-central Italy, most notably Deruta, Montelupo, Faenza and Pesaro, attained dominance. The style of the decoration on the San Paolo tiles is most closely related to the maiolica of Pesaro. RL

Footed bowl

Incised slipware was first produced in China and the technique spread throughout the Byzantine and Islamic empires, from where it reached Italy by the thirteenth century.

The principle of the technique is simple. The potter covers a vessel made of dark red clay with a pale slip by dipping it in liquid clay. When this has dried, he scratches a design through the lighter upper layer, partly revealing the darker clay below. After firing, the vessel can be further decorated with coloured glazes.

Incised slipware was the most common type of pottery used in northern Italy throughout the Renaissance period. The bulk of the wares were simple dishes and bowls, with roughly incised decoration, made for everyday use. More ambitious and higher-quality work was produced at Bologna and a few other northern centres. The most complex and finely decorated pieces were made in Ferrara under the patronage of the d'Este dukes and the circle around their court.

This footed bowl is probably the most elaborate and beautiful example of Italian slipware to survive. It was formed in several parts, which were 'luted' together to form the complex shape. All visible surfaces were covered with incised designs and then further embellished with coloured glazes. In the centre of the bowl a naked youth is shown fighting a dragon held on a leash by a young woman in late fifteenth-century dress – probably in witty allusion to a theme of courtly love. Footed bowls of this shape might have been used to serve sweetmeats or fruit during the dessert courses of special banquets. RL

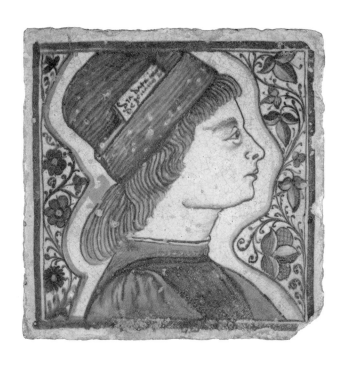

Floor tile
Tin-glazed earthenware, painted in
colours ('maiolica')
Italy, probably Pesaro
About 1480
Inscribed: 'Sia data in m de zovano...'
('To be given into the hand of John')
From the Convent of San Paolo, Parma
Height 21cm, width 20.9cm,
thickness 2cm
12–1890

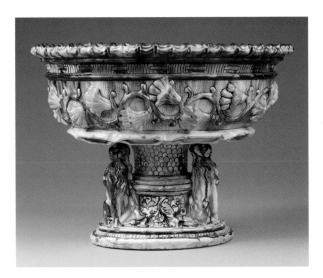

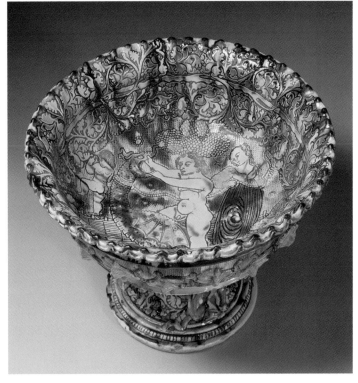

Footed bowl
Earthenware, with incised slip
decoration and coloured glazes
Italy, Ferrara
1480–1500
Height 25.3cm, diameter 33.5cm
187–1866

Figure of Bodhidharma

This life-size temple sculpture represents Bodhidharma, an Indian Buddhist monk who came to China in AD 520 and founded the Chan (Zen) sect of Buddhism.

Ceramic religious figures have the advantage of durability over their wooden counterparts, though making and successfully firing this exceptionally large one must have posed formidable technical challenges to the potter. Such sculptures were offered by faithful Buddhists, who paid for their manufacture, and these specially commissioned pieces often bear an inscription to commemorate the occasion. On this figure the inscription is incised on the right-hand side of the pedestal, giving a date equivalent to 1484: 'Chenghua 20th year, male faithful Dang Yan and Madam Mai. Priest Dao Ji. Craftsman Liu Zhen.'

By a historical coincidence, three other Buddhist figures with similar inscriptions dated 1484 survive in the UK. This suggests that in this year the Buddhist priest Dao Ji persuaded several families to donate money towards the production of ceramic sculptures, the occasion probably being the completion of a new temple. Unlike other ceramics, religious figures of this size seldom changed hands and, once installed in a temple, under normal circumstances they would remain there. During the 1930s, however, when China was experiencing political turmoil, these four figures were shipped to the UK for sale on the art market. The other three are now in the British Museum, the Burrell Collection, Glasgow, and the Lady Lever Art Gallery, Liverpool. MW

Figure of a boy playing the bagpipes

Andrea della Robbia was a member of a famous Florentine family of sculptors. He started working in the workshop of his uncle Luca della Robbia, one of the early exponents of the Florentine Renaissance style and a pioneer of the use of polychrome glazed earthenware as a sculptural medium. In using tin-glazed earthenware, Luca had adapted what was then a relatively new technique to the manufacture of large-scale architectural sculpture, which became the speciality of the family workshop. The use of an opaque white tin glaze, which could be coloured by adding metallic oxides, provided a durable and vibrantly polychrome surface suitable for both interior and exterior work.

After Luca's death in 1471, Andrea became the major force in the workshop. Trained as a marble sculptor, he was also an excellent modeller, unrivalled in his ability to capture the life of his subjects in glazed clay. His best-known works are 10 roundels of infants on the façade of Florence's Foundling Hospital (about 1487).

This small statue was probably originally part of an altarpiece. Several large altarpieces by the Della Robbia family show similar naked boys – some of them with musical instruments – high up on the architectural framework. It is stylistically close to two winged putti on the cornice of an altarpiece supplied by Andrea della Robbia to the Church of the Santi Apostoli in Florence in 1512. RL

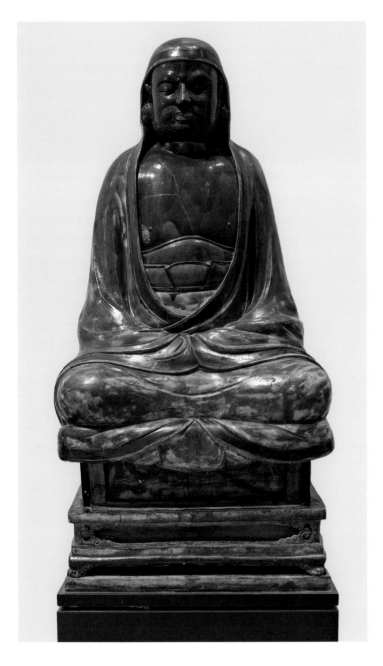

Figure of Bodhidharma
Stoneware, with green and
brown glazes
North China
Ming dynasty, dated 1484
Inscription incised on right-hand side
of pedestal (see entry)
Height 132cm, width 70cm,
depth 50cm
John Sparks Gift, C.110–1937

Figure of a boy playing the bagpipes
Tin-glazed earthenware, painted
in colours
Italy, Florence
Attributed to Andrea della Robbia
(1435–1525)
About 1490–1520
Height 46.2cm, width 34cm,
depth 19cm
Given by HRH the Prince Consort,
4677–1858

Dish

The term 'maiolica' was first used in Italy to describe lustre-decorated ceramics imported from Islamic Spain. The name probably derives from 'Málaga', the most important centre for Spanish lustre pottery, but was soon used for tin-glazed wares made in Italy itself.

It was in Renaissance Italy that the full pictorial potential of the tin-glazing technology was first explored. Italian potters found that the white, tin-glazed surface proved an ideal 'canvas' for the new Renaissance aesthetic, its styles of ornament and especially figurative imagery. From about 1520, dishes, bowls and vases were entirely covered with complex narrative scenes, regardless of shape or function. Such fine luxury wares were intended for use on special occasions and for display, and the complexity of their pictorial imagery was much admired by their purchasers.

During the Renaissance a distinction was drawn between fine art and the decorative arts. Maiolica painters were regarded as artisans who copied or freely followed printed sources or designs provided by major artists, but some regarded themselves as artists in their own right and signed their work. This dish shows a maiolica painter at work, magnificently dressed and watched by wealthy patrons. It was made at Cafaggiolo, a small potters' workshop set up in the grounds of a Medici villa near Florence to satisfy the needs of its aristocratic owners. It was probably painted by Maestro Jacopo, one of the most skilled maiolica painters of his time, here clearly making a statement about his aspirations as a fine artist and about his noble patronage. RL

Dish
Tin-glazed earthenware, painted
in colours
Italy, Cafaggiolo
Probably painted by Maestro Jacopo
About 1510
Mark: 'SP' in monogram crossed by
a calligraphic flourish
Height 2cm, diameter 23.9cm
1717–1855

Dish

The bold graphic decoration of this dish was achieved by the *cuerda seca* technique. Meaning literally 'dry cord' in Spanish, this refers to a special method of separating glaze colours. The potter first drew the outline of a design on his pot using a mixture of manganese and grease, then filled in the design with glazes of different colours. The greasy lines prevented the glazes from running into each other, while the grease burned away during firing, leaving a subtle dark outline in manganese brown.

The technique was in use at Madinat al-Zahra, an important production centre near Cordoba, as early as the mid-tenth century, and from the late twelfth century it was increasingly common for wall tiles. Prior to this, complex designs for ceramic wall decoration had been built up mosaic-style, using many small geometric pieces cut from monochrome tiles. The advantage of the *cuerda seca* technique was that it allowed potters to apply different glaze colours quite thickly onto a single tile, so repeating patterns could be achieved using standard square tiles. By the fifteenth century, Seville was producing such tiles in huge quantities, partly for export.

Potters revived the *cuerda seca* technique for decorating vessels during the reign of Ferdinand and Isabella, in the late fifteenth century, when geometric patterns of Middle Eastern origin made way for figurative and heraldic designs in a Gothic idiom. The glazes on this dish have been thickly applied. It was fired face down on cockspurs (small triangular separators used to stop wares fusing together during firing) and the glaze has run in places beyond the *cuerda seca* boundaries. RL

Dish
Tin-glazed earthenware, with
cuerda seca decoration
Spain, Seville
About 1500–1530
Height 7cm, diameter 44.9cm
Formerly in the collection of
Juan Facundo Riaño
300–1893

Basin

The small town of Iznik in north-west Turkey has given its name to some of the most accomplished ceramics produced in the Islamic world. In the mid-fifteenth century, potters there specialized in modest earthenware imitations of Chinese blue-and-white porcelain. In the 1460s or 1470s, however, under the patronage of Sultan Mehmet II (ruled 1451–81), the kilns began to produce vessels in fritware (see p.78) that are elegant in shape and decoration, and often very large.

The earliest examples, based on metal prototypes, have decoration in the court style of Mehmet II's reign, dominated by stylized plant motifs. The colour scheme, though, was borrowed from Chinese blue and white. At first, the decoration primarily consisted of motifs 'reserved' in white on a blue ground. These were combined with plain white bands, which may have originally have been gilded. By the 1520s, the kilns were supplying a wider market at home and abroad with vessels of varied form and decoration. The range of colours began to increase, the first addition being the turquoise highlights visible on the interior of this basin. The basin's exterior shows a shift to less laborious blue-on-white decoration, and no plain bands, but the pattern of tendrils set with fantastic flower and leaf forms is still rooted in the court style of the later fifteenth century. Subsequent innovations included the introduction of a bright red slip and the production of a new and very attractive type of tilework. Both date from the 1550s. Iznik ceramics were imitated in Italian Renaissance maiolica and nineteenth-century 'art pottery'. TS

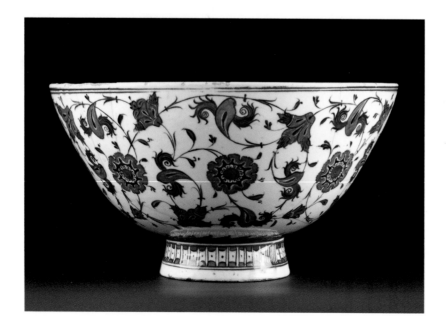

Basin
Fritware, painted with underglaze colours
Turkey, probably Iznik
About 1530
Height 20.4cm, diameter 38.9cm
C.257–1921

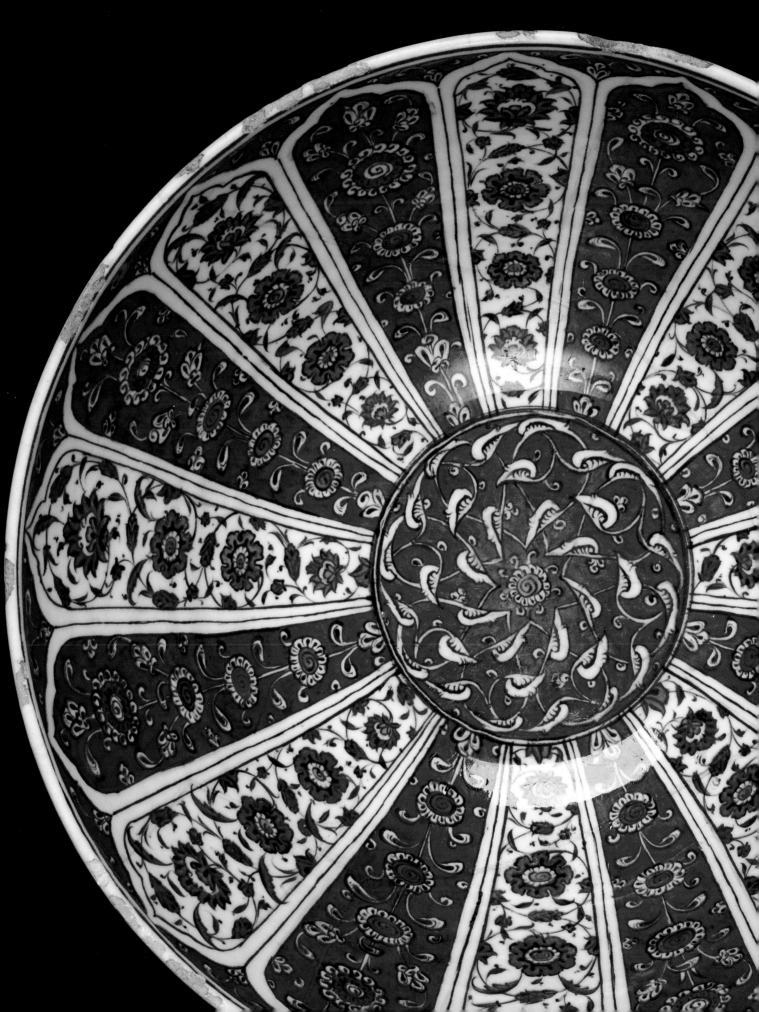

Ewer

This splendid ewer is one of the earliest pieces of Chinese porcelain made for a European customer. Having no familiarity with European vessel shapes, the potter has used a design then being made for export to the Middle East. It bears the arms of the Peixoto family of Portugal and must have been commissioned by Antonio Peixoto, a navigator and merchant who reached the southern Chinese port of Canton in 1542. Refused entry to Canton, he went on to trade off the south China coast and became one of the first Portuguese to reach Japan. The Portuguese dominated the European trade in Chinese porcelain during the sixteenth century, when they were also a major supplier of Chinese wares to the Middle East. The silver mounts are contemporary with the porcelain and must have been added in Iran on Peixoto's return journey from China.

Jingdezhen potters had no experience in painting European coats of arms, though they seem to have risen to the challenge very competently. The 'Great Ming' mentioned in the painted mark on the base refers to both the ruling dynasty and the country of China itself. The Jingdezhen potters evidently wanted to make it clear to their foreign customer that this fine porcelain ewer was made under the Emperor Jiajing in the great country called 'Ming' (although no one in Europe could read Chinese and few would have been concerned about its date of manufacture). MW

Jug

Stoneware, first developed in Europe by German potters, is a robust, non-porous and durable material that proved ideal for drinking and storage vessels. Stoneware mugs, jugs and bottles became indispensable to daily life in late medieval Germany and, being tough enough to withstand rough handling and transport by sea, they were also widely exported. They are made from refractory clays, which fuse and vitrify at very high temperatures during firing.

The development of a true stoneware body in the Rhineland was achieved by 1300–1350 through a process of careful experimentation that was entirely independent of developments in Asia, where stoneware has a much longer history. Early wares were left unglazed or, like Chinese stonewares, were ash-glazed (see p.24). During the fifteenth century, potters discovered that salt thrown into the kiln would vaporize and form a pleasing tight-fitting glaze. The colour of this ranges from buff to dark brown and is often recognizable by its 'orange-peel' texture. The process demanded vast quantities of salt, which was imported through Cologne. During the sixteenth century German stoneware achieved huge economic success and attained a peak of technical and decorative refinement, with the best workshops able to command high prices for specially commissioned or elaborate designs. Salt-glazing was almost entirely confined to the Rhineland until the 1670s, when the Englishman John Dwight independently discovered the secrets of the technique.

This bulbous vessel is of a type known as a 'Bartmann', a German term referring to the relief-moulded bearded face mask, which is the defining characteristic of such wares. JC

Ewer
Porcelain, painted in underglaze blue
and with silver mounts
China, Jingdezhen (porcelain),
Iran (mounts)
Ming dynasty, Jiajing reign period
(1522–66)
Mark: 'Daming Jiajing nian zhi'
('Made in the Jiajing reign period of
Great Ming') painted in blue on base
Height 33.5cm, maximum width 23cm
W.G. Gulland Bequest, C.222–1931

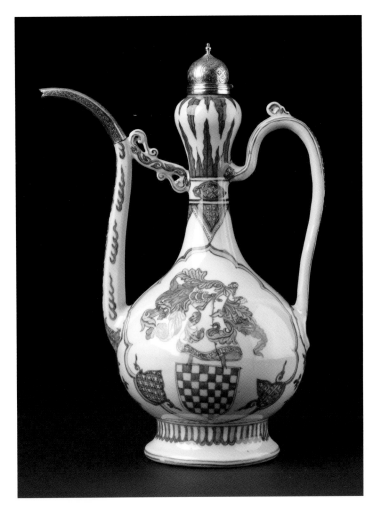

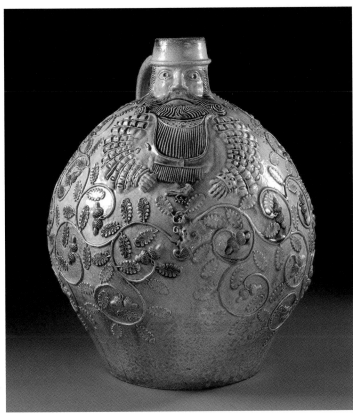

Jug
Salt-glazed stoneware, with applied
relief-moulded decoration and details
picked out in cobalt blue
Germany, Cologne
About 1525–50
Height 36.2cm, diameter 30.9cm
4610–1858

Relief tile from an architectural frieze

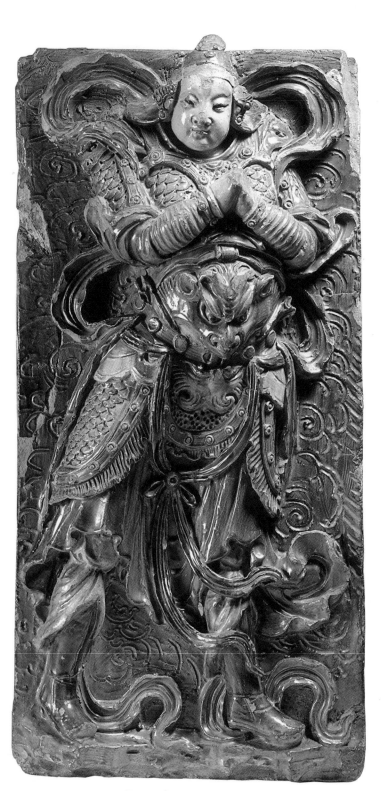

This architectural component shows a warrior in high relief. It is much more imposing than an ordinary tile, although it would have been made in a kiln that specialized in tilework. It was once part of a frieze, most probably on the front of a Buddhist temple. The body is stoneware and the use of a low-temperature lead glaze involved the piece being fired twice – the first, high-temperature firing to fuse the body and the second, lower-temperature firing for the glaze. There are wide grooves on both sides of the piece, allowing a row of similar components to be joined together and secured into their correct position. Seen from a distance, the military figure would give the impression of being a sculpture rather than part of a building.

On the back of the piece is an inscription that reads 'Zhending Prefecture, Jingjing County, Yi-an Community, Mashan Village, Fuchang Temple. Rebuilt Jiajing 27th year, 5th month, 18th day.' Jiajing 27th year is equivalent to 1548. Zhending Prefecture was in present-day Hebei province, which neighbours Shanxi province, where most tile-making kilns were located. That a small village temple could afford such an elaborate architectural frieze is an indication of the affluence of sixteenth-century China. The inscription does not give the name of the warrior, but he probably represents Wei Tuo, one of the Buddhist deities, who is always portrayed wearing a suit of armour.
MW

Relief tile from an architectural frieze
Stoneware, with green and yellow glaze
China, Shanxi province
Ming dynasty, dated 1548
Inscription incised on back (see entry)
Height 73cm, width 27.5cm, depth 20.5cm
Given by Mrs E.L. Cockell, in memory of
Edward Lawrence Cockell, C.71–1939

Covered bowl

This rare and elaborate-footed bowl is from a group of about 70 surviving examples made in a highly distinctive technique and decorated in the 'mannerist' style fashionable at the French court in the mid-sixteenth century. The rich and delicate decoration was achieved by stamping patterns into the surface and then inlaying clays in contrasting colours. Its sophisticated design was inspired by contemporary metalwork, printed designs for ornament and Renaissance bookbindings. Many examples are decorated with the royal arms of France – as here – or of people close to the court, demonstrating that they were intended for a refined and aristocratic market. In addition, this piece bears the portrait of a fashionably attired young woman on the underside of the cover. Objects of this quality were highly valued possessions, intended for display and use on important occasions.

Often known as Saint-Porchaire ware, these pieces were most likely made in or near to Paris rather than in the small village of Saint-Porchaire (in the Poitou region of western France), which was well known for its deposits of uncommonly lightweight and pale pipeclay. Although their maker remains unknown, the celebrated French potter Bernard Palissy (about 1509/10–90) has recently been associated with their production (see p.72). Palissy began his career in the Saintonge, near to Poitou, and would have been familiar with the clays of the region, and moulds excavated on the site of his Paris workshop confirm close links between the mysterious Saint-Porchaire wares and his Parisian work. CM

Covered bowl
Lead-glazed earthenware, with moulded
and inlaid decoration
France, probably Paris
About 1550–75
Height 16.8cm, width 12.5cm, length 16.8cm
8715&A–1863

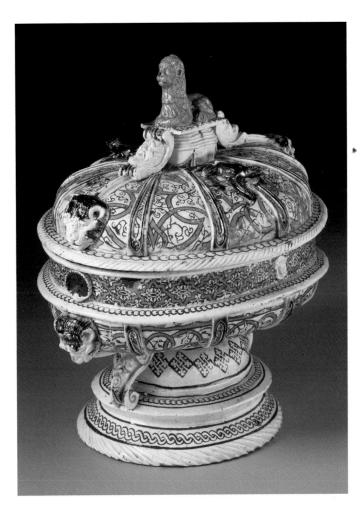

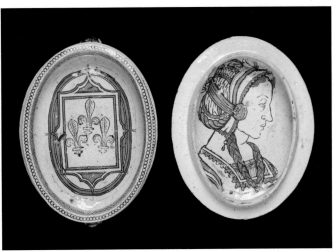

Flask

Small quantities of Chinese porcelain and its Middle Eastern imitations began to reach Italy during the fifteenth century. With its hard, glossy white surfaces and intense blue decoration, porcelain was unlike any material known in the West and was regarded by some as a magical substance of such purity that it would shatter on contact with poison. Examples found their way into the treasure cabinets of the wealthy, the most notable collection being that started by Piero de'Medici (1416–69), which contained nearly 400 pieces by 1553.

Chinese blue-and-white wares had been copied by Italian Renaissance glassmakers and maiolica painters, but the first attempts to imitate the material itself were made at Italian courts – first at Ferrara (about which almost nothing is known) and subsequently by Francesco de'Medici, Grand Duke of Tuscany, at Florence. Francesco was himself closely involved in experimental work and had a specially constructed laboratory by 1568. Working with his court artist, Bernardo Buontalenti, and assisted by maiolica craftsmen from Urbino and a potter from 'the Levant', he developed a fritware body comprising fine clay from Vicenza and ground glass; possibly the Levantine potter was a Greek or Turk familiar with Iznik pottery (see p.66), which is technically related to Medici porcelain. The shape of this flask was derived from metalwork, but the hazy underglaze painting was inspired by Chinese porcelain or its Middle Eastern imitations (see p.78).

Production ceased with the Grand Duke's death in 1587 and today only about 70 pieces of 'Medici porcelain' survive, many of them with technical defects, betraying their experimental nature. RL

Dish

Bernard Palissy was the most innovative and original potter of the French Renaissance. A man of multiple talents and interests, he was an obsessive experimenter with pottery glazes and moulding techniques, but was keenly interested in geology and the natural world as well, publishing numerous studies on natural history and a lively account of the long struggle, and the financial hardships he endured, while perfecting his wares. He was a favourite of the Catholic royal family and nobility of France, but also an ardent Protestant who was persecuted for his beliefs.

Palissy is best known for his basins, ewers and dishes decorated with plants and animals skilfully cast from life and with vividly coloured glazes. Contemporary goldsmiths were already taking casts from real animals and plants, but Palissy was the first to apply the process to ceramics. Having perfected his first rustic basin around 1555, he was presented to Henri II, who praised and purchased the piece. By 1567 Palissy had set up a kiln on the grounds of the Palais des Tuileries in Paris, for which he was commissioned to make a rustic grotto by the French queen Catherine de'Medici. Such elevated patronage confirms the high status of his ceramics, which reflect the period's increasing empirical understanding of the natural world, on the one hand, and courtly delight in artifice and elaboration, on the other. His pottery was hugely influential in sixteenth- and seventeenth-century France and was widely copied during the nineteenth century, by which time his life story and reputation had achieved almost mythic status. CM

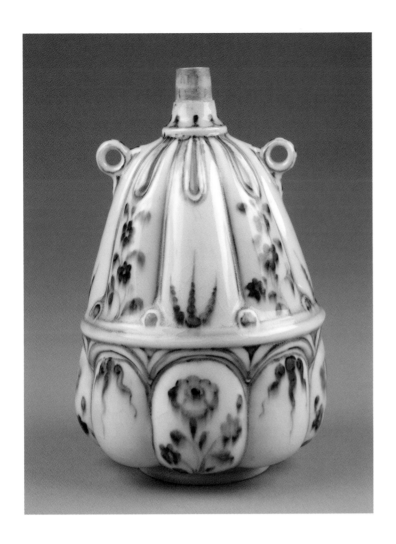

Flask
Soft-paste porcelain, painted in
underglaze blue ('Medici porcelain')
Italy, Florence
1575–87
Marks: 'F' and a depiction of
the dome of Florence Cathedral,
painted in blue
Height 17.4cm
C.137–1914

Dish
Lead-glazed earthenware, moulded
and with coloured glazes
France
Possibly made by Bernard Palissy
(about 1509/10–90) or his sons
1565–85, or possibly 17th century
Height 4cm, width 40.6cm,
length 53.3cm
5476–1859

Stove tile

Wood-fired stoves clad with ceramic tiles were widely used for heating interiors in northern Europe from the fifteenth century. A typical stove took the form of a large, free-standing firebox supported on legs and surmounted by a tower to maximize the radiation of heat. The stove would usually be positioned against a wall in which openings had been made to connect to a stoke hole and flue at the rear. It was constructed from thick moulded tiles, with protruding ridges on the reverse to form heat-retaining cavities. Their production method was probably introduced to England by German potters working in the Surrey–Hampshire borders. However, the use of tiled stoves never caught on in England and seems to have been restricted to the wealthiest houses and ecclesiastical establishments of London and the South-East.

The decorative use of royal arms and badges was fully supported by Tudor monarchs, who took a keen interest in the promotion of their dynasty and of their right to the throne of England; Henry VIII (1509–47) in particular was committed to raising the status of the monarchy. Royal heraldry, therefore, became one of the most common motifs of English Renaissance interior decoration and architecture. The initials 'ER' here probably refer to Edward VI (1547–53), though they could equally have been meant for Elizabeth I (1558–1603), and the tile itself is almost indistinguishable from earlier examples with the initials of Henry VIII. CM

Fresh-water jar

With its exploitation of chance effects, rough textures, controlled irregularity and clear evidence of handwork, this pot is characteristic of a strand in Japanese ceramics particularly associated with the tea ceremony, for which this fresh-water jar was made.

Like the dish in the following entry, the jar was acquired from the Philadelphia Centennial Exposition of 1876. The previous year the South Kensington Museum (now the V&A) had paid £1,000 to the Exposition's Japanese commissioners to make a selection of ceramics 'to give fully the history of the art'. At nine shillings (45p), this jar was relatively inexpensive, reflecting the low value attached to historical tea wares at a time of extreme admiration of the West. The importance of such pieces in the Japanese ceramic canon has long since been recognized, however, and it now ranks as one of the cornerstones of the Museum's Japanese collection.

The jar was made in Bizen, one of the first areas to produce purpose-made tea wares in the late sixteenth century. Before that, ceramics from China, Korea and South-East Asia had been prized, as had some native Japanese ceramics. The latter included earlier Bizen and Shigaraki wares originally made for alternative purposes but adopted by tea aficionados for tea-ceremony use. This jar would have been used to contain cold water, which was then ladled into a cast-iron kettle. Powerfully sculpted, it embodies the spirit of *wabi* (the taste for the simple and restrained) so central to the tea ceremony. Its ochre-green glaze is the result of ash from the wood-firing settling on the pot and melting in the kiln. CD

Stove tile
Red earthenware, moulded and
with green lead glaze
England, probably Surrey–Hampshire
borders
About 1550–1600
Height 34cm, width 24.5cm,
thickness 9cm
C.383–1940

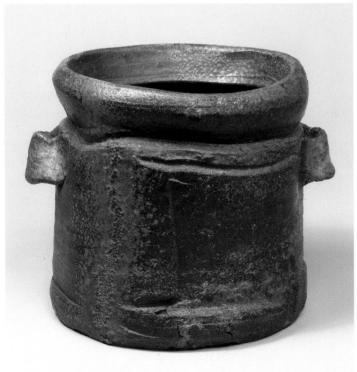

Fresh-water jar
Stoneware, with natural ash glaze,
firing marks and incised decoration
Japan, Bizen kilns
About 1590–1630
Mark: impressed seal on inside bottom
and incised mark on base
Height 20.3cm, maximum width 26cm
191–1877

Dish

Porcelain manufacture began in Japan during the first decades of the seventeenth century, with production centred around the town of Arita, on the western island of Kyūshū. Arita porcelain is of exceptional quality. It is made from crushed volcanic rock combined with a small proportion of china clay and fired in Chinese-style multi-chambered kilns. The earliest wares were mainly blue and white, with enamelled wares appearing from around 1640.

This powerful dish is a rare example of so-called Kutani ware, a type of enamelled porcelain made at Arita in the mid-seventeenth century. While no two examples of Kutani ware are exactly the same, this particular piece belongs to what is known as the 'Green Kutani' group. Its design of rocks, fir and bamboo is spontaneously sketched in black and coloured with intense jewel-like yellows, greens, browns and aubergine.

The term Kutani is misleading, for it is the name of a village in Ishikawa Prefecture, an area formerly ruled by the Maeda family of feudal lords, hundreds of kilometres away from Arita on the main island of Honshū. Ceramics were made there for a short period during the seventeenth century, but it was only in the nineteenth century, which saw a revival of the Kutani style there, that it became an important centre of ceramic production. While it is now accepted that seventeenth-century Kutani wares were commissioned by the Maeda family, which explains the name by which they are known, examples have also been excavated on the Indonesian island of Java, apparently exported there by Dutch East India Company and Chinese merchants trading out of Nagasaki. **PF**

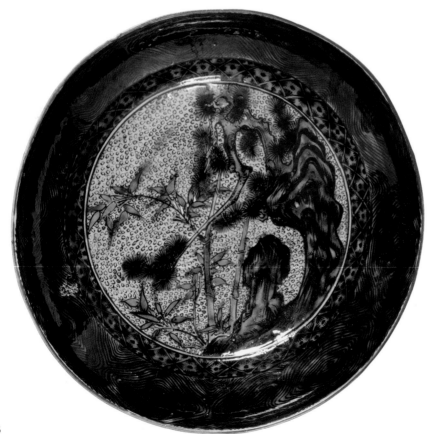

Dish
Porcelain, painted in enamels
Japan, Arita kilns
About 1650–80
Mark: 'Fuku' ('Happiness') painted
in enamels
Diameter 41.9cm
309–1877

Dish

In the late 1650s, following the fall of the Ming dynasty in 1644 and the consequent collapse of the Chinese export ceramic trade, Dutch merchants based in Japan began commissioning copies of Chinese porcelain from Japanese potters. These new orders greatly invigorated the fledgling potteries of Arita, which was Japan's main centre for porcelain production during the seventeenth and eighteenth centuries.

The design seen here of a central image within a panelled border was developed in China between 1570 and 1650 for inexpensive export wares for Middle Eastern and European consumption. Dutch merchants called these wares *Kraakporselein*, or 'Kraak' porcelain, a term that is still used today. This may derive from *Carrack*, the Dutch term for a type of Portuguese ship, or perhaps from the name of the shelves above fireplaces where porcelain was often displayed in Dutch homes. The central motif of a deer drinking from a pond appears on many large Japanese 'Kraak' dishes, several of which found their way into princely European collections, including that of Augustus the Strong in Dresden. These probably correspond to the dishes recorded as painted 'with deer' in the Dutch East India Company's order books for 1679 and 1681. Japanese painters simplified the Chinese design, eliminating superfluous details to create a strong graphic image. Japanese copies were also larger and heavier than their Chinese counterparts. The cobalt with which they were painted contained impurities that resulted in a distinctive bright but soft blue with a purplish or greyish hue. **PF**

Dish
Porcelain, painted in underglaze blue
Japan, Arita kilns
About 1660–80
Acquired in Iran
Diameter 55cm
1724–1876

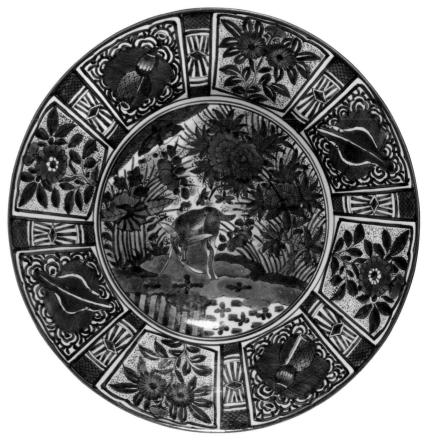

Dish

The white body material of this dish is fritware, composed of ground quartz and small quantities of white clay and ground glass. Fritware, introduced to Iran in the twelfth century, was valued for its superficial resemblance to Chinese porcelain, and from the fifteenth century it was used to produce imitations of Chinese blue-and-white wares.

The earliest phases of Iranian blue-and-white production are known mostly from excavated material, but a much larger number of vessels from the seventeenth century have survived above ground. The Museum has a particularly important collection numbering more than 500 items. Almost all of these, and a substantial number of Chinese blue-and-white porcelains of the Yuan period onwards, were purchased in Iran in the last quarter of the nineteenth century, when a taste for blue-and-white ceramics was widespread in Britain. The Iranian pieces show a considerable range of shapes and decoration, the most spectacular examples including enormous dishes such as this. Their size reflects dining customs in Iran, where several people would eat rice or a rice-based dish from a single vessel. The decoration of some dishes follows Chinese models precisely, while others have designs of local origin. Many, like this boldly painted example, show a free interpretation of Chinese themes. The beast in the centre is a Chinese *qilin*, a mythical animal, which is shown floating in mid-air against a spray of flowers and leaves. Unusually, the rim and curve of the bowl form a single band of decoration, with two dragons against floral scrolls. TS

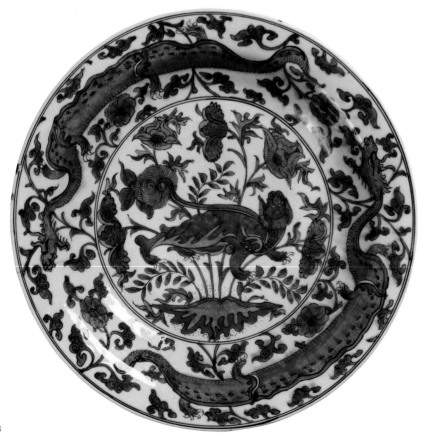

Dish
Fritware, painted in underglaze blue
Iran
1666–74
Height 8.9cm, diameter 47.9cm
2808–1876

Dish

With its highly stylized motif of a heraldic lion executed by virtuoso trailing in coloured slips (liquid clays), this massive dish is a masterpiece of the Staffordshire potter's art. Its maker was Thomas Toft, who prominently incorporated his name into the design. Toft would have trailed thick coloured slips onto the upper face of an unfired moulded dish with a tool similar to that used for cake decoration today. Once glazed, the dish was stacked vertically for firing, which has resulted in the warping on the right-hand side. Staffordshire potters continued to make such large dishes as late as the 1750s, by which date production was mainly industrialized and dominated by finely potted tea and tablewares for home and export markets. The design on these later dishes was generally moulded and emphasized with slips.

Thomas Toft, about whom almost nothing is known, was the most accomplished maker of these Staffordshire trailed slipware dishes. Active in the years following the Restoration of the monarchy in 1660, he favoured patriotic and royalist imagery: the lion here, for example, is from the royal arms. His dishes show no sign of wear and they may have been intended for display in taverns. Overlooked for 200 years, they were championed as supreme examples of English vernacular art by collectors in late Victorian industrial Britain, and Toft and his tradition proved a formative influence on the pioneering studio pottery of Bernard Leach and Hamada Shōji from the 1920s onwards. HY

Dish
Lead-glazed earthenware,
with trailed slip decoration
England, Staffordshire
Made by Thomas Toft (died ?1689)
About 1670–89
Diameter 45.8cm
Transferred from the Museum of
Practical Geology, 2079–1901

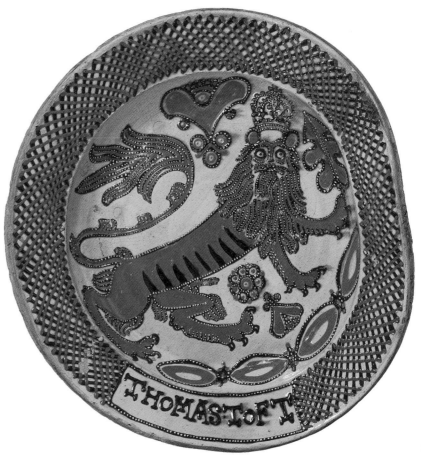

Bottle

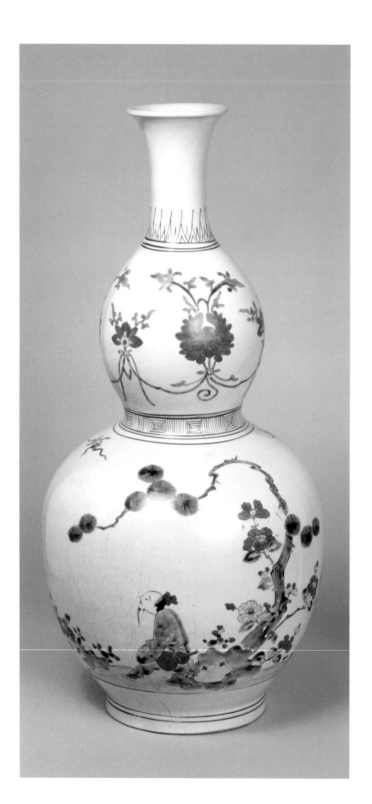

By the 1660s, Delft potters were producing convincing copies of Chinese blue-and-white porcelain in tin-glazed earthenware and the Dutch East India Company's agents needed new products to entice consumers to buy their costly imports from Japan. The solution they found was to order Japanese porcelains painted in brightly coloured enamels. Entirely new to the West, these polychrome wares immediately captivated the market and long remained highly prized. Arita potters made two types of export porcelain to satisfy this demand: Kakiemon wares, of which this bottle is a particularly fine example, and Imari wares (see p.86).

Kakiemon wares were highly refined and sparingly decorated with asymmetrical designs that left much of the beautiful milk-white body exposed. In some cases, though not here, parts of the design were painted in underglaze blue prior to the initial high-temperature firing. Enamels in a striking palette of cerulean blue, soft-coral red, green, yellow and black were applied and fused on in a second, lower-temperature firing. This was carried out at independent enamelling studios, of which several, including that run by the Kakiemon family (from whom the whole category of wares takes its name), were in business by the 1660s.

Kakiemon wares had more influence on European ceramics than any other kind of polychrome porcelain imported from East Asia. They were extensively copied in the Netherlands, France, Germany and England. PF

Bottle
Porcelain, painted in enamels
Japan, Arita kilns
About 1680–1700
Height 43.2cm
C.197–1956

Figure of Guanyin

This figure represents the Chinese goddess Guanyin, the Compassionate Bodhisattva (literally 'enlightened being'), sitting on a rock. It was made at Dehua in Fujian province, southern China. Fujian, a tea-growing region, attracted the attention of European merchants in the sixteenth and seventeenth centuries, and many of these figures were brought back to Europe, where this type of white Dehua porcelain became known as '*blanc de Chine*'.

Dehua specialized in whitewares. The finest products are those with an ivory-coloured glaze, such as this Guanyin. A local publication of about 1604 describes how a 'truly fine' porcelain stone was dug by driving a shaft into the side of a hill, from where the material was then pulled out with a rope. The earliest pieces were expensive, but prices dropped as production increased. Dehua porcelain is made of locally mined porcelain stone, with little or no clay, which makes it extremely white and very translucent when thinly potted. The materials of the body and glaze integrate so well that they appear to be of a single translucent material.

The most common Dehua products were incense burners and Buddhist figures made for domestic use. Brought to Europe as exotic curiosity items, Dehua porcelain was often gilded or enamelled there in the eighteenth century – by which date Europeans were familiar with Chinese polychrome ceramics and Dehua wares may have been judged too plain. The kilns also made figures of Dutch men and women and of the Virgin and Child for export to Europe. MW

Figure of Guanyin
Porcelain, with ivory-coloured glaze
China, Dehua kilns, Fujian province
17th century
Mark: 'Xinmozi' in a square seal stamped on
the back, possibly the name of the maker
Height 39.3cm, width 19.9cm, depth 15cm
George Salting Bequest, C.548–1910

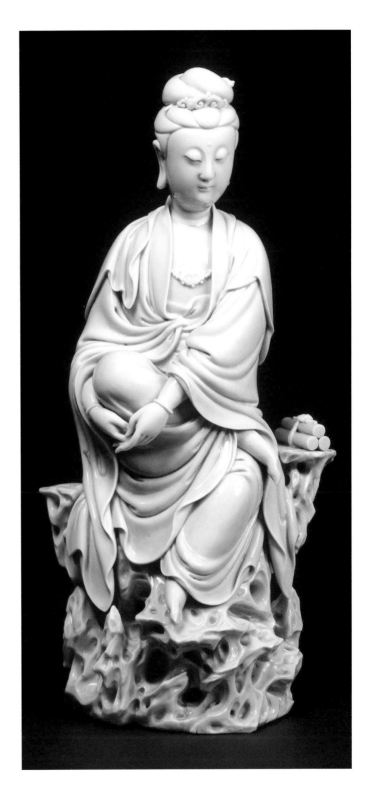

Flower pyramid, one of a pair

In 1644, the Chinese Ming dynasty fell and the ensuing civil war severely disrupted export of porcelain to Europe. Delft potters rose to the challenge by copying Chinese designs in tin-glazed earthenware. Expanding rapidly, Delft soon became one of Europe's major ceramic producers, with over 30 workshops and factories in operation during the seventeenth century. Delft potters made numerous technical improvements, and adopted the Italian maiolica potters' practice of applying a layer of clear lead glaze over the painted tin glaze, which resulted in a gloss sometimes equal to that of Chinese porcelain. The factories were patronized by Mary II (1662–94), Queen of England and wife of William of Orange, who developed a passion for blue-and-white Delftware during her years in the Netherlands. Some of the grandest Delft pieces for William and Mary reflect the influence of the Dutch court architect Daniel Marot (see p.14), who included Delftware as an integral part of his interior designs.

Grandest of all Delft productions were the large flower vases in the shape of tall pyramids, which combine the late seventeenth-century craze for tulips with emphatically Baroque design. Mostly made in pairs and consisting of a number of stacked, individual compartments, such vases became colourful focal points in interior decoration. Their short-lived fashion was strongly focused on the court of William and Mary, and the large size and quality of this pair, combined with elements of their decoration, suggest an important commission from within this circle. In view of their provenance, it is likely that they were made for the 1st Earl of Portland, who was a close confidant of William III. RL

Teapot

The modest size and muted colours of this teapot belie its historical significance, as it was made by the revolutionary new technique of slip-casting – which transformed production in Staffordshire in the eighteenth century – and is among the earliest examples of English 'fineware' (thinly potted ceramics made for domestic use).

The Elers brothers, the makers of the teapot, were silversmiths from the Netherlands, and it was probably their lack of experience in throwing, combined with their knowledge of casting metals, that led them to invent slip-casting. This involved pouring liquid clay into plaster moulds and allowing the water to evaporate, leaving a very thin casting in clay. As later Staffordshire potters were to discover, slip-casting allowed repetition of complex asymmetrical or non-circular shapes. Curiously, this potential was never fully exploited by the Elers brothers themselves, who frequently cast shapes that could have easily been thrown on a wheel.

Most Elers pieces are of slip-cast red stoneware inspired by Chinese Yixing examples, finished on a lathe and with stamped decoration. This teapot is a very rare example in salt-glazed stoneware, probably made before their move to Staffordshire, in contravention of the patent held by the London potter John Dwight (for salt-glazing, see p.68). It is also one of the earliest examples of English pottery with enamelled decoration, which was probably added by a Dutch craftsman. The Elers brothers specialized in making small beer mugs and wares for the new hot drinks, tea, coffee and chocolate, all three of which were expensive luxury imports during the seventeenth century. HY

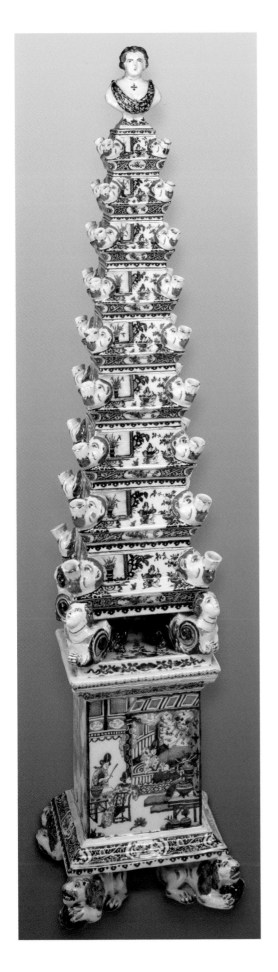

Flower pyramid, one of a pair
Tin-glazed earthenware, painted
in blue
Netherlands, 'Greek A' factory or
'De Metalen Pot' factory, Delft
About 1690
Height 160cm
Formerly from North Mymms Park,
Hertfordshire
C.19 to J–1982

Teapot
Salt-glazed stoneware, painted
in enamels and with a replacement
silver spout
England, probably Vauxhall, London
Made by John Philip Elers
(about 1664–1738) and
David Elers (about 1656–1742)
Probably about 1693
Height 14cm
C.133&A–1938

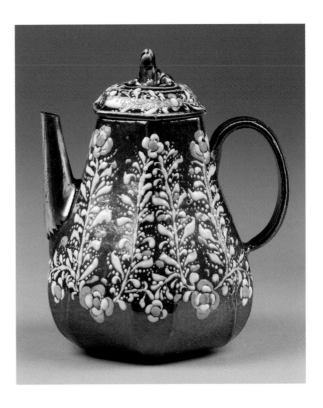

Bowl

The export of Spanish tin-glazed earthenware, begun in the fourteenth century, continued during the fifteenth century, especially to Italy and the Netherlands. But as local ceramic industries in these countries expanded and their potters developed more colourful, painterly styles, imported Spanish lustre pottery rapidly fell out of fashion.

From about 1500 onwards, potters from Italy, and later also from the Netherlands and France, moved to Spain, taking their craft skills and decorative styles to Seville, Toledo and Talavera. Talavera, in Toledo, became the leading centre of ceramic production in seventeenth-century Spain, renowned for its tin-glazed wares painted in a Baroque style with warm rich colours. Subjects favoured include armorials and hunting scenes (often after the prints of Johannes Stradanus), and the freedom of design and sketchy brushwork of Talavera's painters endow their wares with a uniquely dynamic and lively quality.

This unusually large bowl has complex decoration with human figures and horses, and an unidentified coat of arms with Baroque mantling and the name Dona Maria Correa Aguado, for whom it was presumably made. Intended for display, this piece must have been an important commission for the potters at the time. Sumptuary laws of 1601 had prohibited the manufacture of gold and silver tablewares, with the result that even the most splendid tablewares were made in other materials, usually ceramic. This gave a great boost to both the potters of Talavera and the Spanish ceramic industry in general. RL

Vase

This impressive vase shows Chinese blue and white at its technological best. The decoration illustrates a popular love story, *The West Chamber*, each of the panels, arranged in four rows, showing an important episode. It was made during a time of social stability and prosperity. The 'Rebellion of the Three Feudatories', led by General Wu Sangui against the Emperor Kangxi had finally been crushed. The rebellion had completely stopped porcelain production at Jingdezhen from 1674 to 1676, but in 1680 a group of state officials was sent to re-establish the imperial ceramic factory, and with the end of civil war foreign trade was resumed.

Kangxi, who ruled from 1662 to 1722, was the longest-reigning emperor in the country's history. Under his rule China's relationship with Europe was also at its best. The fact that a Jesuit missionary, Père d'Entrecolles (1664–1741), was able to observe porcelain production first-hand at Jingdezhen in 1712 and again in 1722 clearly demonstrates that Europeans were allowed greater freedom than at later times.

A large number of tall vases made between about 1685 and 1720 were shipped to Europe, where 'Oriental porcelain rooms' were in fashion. The shape of this vase is not one produced specifically for the European market, but several such vases were acquired for the 'Japanese Palace' porcelain collections of Augustus the Strong, Elector of Saxony and King of Poland, before 1721 (see p.90). This highlights the fact that the division between 'export' and 'domestic' wares is not always straightforward and clear cut. MW

Bowl

Tin-glazed earthenware, painted in colours

Spain, Talavera

About 1700

Inscribed: ´Da [Dona] MARIA

CORREA AGUADO´

Height 18.6cm, diameter 46.5cm

329–1876

Vase

Porcelain, painted in underglaze blue

China, Jingdezhen

Qing dynasty, Kangxi reign period

(1662–1722)

Height 75cm,

maximum diameter 22.4cm

George Salting Bequest, C.859–1910

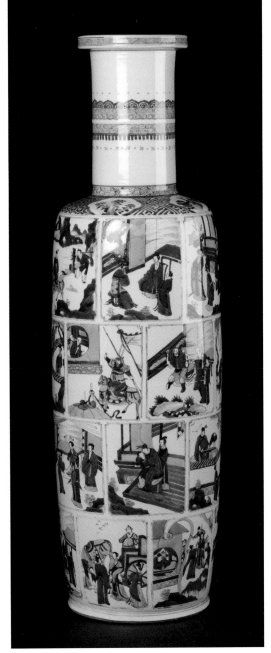

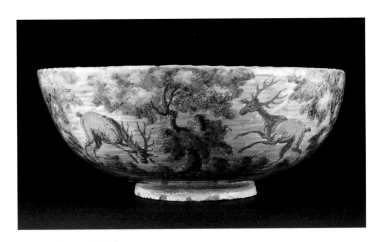

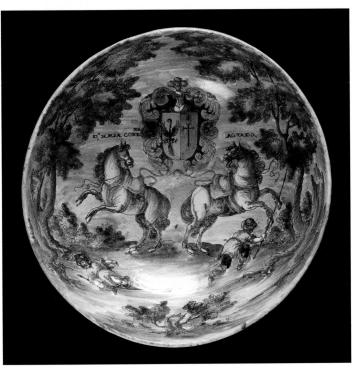

Vase from a five-piece garniture

This magnificent vase and cover is from a garniture (a set of matching vases) made for display in a princely European interior. Comprising three covered jars and two beaker vases decorated in the Imari style, it is among the finest garnitures of this type to survive. A similar set is displayed on a balustrade at the top of a grand Baroque staircase at Schloss Fasanerie, near Fulda, Germany; elsewhere they were massed on top of cabinets or arranged on wall brackets, and in the summer months they were often grouped inside fireplaces. In contrast to Kakiemon porcelains (see p.80), Imari wares are bold and ostentatious, characterized by dense patterns in a palette of underglaze blue combined with iron-red enamel and a rich use of gold.

The grandeur of this garniture suggests that it would have been ordered privately through an agent of the Dutch East India Company stationed in Japan in the early 1700s. In this respect it is different from the more run-of-the-mill porcelains imported by the Dutch East India Company itself, the profitability of the trade in which declined during the early eighteenth century.

The term 'Imari' used to designate wares like this derives from the name of a port near Arita. From here porcelain was trans-shipped to Nagasaki, where the Chinese and Dutch merchants permitted to trade with Japan lived in strictly confined quarters (in the case of the Dutch on the fan-shaped artificial island of Dejima). PF

Teapot

Like the figure of Guanyin (see p.81), this teapot was made at Dehua and of the same white porcelain, known as 'blanc de Chine' in the West. One side is very subtly incised with a design of rocks and plants, and the other with a poetic couplet that reads: 'At night in springtime one moment is precious like a thousand pieces of gold, the orchid sends forth its fragrance in the shade of the moon.' These are the first two lines from a poem by the famous eleventh-century writer Su Shi. It might be assumed from this that the teapot had been commissioned by a scholar. However, Chinese scholars traditionally preferred the 'purple sand' teapots from Yixing (see p.88), not white ones from Dehua. Examples in Dehua porcelain were probably made after the kilns diversified into tea-ware production, following demands from European merchants for European shapes. Dehua wares were closely copied at European porcelain factories, notably Meissen, Chantilly and Bow. Ceramic historians argue that Dehua's raw materials are superior to those of Jingdezhen, but the kilns had no access to water transportation and until the arrival of European merchants most of its products were sold locally.

The base is inscribed with the name of the Emperor Xuande, who reigned from 1426 to 1435, more than 250 years before the teapot was made. The use of earlier reign marks has a long history in China, much to the vexation of modern researchers, and was intended to indicate respect rather than to deceive. The teapot's bold geometric design anticipates the forms of European modernism by more than two centuries. MW

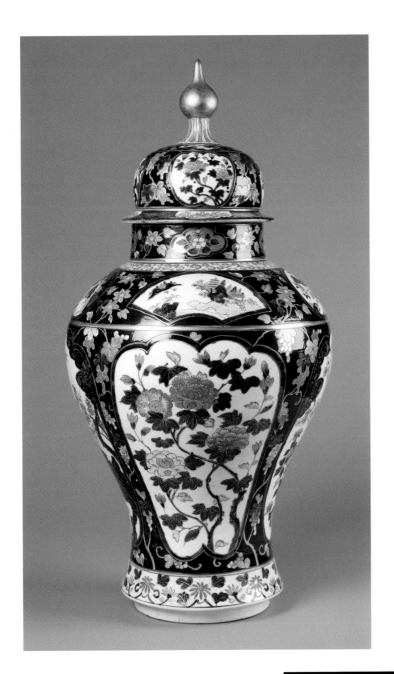

Vase from a five-piece garniture
Porcelain, painted in underglaze blue,
enamels and gilt
Japan, Arita kilns
About 1700–1725
Height 76.2cm
George Salting Bequest, C.1523–1910

Teapot
Porcelain, with ivory-coloured glaze
China, Dehua kilns, Fujian province
About 1690–1720
Mark: 'Xuan De' incised on base
Height 11cm, maximum width 18.5cm
W.G. Gulland Bequest, Circ.62–1931

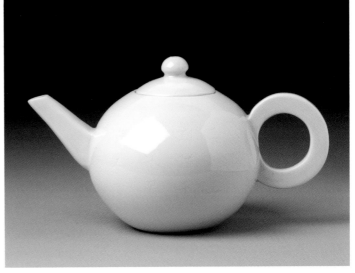

Teapot

This extraordinary teapot was made in Yixing, a small town located a little way inland from the coastal city of Shanghai. It is modelled in the shape of a *sheng*, a Chinese musical wind instrument formed from a group of hollow reeds or bamboo tubes of different heights.

The rise of Yixing was the result of the changeover from whipped tea, which was prepared in a bowl, to steeped tea, which could be prepared in a pot, the latter becoming prevalent in China in the sixteenth century. In Yixing potters discovered deposits of a clay known as 'purple sand' that fires to a variety of rich brown colours. Yixing clay is highly plastic and as a result even amateur potters could mould it into the desired shape. It needs no glazing and remains slightly porous, allowing any unpleasant smells from the boiled water to evaporate, while retaining the aroma of the tea – or at least so believed the Chinese tea connoisseurs. According to Chinese textual sources, it was a Buddhist monk who first used Yixing clay to make teapots, and he signed his work upon completion. Since then Yixing potters have prided themselves on their creativity and dexterity, and they enjoyed higher social status than their Jingdezhen contemporaries.

Yixing teapots were exported in some quantity to Europe, where they inspired imitation in Delft, at Meissen and in Staffordshire (see p.90). This teapot and its pair were once owned by the eccentric millionaire antiquarian and collector William Beckford, and similar pieces entered the Dresden collections of Augustus the Strong before 1721. MW

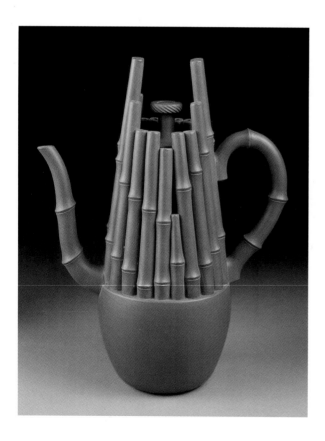

Teapot
Unglazed brown stoneware
China, Yixing kilns, Jiangsu province
About 1700–1720
Mark: 'Meng Hou' stamped below spout, possibly the name of the maker
Height 18cm, maximum width 14.1cm
Formerly in the collection of William Beckford
W.H. Cope Bequest, 662&A–1903

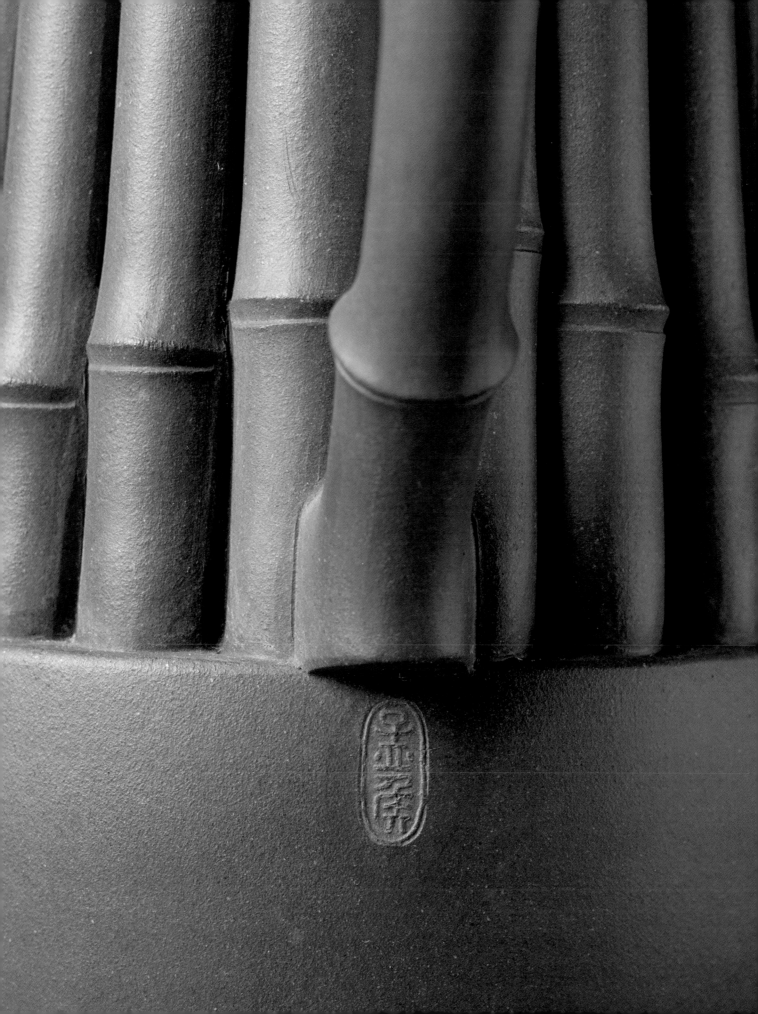

Tankard

The story of how Meissen became the first European factory to unravel the secrets of making porcelain of the Chinese type is rich with intrigue, espionage and improbable characters, and has in fact been turned into a best-selling novel. Founded in 1710, Meissen was run under the protection of Augustus the Strong, Elector of Saxony and King of Poland. Augustus developed a passion for this 'white gold' and amassed the largest collection of Asian ceramics in Europe – once famously exchanging 600 mounted soldiers for 151 Ming vases – and he later commissioned a life-size porcelain menagerie from Meissen (see p.95).

The story begins in 1701 with the arrival of the young alchemist Johann Friedrich Böttger in Saxony. Imprisoned by Augustus, Böttger failed to synthesize gold, but his potential was recognized by Walter von Tschirnhaus, a scientist interested in minerals and optics. Working under intense secrecy, and joined by a geologist, they attempted to discover the 'arcana', or 'secret knowledge', of the manufacture of porcelain. Correctly identifying the ingredients and using lenses to achieve the necessary high temperatures in experiments, the trio succeeded in two truly remarkable achievements. The first, in 1707, was the invention a dense red stoneware inspired by Chinese Yixing wares (see p.88), of which this polished tankard is a magnificent example. The second was more momentous: the discovery in 1708 of the composition of and firing conditions for porcelain. His health destroyed by work and incarceration, Böttger let slip some of Meissen's secrets shortly before his death, an indiscretion that ultimately led to the establishment of a European porcelain industry. HY

Teapot

This jewel-like teapot – which is finely, and most unusually, painted with female characters from the Italian Comedy – is a small masterpiece from the Vezzi factory of Venice. Although in production for only seven years, the factory played a key role in the history of European porcelain, as it was via a series of acts of industrial espionage centring on the Vezzi and Vienna factories that knowledge of Meissen's materials and processes became widespread throughout Italy and Germany.

The factory was founded in 1720 by the goldsmiths Francesco and Giuseppe Vezzi. In 1719 Francesco had met Christoph Conrad Hunger, who had worked alongside J.F. Böttger at Meissen and had discovered information about the factory's materials and processes. Armed with this knowledge, he fled to Vienna, where he helped found the Du Paquier porcelain factory and was joined by the kiln master from Meissen. From Vienna Hunger then went to Venice, joining forces with the Vezzi brothers, who began making small tea wares like this teapot using kaolin from Saxony. Hunger left in 1724 and three years later was back at Meissen, where he revealed the Vezzi brothers' source of clay. Exports of Saxon kaolin were immediately forbidden, forcing the factory to close. Meanwhile, the Vienna factory prospered, but by the 1740s was employing a workman named Jakob Joseph Ringler. Through friendship with the director's daughter Ringler learned the secrets of porcelain manufacture, and in 1747 he defected, taking the Meissen/Vienna formula and processes to a string of porcelain factories in Germany, including Höchst, Strasbourg, Nymphenburg and Ludwigsburg. HY

Tankard
Red stoneware (Böttger stoneware),
lapidary polished and with silver-gilt
mounts
Germany, Meissen porcelain factory,
Saxony
About 1710–13
Height 21.6cm
From the Arthur and Hilde Weiner
Collection. Accepted by HM
Government in Lieu of Inheritance Tax
and Allocated to the V&A, C.22–2006

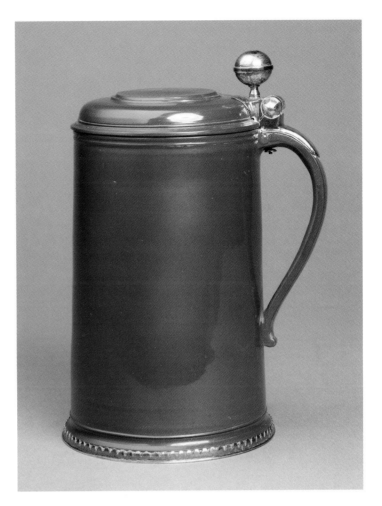

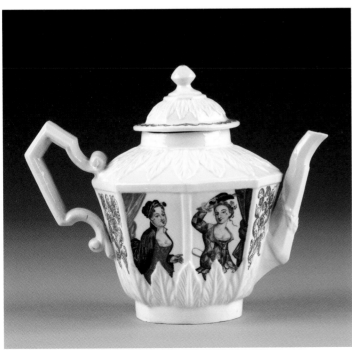

Teapot
Porcelain, painted in enamels
Italy, Vezzi porcelain factory, Venice
1720–27
Mark: 'Ven:a' painted in red and
'A' incised twice
Height 5.2cm
Arthur Hurst Bequest, C.130&A–1940

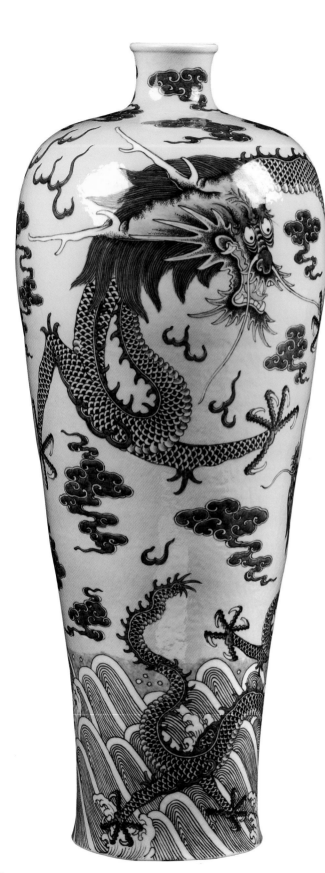

Vase

This graceful *meiping* ('prunus vase') is decorated with two swirling dragons rising above breaking waves into the clouds and was probably made for the imperial court. Both the shape and the decoration have a long history in China, the *meiping* making its appearance in the eleventh century (see p.34) and the dragon being traceable to Neolithic times.

The special feature of this vase is that the white background to the dragons has been over-painted with yellow enamel, a colour combination requiring a second firing. First, the cobalt-painted porcelain was covered with a clear glaze and fired at a high temperature (between 1,280 and 1,350°C). Yellow enamel was then painted over the white areas of the design and the piece was given another firing at about 700–800°C. This temperature maximized the intensity of the colorant (iron oxide) and was just high enough to melt the enamel and fuse it to the glazed porcelain below.

From the fifteenth century four different types of monochrome porcelains had been required by the Chinese court for ritual use – blue, yellow, red and white. Yellow was the only one that could not be produced at high temperatures, and although the twice-fired method sounds complicated, it guaranteed a good yellow colour. Having taken this step, Jingdezhen potters then quickly realized the decorative potential of painting polychrome designs in low-temperature enamel colours onto pre-fired porcelain wares. This made possible the multitude of polychrome-painted wares that followed, among them 'famille verte' and 'famille rose' (see following entry). MW

Vase
Porcelain, painted in underglaze blue
and overglaze yellow enamel
China, Jingdezhen
Qing dynasty, Yongzheng reign period
(1723–35)
Height 65cm, maximum diameter 24cm
George Salting Bequest, C.995–1910

Dish

Like most decoration on eighteenth- and nineteenth-century Chinese porcelain, the design on this very large dish is charged with auspicious symbolism, the peach being a symbol of long life. The painting is of exceptional quality, with very fine linear treatment and detailing: the style and overall composition emulate court flower painting on silk.

The colour scheme used by the painter is known in the West as 'famille rose' (literally 'pink family'), because of the prominence of the pink enamel. This was one of several terms coined in the 1870s, when Chinese Qing dynasty enamelled wares were all the rage in Europe and they were classified according to their predominant colours, the other main categories being 'famille verte', 'famille jaune' and 'famille noire'.

'Famille verte' ('green family') was the earliest and most common of these four 'families'. All the coloured enamels used – mostly green but sometimes also blue, red, yellow and aubergine – are transparent. The pink enamel and the opaque yellow, seen on this 'famille rose' dish, appeared in the 1720s, at the latest. A relatively large number of Jesuit missionaries served at the imperial workshops at the time that this colour was developed and it has been suggested that they introduced the method for achieving a pink enamel to Chinese craftsmen, but this has yet to be proved. MW

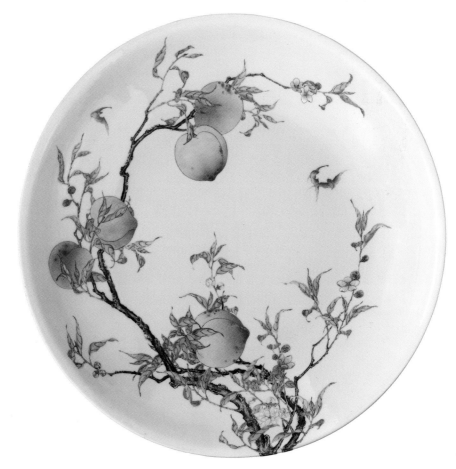

Dish
Porcelain, painted in enamels
China, Jingdezhen
Qing dynasty, Yongzheng reign period
(1723–35)
Mark: 'Daqing Yongzheng nian zhi'
('Made in the Yongzheng reign
period of Great Qing') painted in
underglaze blue
Diameter 50.8cm
Dr Henry Couling Bequest, 719–1907

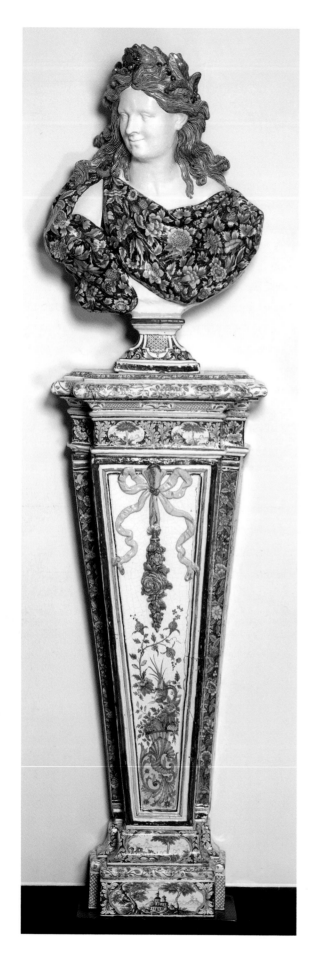

Bust of Apollo with pedestal

The manufacture of tin-glazed earthenware, known in French as 'faïence', was introduced from Italy and established in Rouen in 1644 with a 50-year royal privilege, protecting it from competition. The high status of this material was confirmed by Louis XIV's order for a pavilion clad in faïence tiles for his mistress, and demand from the nobility increased dramatically after an edict of 1709 commanding that all silver plate be melted down to pay for his wars. As one contemporary diarist commented, 'Every man of any status or consequence turned within a week to faïence', and it continued to enjoy an aristocratic and much wider market well into the eighteenth century.

This very large bust of the Roman sun god Apollo is a hugely ambitious sculptural production and is of a quality never surpassed in this material. It originally presided over four others representing the seasons and originally stood in the office of the factory's director, no doubt to advertise Rouen's capabilities to potential clients. The factory was evidently able to employ sculptors and designers well versed in the late Baroque style favoured at Louis XIV's court. Indeed, the bust makes reference to the late king, as Apollo was directly associated with Louis XIV and his reign. Its style is indebted to the great Italian Baroque sculptor Gianlorenzo Bernini, and the design of the pedestal is similar to those by the royal French furniture maker André Charles Boulle. Both are painted in the rich polychrome palette characteristic of much mid-eighteenth-century tin-glazed pottery. CM

Bust of Apollo with pedestal
Tin-glazed earthenware, painted in colours
France, Nicholas Fouquay's factory, Rouen
About 1730
Bust: height 83cm, width 60cm, depth 35cm;
pedestal: height 138.5cm, width 59cm, depth 29cm
4551–1857

Billy goat

This vigorously modelled sculpture of a goat is from one of the great landmarks of ceramic history: the porcelain menagerie commissioned by Augustus the Strong, Elector of Saxony and King of Poland, for his 'Japanese Palace' at Dresden. Nearly 600 of these life-size animals were planned and at least 458 were made. Several casts were made of each model and these were to have been set out in tiered and massed displays on plinths and brackets. The majority of the original models were created by Johann Joachim Kändler, the greatest and most influential porcelain modeller of the eighteenth century.

Work began in 1730, only 20 years after Meissen had become the first European factory to make 'true' porcelain. Prior to 1730 the factory had made few large wares and had very little experience of sculptural production; indeed, no porcelain sculptures on the scale of the largest 'Japanese Palace' animals had been made anywhere in the world. The factory's 'arcanists' − men who prepared the porcelain formula and glaze − developed a new porcelain body for these large sculptures, one that could bear their weight during the high-temperature firings. But despite repeated experiments and improvements, most of the larger models have large firing cracks. Augustus had specified that all the animals should have their natural colours, which normally would have been painted in enamels. However, the factory technicians considered it too risky to subject the largest models to the heat of an enamel firing, so painted them in unfired pigments instead. Such colours darken over time and have usually been removed, as here. HY

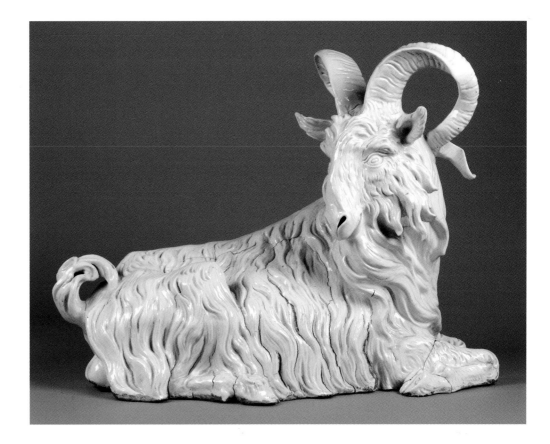

Billy goat
Hard-paste porcelain
Germany, Meissen porcelain
factory, Saxony
Modelled by Johann Joachim
Kändler (1706–75)
1732
Mark: 'Z' incised
Height 56cm
C.III-1932

Figure of a European woman

This figure with eerily blanched face represents a European woman wearing regional dress and was clearly modelled after much earlier European prints. She was probably intended to be Dutch, although details of her dress correspond to a late seventeenth-century engraving of a Swabian (southern German) peasant. Round her neck she wears a ruff of a type that had passed out of fashion in the Netherlands nearly a century before the figure was made.

Other versions of this figure are known, from which it is apparent that she was made in a mould and hand-finished before firing, as with some slightly earlier Dehua figures that show somewhat similar style and sculptural conventions. At least one of these other versions is paired with a male companion wearing a falling collar in early seventeenth-century style. Clearly made for export, such figures were probably intended for display on mantelpieces or brackets in western European interiors. Presumably the craftsman who modelled this piece had never seen a European woman in this or any other style of dress, the result being an image as arresting and unrealistic as many European representations of Chinese people made at about this date. MW

Figure of a harlequin

This superbly modelled harlequin is one of the great early small-scale works by the artist who largely defined the sculptural conventions of the eighteenth-century porcelain figure: Johann Joachim Kändler. Kändler, the greatest porcelain modeller of the century, had been recruited for the Meissen factory by Augustus the Strong to create models for his life-size porcelain menagerie at Dresden (see p.95). After excelling at large-scale work, he turned his attention to small figures in the later 1730s, in doing so inventing the porcelain figure as we know it today. He went on to create or supervise the creation of about 1,000 models during his remarkably long career, including figures for collectors' cabinets and interior decoration, but also for display at grand dinners.

It may seem curious that many of the earliest European porcelain figures were originally made to replace the sugar and wax sculptures that had for centuries decorated the dessert course of grand meals. It was Kändler who took the revolutionary step of making replacements for confectionery figures in the more durable and colourful material of porcelain. Introduced in the 1730s, these were often conceived in series and were modelled with elegantly turning poses that could be appreciated by diners on all sides.

This figure, however, was probably not intended for the dessert table, but, like most of Kändler's Italian Comedy models, was a virtuoso cabinet piece for collectors. Kändler evidently keenly enjoyed the expressive grimaces and contorted poses of Italian Comedy actors, and created this model as a tribute to a harlequin who made his debut at Dresden in 1738. HY

Figure of a European woman
Porcelain, painted in enamels
China, Jingdezhen
Qing dynasty, 1735–45
Height 75cm, maximum width 22.4cm
Basil Ionides Bequest, C.94–1963

Figure of a harlequin
Porcelain, painted in enamels
Germany, Meissen porcelain factory,
Saxony
Modelled by Johann Joachim Kändler
(1706–75)
About 1738
Height 16.5cm
Given by Mrs Josa Finney, C.11–1984

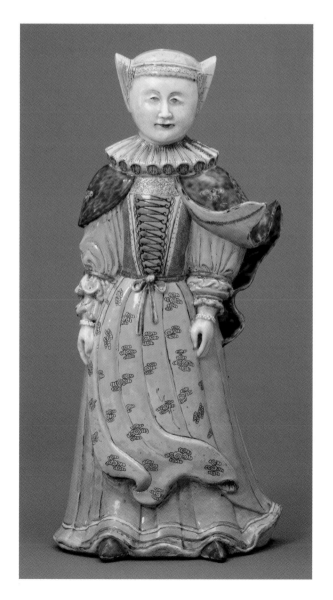

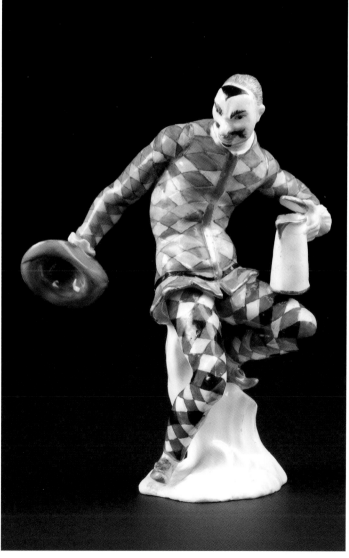

Vase

This long-necked vase is covered with a deep red glaze suffused with blue streaks. Western writers call this glaze 'flambé', but the potter who created it believed he was imitating the classic Jun ware of the Song dynasty (see p.40). The glaze is described in Chinese texts as 'yaobian', meaning 'changing of colour in the kiln'.

By the eighteenth century Jun wares had become highly prized and there were many pieces in the imperial treasury. The impulse to imitate the ware probably came from the Yongzheng Emperor (reigned 1723–35), who took a personal interest in production at the imperial ceramic factory at Jingdezhen. Although Jingdezhen potters knew that the red was derived from copper, they would not have known the exact formula used by Jun potters 600 or 700 years earlier and they arrived at a substantially different glaze recipe. The dazzling streaks here were created by copper flicked or blown onto the surface, resulting in an uneven, dappled effect. Towards the mid-eighteenth century cobalt was sometimes added, no doubt to enhance the blue of the streaks. The glaze round the mouth has reoxidized to a translucent pale green.

Flambé glazes fascinated French and British ceramists of the late nineteenth century – to the extent that in 1882 a French diplomat collected raw materials and recipes from Jingdezhen and had them examined at Sèvres. They inspired the glaze effects of both Auguste Delaherche (1857–1940; see p.123) and the pioneer English 'art potter' Bernard Moore (1850–1935). MW

Architectural ornament from a palace in the Yuanming Yuan

This architectural fragment once ornamented a palace in the Yuanming Yuan, or 'Garden of Perfect Clarity', a vast complex to the north-west of Beijing that served as a summer retreat for the Qing dynasty emperors of China.

The Yuanming Yuan, begun in 1709 by the Emperor Kangxi, was greatly enlarged by his grandson Qianlong, who ruled China from 1736 to 1795. From 1747 Giuseppe Castiglione (1688–1766), an Italian Jesuit missionary serving at Qianlong's court, designed a series of western-style palaces in the north-eastern corner of the complex to house the emperor's collection of European tapestries, paintings, clocks and furniture. These palaces were a fascinating mix of European and Asian elements. Exuberant rococo pilasters, balustrades and decorative embellishments, such as this architectural ornament, were combined with typically Chinese roofs, while the plain grey exteriors of Europe gave way to bright colours of red, yellow, green, purple and, as here, turquoise. The latter is an unusual colour for Chinese buildings, however, its use perhaps reflecting the 'foreign' nature of the palaces.

As emperor, Qianlong was positioned as huangdi or 'supreme lord' and his desire for comprehensive knowledge of the world was an expression of his benevolent authority over it. His construction of western-style palaces at the Yuanming Yuan was thus not merely fanciful, but signified the incorporation of Europe into a world order over which Qianlong ruled as universal sovereign.

The entire Yuanming Yuan complex was destroyed by British and French troops in 1860. All that remains of the remarkable European-style buildings are scattered ruins and architectural fragments such as this. AJ

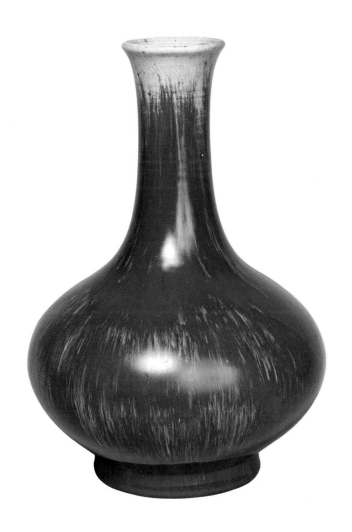

Vase
Porcelain, with *flambé* glaze
China, Jingdezhen
Qing dynasty, Qianlong reign period
(1736–95)
Height 35cm,
maximum diameter 22.6cm
George Salting Bequest, C.397–1910

**Architectural ornament from
a palace in the Yuanming Yuan**
Stoneware, with turquoise glaze
China
1747–70
Height 34.5cm, width 38cm,
depth 23cm
C.382–1912

Figure group known as 'L'Heure du Berger' ('The Shepherd's Hour'), but perhaps representing Zephyrus and Flora

The royal French porcelain factory of Vincennes/Sèvres was the most important in Europe during the second half of the eighteenth century. It set many of the fashions followed elsewhere, introducing a range of coloured grounds complemented by exquisite enamel painting and elaborately tooled gilding – for vases and useful wares – and pioneered unglazed 'biscuit' for figures. As it supplied an exclusively royal and aristocratic clientele, the quality of its paste, potting, design and decoration was always superlative.

The factory had been founded at Vincennes in 1740 and obtained a royal privilege from Louis XV to make porcelain in the style of Meissen in 1745. During the early 1750s Vincennes established its aesthetic independence from German and Asian prototypes, introducing tablewares and figure models that were purely French in style. In 1753 it became the royal French factory and was relocated to Sèvres (between Paris and Versailles) three years later.

This figure group is one of Vincennes' earliest productions, probably made before the introduction of biscuit porcelain for sculptural work in 1751. It showcases the factory's much admired ivory-white 'soft-paste' body. Like other soft pastes (imitation porcelains), this was made with a variety of ingredients rather than kaolin and china stone. These included sand, saltpetre and alabaster, which could be fused together for up to 50 hours, ground up for about three weeks, dried and crushed again, before being mixed with clay. Incredibly expensive and labour-intensive to produce – and also vulnerable to damage during firing and use – this was eventually phased out after the discovery of kaolin at Limoges and the subsequent manufacture of 'hard paste' in the 1770s. HY

Teapot

The years around 1750 were extraordinarily creative and prosperous for the Staffordshire pottery industry, with factories responding to widening markets and changes in dining and drinking habits by developing or perfecting new designs, materials, and forming and decorative techniques.

This teapot is made in white salt-glazed stoneware, a material introduced before 1720 containing white clays and calcined flint that was fired and glazed in the manner of German stonewares (see p.68). The flint gave the material tremendous strength and allowed very thin potting. Around 1740 Staffordshire potters revived the slip-casting technique, which had been invented by the Elers brothers in the 1690s but had not been used since that time (see p.82). This process involved pouring liquid clay into hollow plaster moulds in which the wares were formed. The great advantage of moulds is that they allowed the manufacture of complex and highly irregular shapes in bulk. Liberated from the circular forms dictated by the potter's wheel, Staffordshire potters responded by making vessels in wildly imaginative shapes, in doing so creating some of the first European novelty teapots, a ceramic genre that still flourishes today. Factories bought in designs for such wares in the form of 'block moulds' (the convex 'master models' from which concave manufacturing moulds were made) from specialist craftsmen.

The widening habit of drinking tea and coffee created a huge demand for such wares, both at home and in the growing export markets in continental Europe and the American colonies, and this gave the Staffordshire Potteries a huge boost as the area began to industrialize in the early eighteenth century. HY

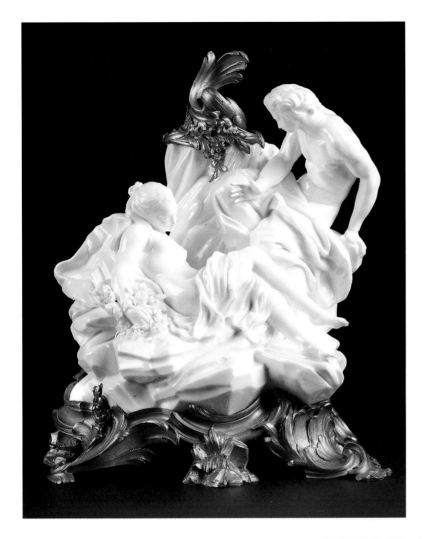

Figure group known as 'L'Heure
du Berger' ('The Shepherd's Hour'),
but perhaps representing Zephyrus
and Flora
Soft-paste porcelain, mounted in
gilt-bronze
France, Vincennes porcelain factory
1745–52
Height 29.2cm
Given by J.H. Fitzhenry, C.356–1909

Teapot
White salt-glazed stoneware
England, Staffordshire
About 1750
Height 10cm
Given by Lady Charlotte Schreiber,
414/989&A–1885

Soup tureen

Such was the status of the new material that the leading porcelain factories of eighteenth-century continental Europe were frequently run under royal or aristocratic protection, in part as a matter of competitive prestige between rival courts and princely households – Meissen, Nymphenburg, Chantilly and Sèvres being notable cases in point. In England things were very different, all the new factories being emphatically commercial ventures, run by energetic entrepreneurs and craftsmen from the 'middling ranks'; many concentrated on the middle market, making relatively inexpensive blue-and-white or modestly enamelled wares. All the early English factories made 'soft paste', or imitation porcelains, as until about 1770 Britain lacked the raw materials and technical know-how to make 'true' porcelain of the East Asian and German type. Soft

pastes were often difficult to work and fire successfully, and ambitiously large pieces such as this tureen are rare.

In terms of aesthetic and social ambition, one early English factory stood head and shoulders above the rest: Chelsea, where this tureen was made. Founded by Nicholas Sprimont, an extremely gifted goldsmith, modeller and designer from Liège, Chelsea aimed at the top end of the British market, and gained aristocratic and ambassadorial support in its attempts to rival imports from the royal factories of Meissen and Sèvres. Meissen had been the first to make trompe-l'oeil dining wares in vegetable or animal shapes, but it was left to Chelsea (and some of the French tin-glazed earthenware factories) to further explore the idea. HY

Figure group for a dining table

While J.J. Kändler of Meissen was the greatest and most innovative porcelain sculptor of the eighteenth century, the most individual modeller working in this material was undoubtedly Franz Anton Bustelli, a brilliant artist of Italian extraction about whom little is known, who worked for the Bavarian court porcelain factory of Nymphenburg from 1754 until his death in 1763.

What makes any work by Bustelli so distinctive is his use of closely observed and sensitively rendered naturalistic detail in combination with extremely elegant and contorted poses, angular treatment of drapery, and wildly asymmetrical abstract rococo bases and ornament. Here rococo scrollwork runs riot in spiral motion, animating the picnic setting for a pair of lovers in hunting dress. The figure group was evidently designed as a centrepiece for a dining table: the spiral movement and twisted postures ensure that the composition is satisfying from whatever angle it is viewed. Like Kändler at Meissen, Bustelli carved his original models (from which the plaster manufacturing moulds were taken) in fruitwood, which allowed sharper detailing than modelling in plaster, wax or clay.

Nymphenburg was one of several German factories that began porcelain production after the kiln master and industrial spy J.J. Ringler defected from Vienna, taking knowledge of the Meissen and Viennese materials and processes with him (see p.90). HY

Figure group for a dining table
Porcelain
Germany, Nymphenburg porcelain
factory, Bavaria
Modelled by Franz Anton Bustelli
(died 1763)
About 1759–60
Mark: a shield with the arms of Bavaria
impressed
Height 27.3cm
Bought with the Murray Bequest Fund,
C.21–1946

Soup tureen
Soft-paste porcelain, painted in enamels
England, Chelsea porcelain factory,
London
About 1755
Marks: an anchor painted in red (twice)
Height 25.1cm, length 34.9cm
Given by Stephen, 6th Baron Lilford,
in accordance with the wishes of his
brother John, 5th Baron Lilford,
C.75 to B–1946

'The Music Lesson'

The porcelain figures made in eighteenth-century England are very different in character from those of continental Europe. In part this arises from differences in materials, as the sharpness of detail, glittering glaze and brilliant enamels achieved at Meissen and Nymphenburg, for example, could not be realized in the English 'soft-paste' bodies (and only Derby among the English factories made biscuit porcelain in the manner of Sèvres). Moreover, unlike continental factories, those in England were purely commercial concerns (see p.102) and few were able to recruit modellers of the first rank. Nevertheless, with their softer forms and muted colours, and very different market and aesthetic ambitions, English porcelain figures have a definite charm and character all of their own.

Chelsea figures are of exceptional quality. They were created by one of the few great modellers working in the English industry, Joseph Willems – who, like many of the key personnel at the factory, was from the Low Countries. Willems's figures included compositions of his own creation, accomplished copies of Meissen models and groups based on prints – as with this subject, taken from an engraving of a François Boucher painting. The group prominently features a distinctive characteristic of English ceramic figures of about 1760–1835: the profusion of hand-modelled and applied flowers and vegetation known as 'bocage' (from the French for 'grove'). Such work was carried out by 'repairers', the skilled craftsmen responsible for assembling separately moulded figure parts and sharpening up their detail, and was later a feature of inexpensive Staffordshire pottery ornaments. **HY**

Punchbowl

Tin-glazed earthenware was made in England from the sixteenth century and in the following century was decorated in the style of imported pottery from Delft, with the result that it became known as 'delftware'. This piece is one of the largest English delftware punchbowls and bears a finely painted elevation of a ship. Such 'ship bowls' were a speciality of the Liverpool ceramic factories – one of which advertised 'the likeness of vessels taken and painted in the most correct and masterly manner' – and were also made at Bristol. Together with London, these two cities were the main centres for English delftware, being well placed to import clay from Ireland and to export wares to the American colonies. Enamelling, used here for the orange and red, is common on European tin-glazed earthenware but rare on English delftware and was a further speciality of the Liverpool factories.

Punch came to Europe during the seventeenth century as a result of the East India trade, which also brought Chinese ceramics to the West, and originally contained arrack, a rum-like spirit from Goa and Jakarta, together with lemon juice, water, sugar and spices. Ceramic punchbowls were made in Europe from the 1680s to the 1820s, especially in Britain, and also in China for export to Europe and America. The smallest were for individual use, and many larger ones were made for public houses and communal drinking. The largest bowls, such as this one, often bore commemorative inscriptions or designs and may have been primarily intended as decorative presentation pieces rather than for actual use. **HY**

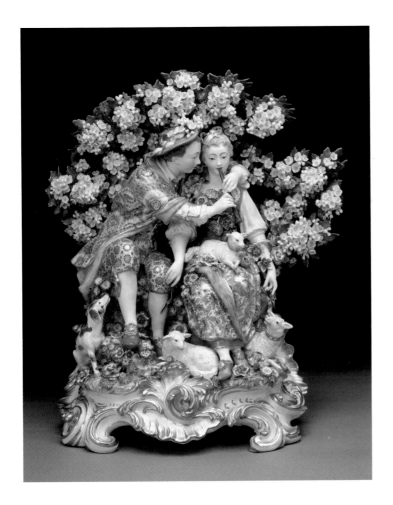

'The Music Lesson'
Soft-paste porcelain, painted in
enamels and gilt
England, Chelsea porcelain factory,
London
Modelled by Joseph Willems (1715–66)
About 1765
Marks: an anchor painted in gold and
'R' impressed
Height 41cm
Given by Lady Charlotte Schreiber,
414/192–1885

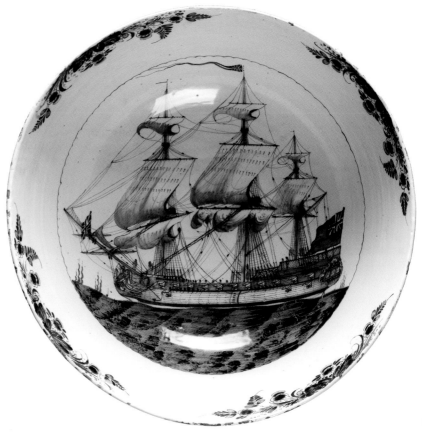

Punchbowl
Tin-glazed earthenware ('delftware'),
painted in colours and with enamelled
details
England, Liverpool
Possibly painted by William Jackson
About 1765–70
Diameter 52.2cm
Transferred from the Museum of
Practical Geology, 3615–1901

Part of a tea and coffee service

Dessert plate

Wedgwood's elegant service illustrates two of the key contributions that eighteenth-century Britain made to ceramic history: creamware, a type of white earthenware, and transfer-printing, an invention that revolutionized ceramic production worldwide.

As a material, creamware had several advantages over porcelain and its other rivals. It was cheap to make; it was strengthened with calcined flint, which made it durable and encouraged thin potting; and the colour and smooth glaze made it hygienic and suitable for eating and drinking. Developed in Staffordshire during the 1740s and 1750s, creamware was perfected by Josiah Wedgwood in the 1760s. It proved enormously popular, remaining in production until the 1820s, and was exported throughout the world.

Creamware was attractive when left plain, but it provided an excellent background for restrained enamel painting or for on-glaze transfer-printing of the type shown here. Transfer-printing over the glaze originally involved printing a design onto a layer of gelatin (animal glue), which was then applied to the body of the ware, thus transferring the design. The revolutionary importance of the technique was that it enabled manufacturers to achieve high-quality decoration at a relatively low cost, for although engravers put much work into the printing plates, the actual decoration of the wares could be carried out by less skilled hands. The first experiments in transfer-printing were undertaken at the Doccia factory in Italy in the 1740s, but on-glaze printing processes were independently developed and perfected in England in the early 1750s. These were soon adapted for cheap underglaze printed blue-and-white wares, a development that transformed the market and the industry (see p.112).

HY

This plate is from one of the grandest and most expensive services ever made at the royal French factory of Sèvres. Comprising 800 pieces and serving 60 diners, this was commissioned by Catherine the Great, Empress of Russia, in 1776. It was the first to be made at Sèvres in the neo-classical style then becoming fashionable and required completely new designs and moulds (none of which were ever reused). Catherine herself selected the Ekaterina II monogram, the use of 'cameo' medallions and the turquoise ground. It proved impossible to achieve the turquoise on the 'hard-paste' body that Sèvres had recently begun producing and a special new 'soft-paste' formula was developed. Thirty-seven painters and five gilders worked on the commission, which took three years to complete. There is a double layer of tooled gold on the plates, each of which went through the kilns eight times for the successive biscuit, glaze, enamel and gold firings. The 'wastage' during production was enormous: 3,000 pieces were made to achieve the total of 800 perfect examples required. Catherine took a close interest in the service and the plates alone were redesigned eight times before she was satisfied. Nevertheless, it proved so costly to make that she initially balked at the price and only paid the final instalment of the renegotiated bill in 1792. By that date the factory was attempting to survive the French Revolution, which brought about a disastrous drop in sales, and no comparable service was subsequently attempted. HY

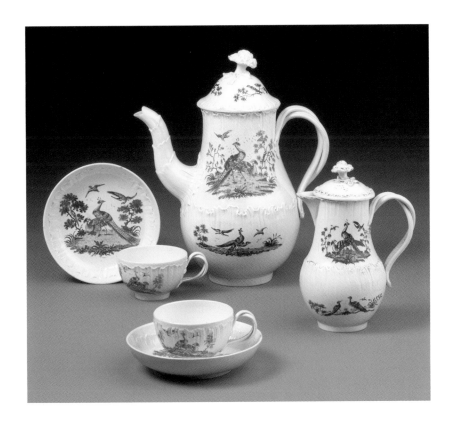

Part of a tea and coffee service
Creamware, transfer-printed in purple
enamel
England, Josiah Wedgwood's factory,
Staffordshire, transfer-printed in
Liverpool by Guy Green (died 1799)
About 1775
Coffee pot: height 24.4cm
Given by Lady Charlotte Schreiber,
414/1155 to 1157C–1885

Dessert plate
Soft-paste porcelain, painted in
enamels and gilt
France, Sèvres porcelain factory
1778
Marks: painted factory mark with date
letters for 1778 and the symbols of the
painter Vincent Taillandier (1736–90)
and the gilder Jean-Pierre Boulanger
(1722–85)
Diameter 26cm
Formerly in the collection of Catherine
the Great, St Petersburg
Bequeathed by D.M. Currie,
C.449–1921

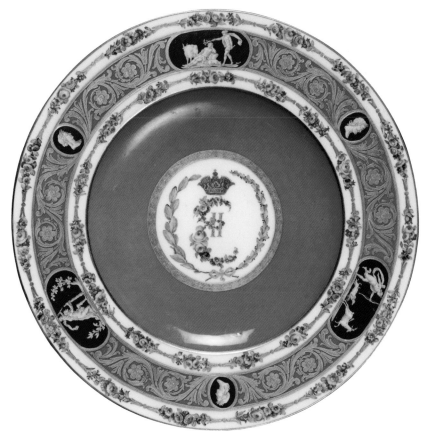

Pair of busts of Louis XVI and Marie Antoinette, King and Queen of France

The use of unglazed porcelain for sculptural work was one of several major innovations that the Vincennes and Sèvres factories pioneered in the 1750s. Curiously, although fired only once after moulding, the term 'biscuit' used for unglazed porcelain literally means 'twice-baked' in French, the other 'baking' implied in the original usage being to fuse raw materials prior to shaping. Vincennes (transferred to Sèvres in 1756) made glazed figures prior to 1752, but discontinued them in favour of biscuit, probably initially because of problems with the glaze pooling in hollows. Biscuit porcelain soon became a very important part of the factory's output, the great sculptor Étienne-Maurice Falconet (1716–91) being appointed Director of Sculpture in 1757. Originally intended for decorating dessert tables at grand dinners, much Sèvres biscuit was made for display in interiors from the 1760s. It became a highly prized material, comparable to marble and bronze: Louis XVI, for example, displayed biscuit sculpture at Versailles. It was always more expensive to make figures in biscuit than in glazed and enamelled porcelain, as the standard of finish had to be much higher in the absence of any covering to hide firing faults or flaws in the modelling.

This magnificent pair of busts was presented by Louis XVI to one of the ambassadors sent to France by Tipu Sultan, ruler of Mysore, in 1788. HY

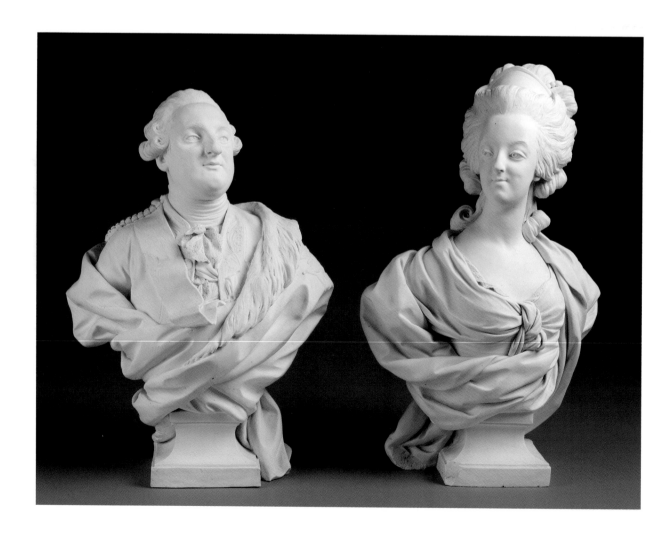

'First Edition' copy of the Portland Vase

There are three reasons why Josiah Wedgwood (1730–95) was a uniquely important potter. First, he had a thorough understanding of the chemistry of pottery and developed or perfected a range of new materials, including Jasper, the fine stoneware of which this vase is made, Black Basalt and the creamware he marketed as 'Queen's Ware' (see p.106). Second, he was in touch with leading architects, artists and collectors, and under their influence he promoted the neo-classical styles that were then becoming fashionable. Third, he was an astute businessman and energetically marketed his wares. The combination of technical excellence, smart classical design and clever marketing strategies made his pottery very fashionable, both in Britain and abroad. This combination is exemplified by his copies of the Portland Vase, his last great achievement.

The Portland Vase, a Roman cameo-cut glass vase of about 40–30 BC, was one of the most celebrated classical antiquities in Wedgwood's day. He first attempted to reproduce it in 1786, and he spent over three years matching the subtlety of the lapidary-worked reliefs of the original. His copies were made in Jasper, the stoneware body he developed following thousands of experiments in the 1770s and which is still in production today. This can be stained a range of colours to provide a background for applied moulded reliefs. Having obtained the approval of leading connoisseurs and taste-makers, such as the artist Sir Joshua Reynolds, Wedgwood exhibited his perfected 'First Edition' copy in London in 1790, showing it to a select audience who had applied for admission tickets in advance. **HY**

**'First Edition' copy
of the Portland Vase**
Jasper with black 'dip' and white reliefs
England, Josiah Wedgwood's factory,
Etruria, Staffordshire
Modelled by William Hackwood
and Henry Webber
About 1790
Height 25.1cm
J.A. Tulk Bequest, Circ.732–1956

**Pair of busts of Louis XVI
and Marie Antoinette,
King and Queen of France**
Soft-paste biscuit porcelain
France, Sèvres porcelain factory
Louis XVI modelled by Louis-Simon
Boizot (1743–1809) 1785
About 1788
Mark: Louis XVI incised 'LR 15'
(for Josse-François-Joseph
Le Riche (1741–1812), in his capacity
as Director of Sculpture)
Height 37.5 and 40.7cm
C.367&A-1983

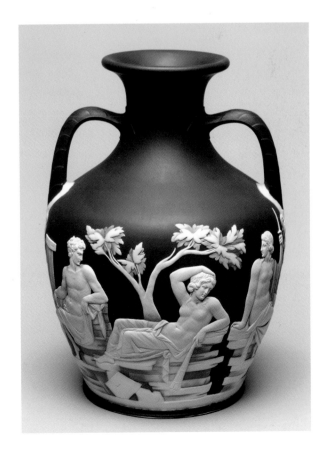

Jar

This robust and heavily potted jar, boldly painted with a magnificent scaly dragon chasing a flaming pearl, shows Chosŏn dynasty potting at its most vigorous best.

During the fifteenth century, there was a shift in Korea from green-glazed ceramics to white wares, with porcelain coming to enjoy popularity and prestige (both the green celadons and the white porcelains having close connections to Chinese wares). Pictorial decoration on large porcelain jars and bottles mainly took the form of animal and plant designs. For much of the long Chosŏn dynasty, from 1392 to 1910, cobalt blue was the favoured colour for decorating pots of all kinds. The cobalt oxide for this underglaze decoration was initially imported from China, but later a native supply was located, mined and widely used. However, in periods of economic hardship, when cobalt was in short supply, potters used iron compounds to produce a brown pigment. In addition to dragons, bamboo, prunus and grapevine designs are found on brown-decorated Korean wares.

Large jars like this one may have been used to store wine or to hold flowers. The dragon is a potent creature in East Asia, an emblem of regal authority and of masculine vitality. Substantial jars with dragons bestriding their shoulders became a favourite ceramic type in Korea. In keeping with the convention that the dragon is a rain-bringing creature, curving, stylized clouds are painted above and below the beast's body. Despite their imposing presence and supernatural powers, dragons are usually depicted as humorous creatures. This example has a slim body, protruding eyes and eyelashes, and a startled expression. BM

Chamber set of jug and basin

With its bold and heavy Grecian-inspired forms, bands of stiff Egyptian lotus leaves and hot 'Etruscan' or 'Pompeian' palette, this very large and thickly moulded chamber set is quite exceptional for English ceramic design around 1810. It is, in fact, much closer to Regency silver and furniture design than to mainstream ceramic production at that time – the reason being that it was almost certainly designed by the great Regency furniture designer, sculptor and upholsterer George Bullock, and was probably intended to complement furnishings supplied by him. Bullock designed similar creamware chamber sets for the use of Napoleon and his officers in exile on the South Atlantic island of St Helena in 1815. Interestingly, those originally intended for the defeated emperor's personal use were never sent to the island, as the painted leaf decoration was considered too 'redolent of the victor's laurels'.

Made 30 years or so before the Gothic Revival architect A.W.N. Pugin's first collaboration with the great Stoke manufacturer Herbert Minton, Bullock's chamber set is among the earliest examples of architect-designed pottery or porcelain wares made anywhere in Europe. It dates from the final period of the manufacture of creamware, the earthenware body that Josiah Wedgwood perfected in the 1760s (see p.106). The basin is one of the largest pieces of creamware in existence. HY

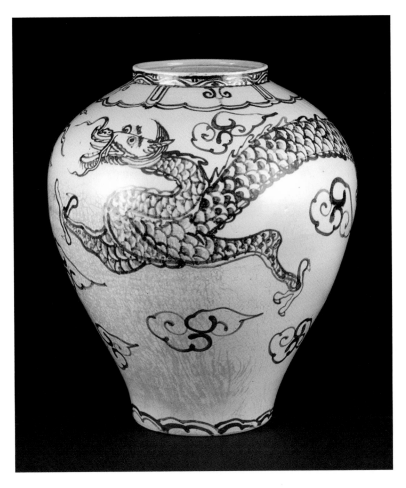

Jar
Porcelain, painted in underglaze brown
Korea
1600–1800
Height 35cm, diameter 31.5cm
C.356–1912

Chamber set of jug and basin
Creamware, painted in enamels
England, Staffordshire (possibly Enoch
Wood & James Caldwell's factory)
Designed by George Bullock (died 1818)
About 1808–15
Jug: height 31.7cm;
basin: diameter 52.2cm
Purchased with funds provided by the
Contributing Members of the V&A,
C.44:1, 2–2005

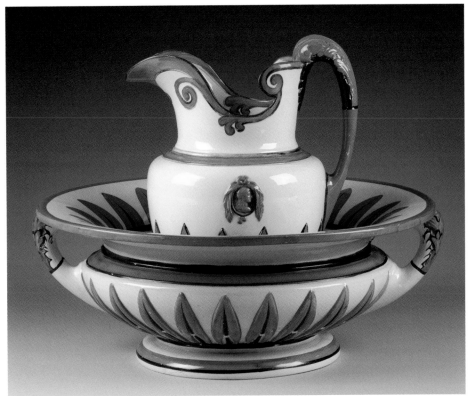

'Polito's Menagerie'

This splendid mantelpiece ornament is probably the most celebrated and certainly the most elaborate of early nineteenth-century Staffordshire figure groups. It represents a high point in quality and elaboration of those models made for a wide market before makers increasingly concentrated on the very much cheaper 'flatbacks' (figures with only rudimentary details on the reverse, made using fewer and simpler moulds). Although made of earthenware, an inexpensive material, all the figures and architectural components would have been formed in separate two-part moulds, then carefully assembled by a 'repairer' (see p.104) before firing and decoration with painted and sponged enamels, so the group would have been relatively costly to produce.

The subject is the entrance of one of the famous travelling menageries of Stephen Polito. Polito was briefly the owner – between 1810 and 1814 – of Britain's most celebrated menagerie, which had been established by the self-styled 'modern Noah' Gilbert Pidcock in the Strand, London. Polito's family continued to tour and exhibit animals under the Polito name during the 1820s and 1830s, chiefly abroad. The banner may show the elephant Chunee, Pidcock's star attraction, which was admired by Lord Byron but which killed his keeper and was destroyed in 1826. HY

Thirty gallon jug

Although massive and not intended for use, this tour-de-force of Staffordshire pottery illustrates one of the archetypal products of nineteenth-century British pottery: blue-and-white transfer-printed earthenware.

Transfer-printing was first perfected in England in the early 1750s. The process usually involved engraving a design onto a copperplate, printing the design onto a medium of transfer (either paper or a thin sheet of gelatin known as a 'glue bat'), laying the transfer onto the ware to be decorated and finally employing one of a number of methods of transmitting the design and pigment onto the ware. At best, the technique had the advantage of reproducing a high-quality design at relatively low cost per unit.

The English potters' first successes were with printing onto glazed wares (see p.106), but within a few years the Worcester porcelain factory had made the crucial breakthrough of devising a means of printing in underglaze blue onto biscuit porcelain, initially in order to compete with imported Chinese painted wares. Cobalt blue had long been used in China, because it was one of the few pigments that could survive the heat of the glaze firing and it could therefore be used under the glaze, which protected the decoration from wear. Underglaze printing in blue proved a cheaper and less exacting method of decorating than the on-glaze technique, and it was widely adopted for decorating inexpensive earthenwares. This development transformed the Staffordshire industry and the market for pottery worldwide, as decorative and utilitarian Staffordshire blue-printed wares were made in vast quantities throughout the nineteenth century and were exported all over the globe. HY

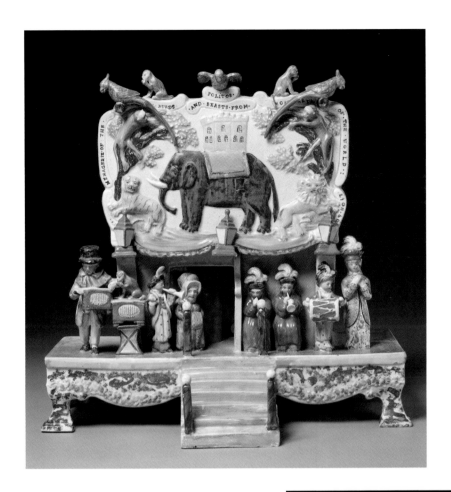

'Polito's Menagerie'
Earthenware, painted in enamels
England, Staffordshire
About 1830
Height 32cm
Purchased through the Julie and
Robert Breckman Staffordshire Fund,
C.128–2003

Thirty gallon jug
Lead-glazed earthenware, transfer-
printed in underglaze blue
England, Bourne, Baker & Bourne's
factory, Staffordshire
About 1830
From the London showrooms of
Messrs Neale & Bailey
Height 70.5cm
Given by Mrs Illidge, 53–1870

Plate

Bearing the medieval French motto 'Souveigne Vous de Moy' ('Remember me'), this plate was the result of a creative partnership between the architect, writer and designer A.W.N. Pugin and Herbert Minton (1793–1858) of Minton & Co. – a collaboration that embraced innovations in both manufacture and design and which had already resulted in a series of encaustic floor tiles. Pugin was one of the main exponents of the Gothic Revival style in England and is perhaps best known for his work on the interior of the Palace of Westminster, London, while in terms of design and technical innovation, Minton's was undoubtedly the leading ceramic firm in mid-nineteenth-century Britain.

In 1848, a technique for multi-colour printing on ceramics was patented by F.W.M. Collins and Alfred Reynolds, based on methods pioneered by the printmaker George Baxter. Both Pugin and Minton were quick to see the advantages of the new process. This involved printing onto a sheet of paper in sequence and 'in register' from a set of printing plates (one for each colour), and this was then used to transfer the design to the ceramic ware. Unlike earlier transfer-printing techniques, block-printing, or 'New Press' as it came to be known, allowed the printing of solid areas of colour, so was particularly suited to the complex flat-pattern designs that were such a strong component of Pugin's Gothic style.

Displayed in the Medieval Court of the Great Exhibition of 1851, this plate exemplified the new printing technique as applied to tableware and demonstrated the Gothic style's potential for use in the domestic sphere. ss

'Alhambra Vase'

This impressive vessel is a faithful replica of the 'Gazelle Vase', the most famous of the so-called 'Alhambra Vases' and the only one of the 10 surviving jars to be recovered at the hilltop site of the Alhambra in Granada in southern Spain (see p.52). These magnificent and highly ornamented jars were probably made at Málaga in the fourteenth and early fifteenth centuries, under the patronage of the Nasrids of Granada (1238–1492), the last Islamic dynasty to rule in Spain.

The palaces of the Alhambra were much visited and studied by European scholars, artists, restorers and travellers during the early nineteenth century, and this sparked a craze for 'Alhambresque' design. The products of the Parisian factory founded in 1859 by Joseph-Théodore Deck reflected this taste and conformed to a wider European aesthetic for decorative wares designed after 'Oriental' models. Deck became the foremost French ceramic artist of his day and burst onto the international exhibition scene with a number of prize-winning exhibits, of which this vase, made in 1862, was one.

Deck probably collaborated on the design with Baron Jean-Charles Davillier, who had published his *Histoire des Faïences Hispano-Moresques à reflets métalliques* in 1861. Davillier took photographs and tracings of the original jar in its storeroom at the Alhambra, and Deck may have based his design upon these. Deck's vase is slightly smaller than the 'Gazelle Vase'. He replaced the wing handle missing from the original and used a darker blue for the background, but did not attempt to copy the lustre, since this technique was not successfully revived until about 1870. MRO

'Alhambra Vase'
Earthenware, inlaid with coloured clays
and painted
France, Paris
Joseph-Théodore Deck (1823–91)
1862
Mark: 'TH. DECK 1862' painted
Height 103cm, maximum width 51cm
Shown at the International Exhibition,
London, 1862, and bought from the
maker, 18-1865

Plate
Bone china, with transfer-printed
decoration
England, Minton & Co., Staffordshire
Designed by A.W.N. Pugin (1812–52)
About 1851
Marks: '10' impressed
Diameter 22cm
Purchased from the Great Exhibition,
London, 1851, 460–1852

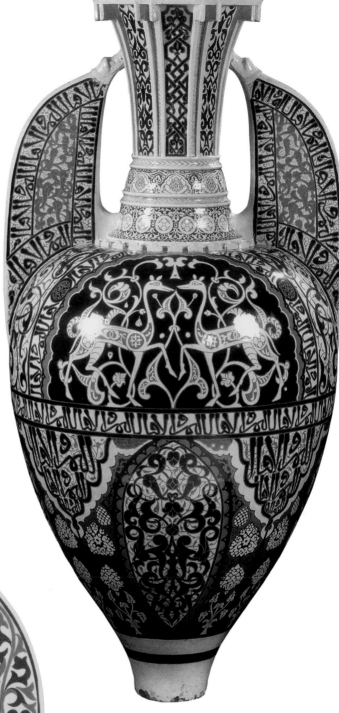

Coffee pot

The second half of the nineteenth century witnessed a series of international exhibitions displaying fine and decorative art from around the world in a rich and competitive environment. Rivalry between England and France, regarding the content and success of such exhibitions, was particularly rife, as nations strove to establish a pre-eminent reputation in design and methods of manufacture.

This piece was displayed by the French national factory Sèvres at the International Exhibition held in London in 1862, when it was described as a coffee pot. Of 'Oriental' inspiration, the elephant shape demonstrates the fantastical imagination of the designer and decorator Marc Louis Solon, the piece being a wonderful combination of humour and artistic excellence. It features the pâte-sur-pâte technique, which involved building up low sculptural relief on the surface of an unfired pot with successive layers of slip – a technique that Solon was later to bring to the Staffordshire factory of Herbert Minton. Ceramics featuring pâte-sur-pâte gained great popularity in both France and England and were expensive, luxury items. This coffee pot employs the technique in delicate moderation to highlight the form of the elephant's face.

Soon after its foundation in 1740, the Sèvres factory established itself as one of the greatest porcelain factories in Europe. Initially catering to the tastes of the French court, the factory maintained a reputation for opulence throughout the nineteenth century. In the 1750s it produced the popular 'Elephant Candelabra Vase', designed by Jean-Claude Duplessis (died 1783), and has since used the elephant, a symbol of magnificence and luxury, as the inspiration for the design of a number of ornamental wares. ss

Ewer and stand

This massive and ambitious ewer and stand is one of Minton's most imposing exhibition pieces and was shown at the International Exhibition in London in 1862. It exemplifies the use, in Victorian design, of a number of historical sources in combination with the latest nineteenth-century ceramic techniques. Originally intended for hand-washing before a meal, ewer and basins were display pieces indicative of wealth and status by Renaissance times, but their forms were revived here in order to demonstrate Minton's excellence of design and command of the new 'majolica' glazes.

The Minton company pioneered the development of majolica glazes, and the materials and processes were perfected by the art director, Joseph François Léon Arnoux (1816–1902), in 1849. These were based in part on Italian Renaissance maiolica and Bernard Palissy's pottery (see pp.64 and 72), but whereas maiolica pigments are painted onto a raw tin glaze (which fired to an opaque white), Minton's majolica, like Palissy's pottery, used brightly coloured semi-transparent lead glazes applied to the biscuit-fired body. Much of commercial majolica production was naturalistically modelled with broad treatment of colour, but this ewer and stand, expressly made to demonstrate the medium's potential, is mannerist in sculptural style and very finely painted onto the biscuit body, with designs taken from sixteenth- and late seventeenth-century sources. In terms of contemporary taste and usage, majolica suited the imposing interiors of Victorian houses and appealed to the antiquarian and sentimental interest in the past. ss

Coffee pot
Porcelain, with pâte-sur-pâte
decoration and gilt
France, Sèvres porcelain factory
Designed and decorated by
Marc Louis Solon (1835–1913)
About 1862
Marks: 'Decore N Sevres' and '62'
beneath a crown, printed, and
with indistinct incised marks
Height 19.7cm,
maximum width 16.6cm
Purchased at the International
Exhibition, London, 1862, 8055–1862

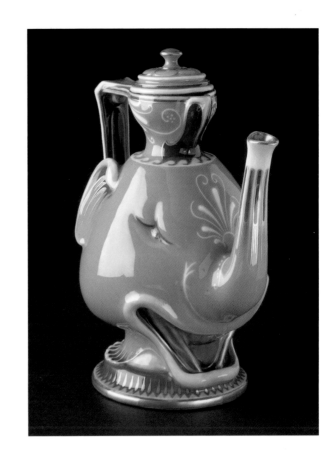

Ewer and stand
Earthenware, with underglaze painting
and majolica glazes
England, Minton & Co., Staffordshire
Designed by Pierre-Emile Jeannest
(1813–57) and painted by Thomas Allen
(1831–1915)
About 1862
Mark: 'MINTON' impressed on stand
Ewer: height 71cm;
stand: width 10.6cm, length 61.7cm
Purchased at the International
Exhibition, London, 1862,
8107&A–1863

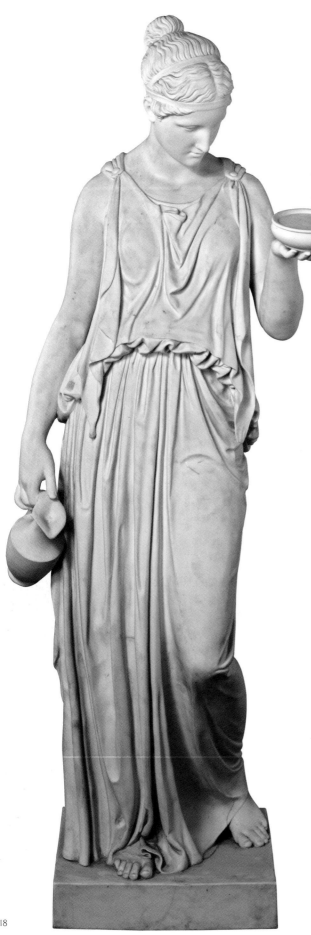

Figure of Hebe

This exceptionally ambitious life-size sculpture is thought to be the largest porcelain figure ever made in a single piece. It represents Hebe, the goddess of youth in Greek mythology and cup-bearer for the gods, and was modelled after a statue carved in Rome in 1816 by the Danish artist and collector Bertel Thorvaldsen, one of Europe's leading sculptors working in the neo-classical style. By the 1870s, when this figure was made, the demand for biscuit porcelain figures after famous statues was well established in Europe. Unglazed and white, biscuit was an ideal medium for the reproduction of sculptures and had maintained a steady popularity since its introduction at Vincennes, France, in the mid-eighteenth century.

The Danish factory of Bing & Grøndahl (founded in 1853) concentrated on fashionable and popular wares for an expanding middle-class market, producing sculptural ceramics in the classical or Renaissance style, in keeping with the European taste for historicism. A popular staple of the Danish porcelain industry in the nineteenth century, Thorvaldsen biscuit replicas also reached the international market. They could be made in series, relatively inexpensively, and thus sold to a much wider public. Bing & Grøndahl manufactured this figure of Hebe in three different sizes. The two smaller sizes were first produced in 1862, and this version, which has the same dimensions as Thorvaldsen's original, is believed to be the only example in this size. It was made for the International Exhibition of 1871, held in London, and was probably intended as a unique showpiece. ss

Figure of Hebe
Biscuit porcelain
Denmark, Bing & Grøndahl's factory, Copenhagen
Modelled by C.O.A. Schjeltved after Bertel
Thorvaldsen (1770–1844)
1871
Height 137.5cm, width 54cm
Given by Her Majesty's Commissioners,
Misc.124–1921

Vase

Essentially, this large and complex vessel is a container with nine cups attached – one forming the cover, four surmounting handles attached to the body and a further four attached directly to the body itself. It is a fantastical blend of the robust and the delicate, with a sturdy thrown body and intricately applied decorative detail, every petal and every leaf being individually cut and modelled. It was made to demonstrate the potter's virtuosity and was almost certainly not intended for use. The complex ornate nature of this piece is typical of Spanish vernacular art. The design appears to follow a traditional Spanish form, as a very similar shape is shown in use as a flower pot in an allegory of smell by an anonymous seventeenth-century Spanish painter. Unglazed pottery was a traditional material for water vessels in Spain and other Mediterranean countries, as it permitted evaporation and so cooled their contents.

The vase was purchased for the South Kensington Museum in 1872, probably direct from the potter who made it, as an example of contemporary crafts. It was acquired through the services of the eminent writer, collector and politician Juan Facundo Riaño, who was a key figure in Spain's nineteenth-century re-evaluation of traditional Spanish arts and crafts. Based in Madrid in the 1870s, Riaño was one of the Museum's art referees (scholars and connoisseurs employed to recommend acquisitions for the Museum's collection). ss

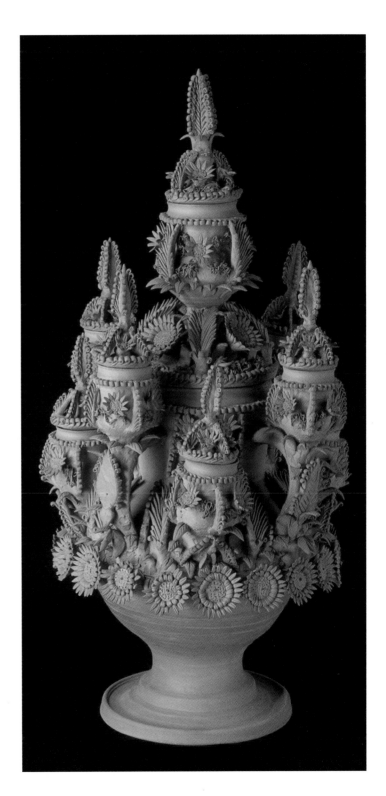

Vase
Biscuit earthenware
Spain, probably Guadix, Granada
1872
Height 57.5cm, width 32cm
981A to J–1872

Jar

This massive jar with its dramatically streaked glaze is typical of the kind of rustic pottery admired by Yanagi Sōetsu (1889–1961), the philosopher-critic who founded the Japanese Mingei (folk-craft) movement during the 1920s. The energetic promotion of rural ceramics by Yanagi and his circle (see p.130) came at a time when Japan was undergoing rapid industrialization, urbanization and modernization. Mingei represented a major reassessment of cultural and social values, prompted by the same problems that had given rise to the Arts and Crafts movement in late nineteenth-century Britain.

The 'true beauty' that Yanagi 'discovered' in the ceramics and other folk crafts he collected was seen as the result of their having been made by craftsmen working in close proximity to nature, using simple techniques and traditional styles, and living within small and harmonious communities without concern for capitalistic gain. A distinction was drawn between such folk crafts and both mass-produced objects and those made for elitist consumption. With mass-produced objects, the maker was felt to be too far removed from the making process to be able to contribute to the 'inner' quality of the product. Elite objects, on the other hand, were criticized for the way they reflected the self-consciously directed ambitions of their makers, which were lower by definition than the selfless and non-individualistic activities of the 'unknown craftsman'. They were also regarded as inferior because of their essentially decorative rather than – as is the case with this jar – utilitarian nature. ss

Vase

Japan's Meiji period (1868–1912) was characterized by a dynamic programme of modernization combined with active cultural and economic engagement with the West. Ceramic production, which was already widespread by the middle of the nineteenth century, flourished under the new governmental drive to compete with western industrialized nations. This included the employment of western advisers, notably the German chemist Gottfried Wagener (1831–92), and the introduction of modern technology.

Miyagawa Kōzan (1842–1916) was one of the leading potters of his time. He demonstrated great versatility and technical innovation, and achieved considerable commercial success. Born into a potting family in Kyoto, he continued in the family business until 1871, when he established his own workshop at Ōta, near the newly opened port of Yokohama. The Makuzu kiln was highly productive, catering to both domestic demands and the expanding western export market.

With its extraordinary high-relief decoration, this vase is a classic example of Japanese export ware aimed at the more extreme end of high Victorian taste. Although it would have been new when it was bought by the Museum in 1879, curatorial understanding of Japanese ceramics was extremely limited at that time and it was initially catalogued as dating to the eighteenth century. ss

Jar
Glazed stoneware
Japan, Tsutsumi kilns
19th century
Height 61.8cm, width 53cm
FE.15–1985

Vase
Stoneware, with crackled cream glaze
and high-relief modelling
Japan, Ōta (Yokohama), Makuzu
(Miyagawa Kōzan) workshop
About 1875
Height 60cm, diameter 45.6cm
308–1879

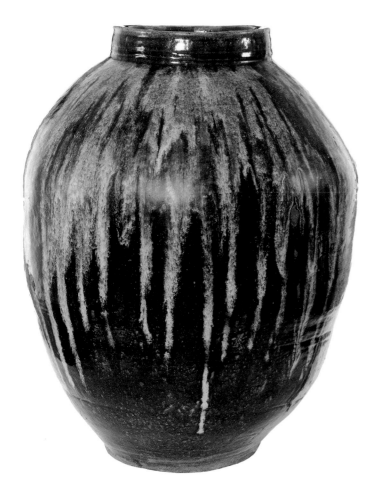

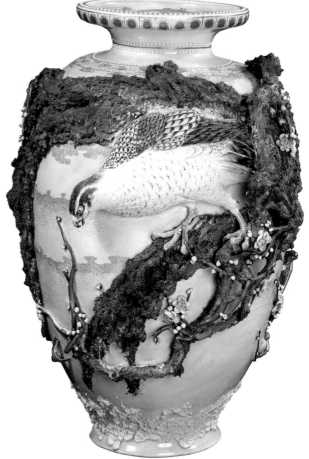

Jar

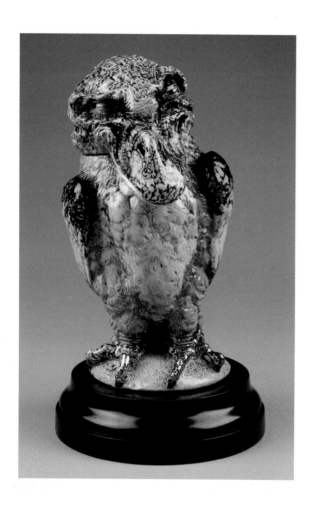

Jar
Salt-glazed stoneware, with turned-wood stand
England, Southall, Middlesex
Made by the Martin Brothers
1887
Marks: 'R.W. Martin & Brothers London & Southall 1 1887' and 'R Wallace Martin Sc Southall 87' incised
Height 30cm, width 14cm, diameter of plinth 17.4cm
Given by Alfred R. Holland, Esq., C.1151&A–1917

If Martin-ware [... has] not the transparency of porcelain nor the elaborately and costly ornamentation of Sèvres [it is] pure and honest art work.

This is how the art critic Cosmo Monkhouse described the output of the Martin Brothers' studio in *The Magazine of Art* in 1882. Eccentric founder Robert Wallace Martin and his siblings Charles, Walter and Edwin epitomized the energy and experimentation of the nineteenth-century art pottery movement. They regarded pottery as a means of artistic expression, rather than a product of industrial manufacture, and were particularly inspired by the naturalistic and rustic flora and fauna forms of the sixteenth-century potter Bernard Palissy (see p.72).

This jar is typical of the Martin Brothers' grotesque and eccentric stonewares and demonstrates a unique blend of fantasy and imagination. The function of these anthropomorphic lidded wares, which were produced in many different shapes and sizes, is unclear. They have been called 'tobacco jars', since Monkhouse used this term, but they are not airtight and the interiors are not finished to a standard fit for storage, suggesting an essentially ornamental and aesthetic purpose.

The Martin Brothers drew upon an eclectic range of sources for their work and it is possible that these jars were inspired by traditional English owl-shaped pottery jugs. Martin-ware birds are not of any known species, and in many examples the lidded heads are made to swivel on the body, further enhancing their irregular form, which evades both meaning and classification. ss

Vase

Sculptural and dramatic, this monumental stoneware vase exudes the new spirit of the ceramics of late nineteenth-century France. A virtuoso potter, Delaherche explores the boundaries of control, exploiting the unpredictable effects of glazes in extreme kiln conditions. Radically different from the deliberate controlling methods of other contemporary art potters, he represents a fundamentally new approach to the making of ceramics.

Prior to the 1870s, stoneware – in France at least – had largely been used for basic functional wares and appeared to have little merit for artistic expression. Its reappraisal was due in part to the growing interest in traditional crafts and local materials, including the stonewares of Delaherche's native Beauvais. But more significant, perhaps, was the influence of traditional Japanese Seto and Bizen wares (see p.74), which were exhibited in Paris in 1878. In addition to the stoneware body itself, Japanese ceramics prompted a looser aesthetic and an interest in organic forms, as exemplified here.

Like porcelain, stoneware provided a suitable vehicle for the spectacular high-temperature glazes, including the copper-based *flammée* reds, that so fascinated Delaherche and his contemporaries. Derived from Chinese court porcelains of the eighteenth century, their recipes were generally closely guarded secrets, and their creation acquired almost mythic status. Principal among the exponents of these high-temperature glazes was Ernest Chaplet (1835-1909), whose Paris workshop Delaherche took over in 1887. Probably made there in the early 1890s, this vase shows Delaherche at his most impressive, paring sculptural forms to a minimum and allowing the glaze effects to take centre stage. AG

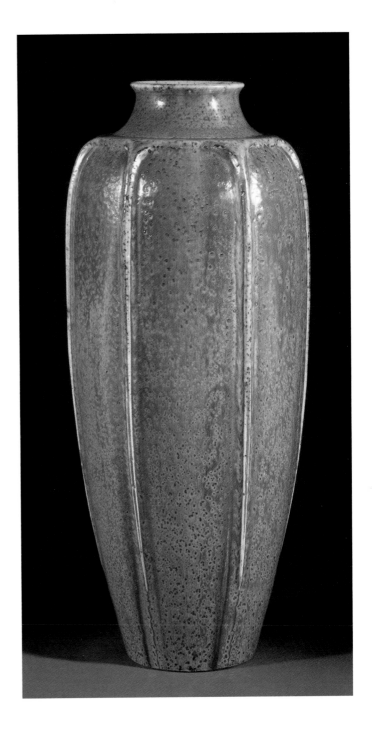

Vase
Stoneware, with a high-temperature
flammée glaze
Made by Auguste Delaherche
(1857–1940)
France, Paris (Rue Blomet, Vaugirard)
About 1890–92
Marks: 'AUGUSTE DELAHERCHE'
within a circle and '6016', all impressed
Height 66.5cm, diameter 30cm
1613–1892

Figure from a table setting

Vase

This figure conveys, in ceramic form, the movement and energy of dance and typifies the spirit of Art Nouveau style. It originally formed part of a group of 15, entitled 'Jeu de l'Echarpe' ('Scarf Dance'), and was inspired by the sensational dance performed by the American Loïe Fuller, a regular fixture at the Folies Bergère, Paris. The form of the free-flowing, silk-clad dancer was employed as early as 1893 in an iconic lithograph by the French artist Henri Toulouse-Lautrec, and the elegant theatricality of this Sèvres figure group further established the motif in turn-of-the-century Parisian art.

The group was designed by Agathon Léonard in 1898 and displayed at the Universal Exhibition in Paris in 1900, where Sèvres won a prize. The success of the figures, described in the exhibition report as 'a graceful and charming ensemble which were a great and deserved success', followed the adoption of a consciously progressive art policy at the factory, part of a national move towards the regeneration and celebration of French craft skills and design. The figures were produced by Sèvres in many editions and were also copied in bronze and porcelain by other factories.

Biscuit porcelain, of which this figure is made, was a material developed and pioneered by Sèvres in the mid-eighteenth century. It continued in popularity throughout the nineteenth century, as it was well suited to the popular classical forms of that period. Although porous and easily stained, biscuit porcelain was much used for table decoration during the eighteenth and early nineteenth centuries, particularly at dessert. ss

The output of the short-lived and modest factory of Rozenburg, in The Hague, includes some of the most powerful examples of ceramics in the Art Nouveau style, which is typified by elongated organic shapes and sinuous, curling designs.

Established in 1883, the Rozenburg factory blossomed under the art director J. Juriaan Kok, who took up the post in 1895. Working with the chemist M.N. Engelen, in 1899 he introduced a delicate ceramic product, *Eierschaalporselein* or 'eggshell porcelain', which is almost identical in composition to English bone china. This was launched at the Paris Universal Exhibition the following year. It can be very thinly potted into flamboyant shapes by means of the slip-casting technique and displays a highly translucent pale ivory hue.

The brittleness of the ware is enhanced by Kok's elegant design, resulting in pieces that combine form and pattern, fragility and bright vibrant colour. This vase is typical of the faceted style of Kok's work, which synthesizes angular and rounded forms. The decoration, executed by highly skilled painters, owes a debt to French and Belgian Art Nouveau, and Kok's effective use of blank space recalls Japanese principles of design.

The success of the Rozenburg factory was, in large part, dependent upon the vision of its art director. Kok left the firm in 1913 and production ceased the following year. ss

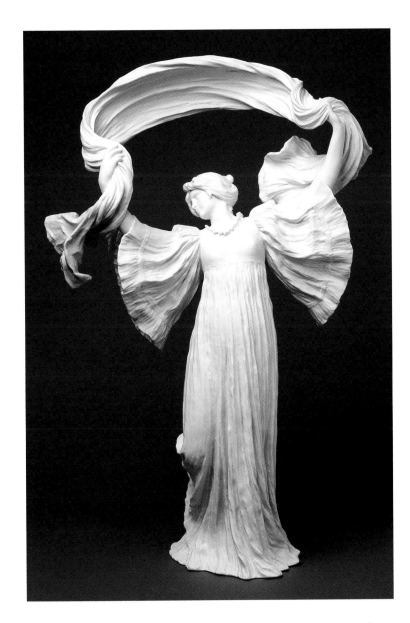

Figure from a table setting
Biscuit porcelain
France, Sèvres porcelain factory
Modelled by Agathon Léonard
(born 1841)
Designed 1898; this set dated 1904
Marks: 'S' and '1904' in triangle,
'No 12' under base, '4' and back-to-
front 'R' at base, all incised
Height 54cm,
maximum width 35.5cm
C.89A–1971

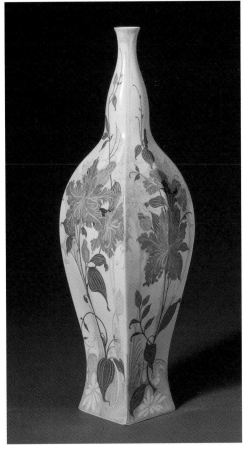

Vase
Bone china, painted in enamels
Netherlands, Rozenburg porcelain factory,
The Hague
Designed by J. Juriaan Kok (1861–1919),
painted by J. Schellink (1876–1958) and
J.M. van Rossum (1881–1963)
1904
Marks: transfer-printed stork factory mark
with 'Rozenburg den haag', 'JS.' monogram
and flag date mark for 1904, painter's mark
for J. Schellink and a quartered square and
'696' painted in black
Height 32cm, width 10.3cm, depth 10.3cm
C.41–1972

Figure group: 'Dame mit Hündchen' ('Woman with Dog')

Plate: 'The Bellringer'

Germany was the cradle of porcelain production in eighteenth-century Europe and had maintained a strong tradition of its manufacture throughout the years that followed. During the Art Nouveau period, from about 1885 to 1910, the artistic quality of its porcelain was revived, strengthening the country's position within the international market. Concentrating as it did on luxury goods involving a great deal of hand-work, the porcelain industry was inherently traditional in aspirations and organization. Much as in the eighteenth century, modellers were either freelance, working to commission, or permanent employees. In the late 1910s and 1920s, German modellers increasingly turned their attention to decorative figurines, the contemporary stylization of which reflects the use of a popular, commercial modernism within a more or less traditional framework – a combination that was typical of the Art Deco style as a whole.

When the modeller Paul Scheurich approached the Nymphenburg factory in 1916, he had already designed a number of figures for Meissen. At Nymphenburg, however, he was so overwhelmed by the beauty and refinement of the figures modelled for the factory by Franz Anton Bustelli (see p.103) that he decided to work in the spirit of the eighteenth-century master, while striving to achieve an entirely contemporary style. The result was a pair of figures of elegant ladies in contemporary dress, showing, for the first time, his mature style and showcasing his great modelling skills. With their subtle refined mannerism, they are closest to the rococo tradition, but display twentieth-century stylization and an unmistakably personal touch. They were sold both undecorated and painted in colours. RL

The phenomenon of Russian Revolutionary porcelain is curiously paradoxical. The Revolution might have been expected to sweep aside a commodity as inherently luxurious as fine porcelain, yet as the People's Commissar for Enlightenment, Anatoly Lunacharsky, later reflected, 'One can only be amazed at the care, one might even say tenderness, shown by the great Revolution in protecting artistic valuables, including this, the most fragile and easily destroyed of all.'

Under the Revolution, the former Imperial Porcelain Factory was set to serve the new state and was placed under the control of Lunacharsky's Commissariat responsible for the arts. The factory's role was to assist in the agitation for change through the production of propaganda. Despite material shortages and horrendous working conditions, the factory witnessed an incredible outpouring of creativity involving the most radical and avant-garde artists of the day.

The Revolutionary porcelains were luxury items, made for display, but were decorated with slogans and propagandist images in a variety of styles with subjects from daily life, folklore and traditional art and costume. Outstanding among the young artists working at the factory was Alexandra Shchekotikhina-Pototskaya, whose work drew on Russian icons and folk art traditions. Her design for this plate depicts a figure ringing the bells in celebration of the 8th Congress of Soviets. Bold and vibrant, the disposition of her design ignores the usual conventions of ceramic decoration, adding to its radical impact. Like many Revolutionary wares, it was painted on an undecorated 'blank' from pre-Revolutionary times, and bears both an Imperial Porcelain Factory mark and the hammer, sickle and cog of the State Porcelain Factory. AG

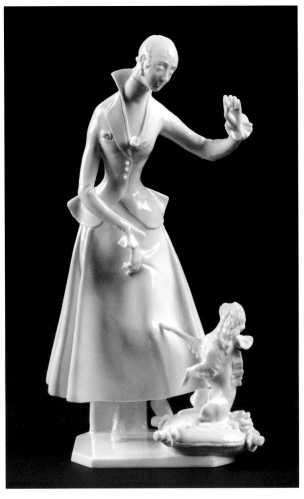

Figure group: 'Dame mit Hündchen'
('Woman with Dog')
Porcelain
Germany, Nymphenburg porcelain
factory, Bavaria
Designed and modelled by
Paul Scheurich (1888–1945)
Designed and modelled in 1916
Marks: 'Scheurich' and factory mark
of Bavarian arms impressed, with
model number '546' and unknown
mark '3' incised
Height 21.5cm, width 13.3cm
C.21–1955

Plate: 'The Bellringer'
Porcelain, painted with enamel colours
and gilded
Russia, St Petersburg
Designed and possibly painted by
Alexandra Shchekotikhina-Pototskaya
(1892–1967); decorated at the State
Porcelain Factory, using an earlier blank
made by the Imperial Porcelain Factory
Designed 1920; decorated 1921 using a
blank made 1911
Marks: Imperial Porcelain Factory
mark with '1911' in underglaze green,
State Porcelain Factory mark and '1921'
painted in blue, Cyrillic inscription:
'Long Live the 8th Congress of Soviets'
Diameter 28.5cm
C.250–1991

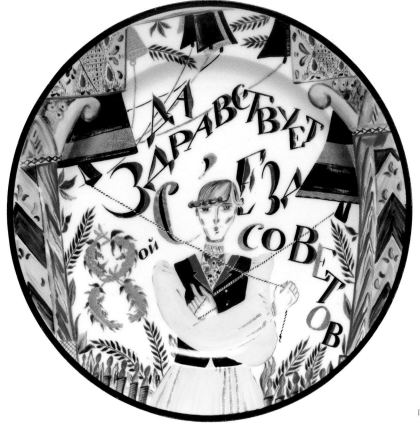

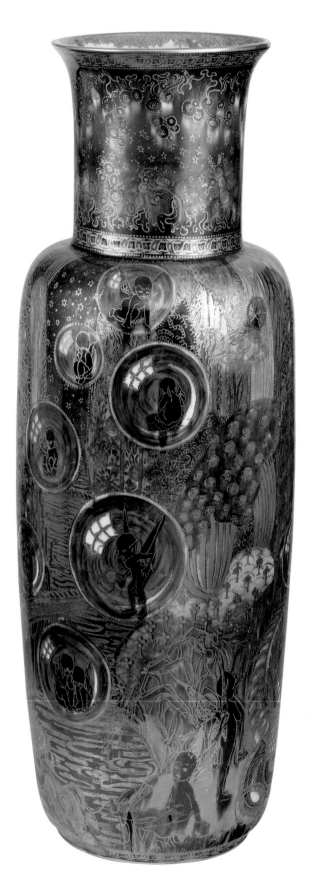

Vase with 'Bubbles' pattern

The vivid, fantastical landscapes of Wedgwood's Fairyland lustre, populated by elves and sprites, demons and dragons, as well of course as fairies, achieve a decorative intensity almost without rival. Complex and sophisticated, and a technical tour de force, they were the creation of Daisy Makeig-Jones.

At the time of their introduction in 1916, and despite the war in Europe, Wedgwood was regaining ground following the trading slump of the turn of the century. An emphasis on progressive design and the reintroduction of hand-painted tablewares had helped to secure its position as a design leader, while the active development of the American market had improved its trading position. In this continued recovery, Makeig-Jones's lustre range played a significant role, enabling them to capture a substantial share in the market for high-class china 'fancies', or ornamental wares.

Both the shapes of the Fairyland wares and the density of painted and gilt decoration derive from Chinese porcelains of about 1680–1720. Their rich colouring, however, was inspired in part by the colour and spectacle of the Russian Ballet, which Makeig-Jones witnessed in 1911. Wedgwood used a complex layering of underglaze colours, overglaze lustres and gilding to produce Fairyland's luminous surfaces with their illusion of depth.

In her depiction of folklore and fairies, Makeig-Jones followed a popular fashion, led by Arthur Rackham and Edmund Dulac, and borrowed freely from the wealth of contemporary books illustrating fairy stories. In the decoration of this vase, she sets her fairy figures in a scene inspired by stories of the Buddhist deity Kwannon and the Japanese goddess Benten, who protected children from a dragon. AG

Vase

Vase with 'Bubbles' pattern
Bone china, printed and painted in
underglaze colours, with lustre glazes
and gold print
England, Josiah Wedgwood & Sons,
Etruria, Staffordshire
Designed by Daisy Makeig-Jones
(1881–1945)
In production 1920–41
Marks: printed factory marks with
painted pattern number 'Z5257'
and shape number '2409' incised
Height 54cm, diameter 19.5cm
Given by Suzanne and Frederic
Weinstein, C.90–1988

Vase
Stoneware with crackled glaze,
painted in enamels and lustre
Designed and decorated by René
Buthaud (1886–1987) and fired at
his workshop
France, Bordeaux
About 1928–30
Mark: 'RB', in monogram, painted
in black
Height 24cm, diameter 25.5cm
C.292–1987

René Buthaud was among the leading exponents of
the Art Deco style in French ceramics. Popularized
internationally by the Paris International Exhibition of
1925, at which Buthaud showed examples of his work,
the new style reflected the spirit of the age. Typified by
a self-consciously modernistic approach to design, and
favouring simple and striking geometrical forms, Art Deco
was also characterized by a glamorizing taste for the
exotic and frequently absorbed stylistic influences from
around the world.

For Buthaud, African art held a particular fascination
and, in common with a number of other artists of the
period, he formed his own collection. In this, he was
assisted by his location in Bordeaux, then an important
trading port with links to the French colonies in West
Africa. The influence of African art is evident in the
decoration of this handsome stoneware vase by virtue of
the strong geometrical patterning, incorporating zigzags
and other motifs, that covers its surface. Another striking
element of its decoration is the intense craquelure, an
effect which Buthaud on occasion likened to snakeskin.
AG

Bottle

Hamada Shōji was one of the leading ceramic artists of the Japanese Mingei (folk-craft) movement. He was closely associated with both Yanagi Sōetsu (1889–1961), the philosopher-critic on whose theories the movement was founded (see p.120), and the pioneer English studio potter Bernard Leach (see p.134), with whom he worked as an assistant in St Ives, Cornwall, during the early 1920s.

The Mingei movement developed in early twentieth-century Japan as a social and aesthetic crusade. It held ideas in common with the English Arts and Crafts theorists John Ruskin and William Morris about the value of hand-work and the negative effects of industrialization and mass production. It actively sought to revive Japanese folk-craft traditions, which were becoming sidelined due to the forces of modernization and urbanization, and was part of a broader cultural movement in which Japan sought to articulate and assert a sense of national identity in the face of burgeoning westernization.

Like other members of the Mingei movement, Hamada was a great admirer of Korean ceramics of the Chosŏn period (1392–1910). This is apparent in the potting of this bottle, notably the faceting of its sides. Furthermore, although the off-white glaze was made from materials local to Mashiko, the pottery-making centre to the north-east of Tokyo where Hamada lived and worked, it has a serene and subdued quality reminiscent of Korean *punch'ŏng* wares, whose distinctive coloration was the result of applying clear glaze over a slip-covered stoneware body. Y-SC

Vase from the 'Argenta' range

The 1930 Stockholm Exhibition – at which Wilhelm Kåge's 'Argenta' range was launched – marked a significant moment for Swedish design. It set out to establish Sweden as major force in international design, and indeed did so, its displays of modern ceramics and glass gaining particular recognition. It was, however, also something of a turning point, with the graceful neo-classicist traditions that had come to characterize Swedish design giving way to the rise of functionalism.

Kåge, one of the most progressive and versatile ceramic designers of the twentieth century, joined the Gustavsberg firm in 1917. That year he designed a service intended to make well-designed tableware available to a wide market at reasonable cost. Known as the 'Worker's service', this exemplified a growing movement, particularly marked in Sweden, that promoted socially responsible design. Throughout his career, Kåge returned repeatedly to such questions of practicality and affordability in design, and produced kitchen and tableware ranges of intensely modernist character.

The 'Argenta' range was, however, aimed at a rather different market. Decorated with designs in silver inlaid into coloured stoneware, the pieces were luxurious and beautiful, and their production demanded highly skilled craftsmanship. This exceptional vase typifies the range, with its exquisite neo-classical figurative design, for which the robust simplicity of its shape, with its rich but uniform glaze, provides the perfect ground. AG

Bottle
Stoneware, with off-white glaze
Made by Hamada Shōji (1894–1978)
Japan
About 1931
Height 32.6cm, diameter 16.4cm
Given by the Contemporary Art
Society, Circ.348–1939

Vase from the 'Argenta' range
Stoneware, with a matt glaze and
inlaid silver decoration
Sweden, Gustavsberg
Designed by Wilhelm Kåge
(1889–1960)
Designed about 1930, made 1954
Marks: 'ARGENTA 979' painted in
silver, 'GUSTAVSBERG' and 'KÅGE',
with an anchor, and 'HANDDREJAD',
all impressed
Height 20.4cm, diameter 15cm
Given by A.B. Gustavsberg, C.129–1984

Part of a tea set

Coffee pot, cup and saucer, and cream jug from the 'Museum' service

Lucie Rie is among the most celebrated potters of the twentieth century. Her flaring bowls and vases – admired for the subtlety and delicacy of their forms – are among the most recognizable objects of post-war art and design.

Arriving in Britain as an émigrée from Austria in 1938, Rie was effectively obliged to start anew as a potter. Her earlier work in Vienna was little known and largely unappreciated in Britain, where Orientalist styles in studio pottery dominated. This, together with the subsequent success of her later work, has tended to obscure the importance of her Austrian period. Rie had, in fact, already achieved considerable success, forging a style that responded to continental modernism and betrayed an interest in the classical and archaic – including Roman pottery. Training at the Kunstgewerbeschule, Rie had links to the Wiener Werkstätte (literally 'Vienna Workshops') and gained the recognition of its leading designer, Josef Hoffman (1870-1956), who later showed 70 of her pots at his Austrian Pavilion at the International Exhibition in Paris in 1937.

This exquisite group of tea wares exemplifies Rie's early aesthetic. There is a simplicity to the forms, a sense of sculptural presence, and an emphasis on containment and interior space. Their clarity of design is reinforced by a concentration on the horizontal and vertical and the use simple geometrical forms, such as the tiny circular handles. The surface finish was inspired by Roman burnished redwares (see p.27). AG

Eva Zeisel's 'Museum' service is a landmark in the history of tableware. Commissioned by New York's Museum of Modern Art (MoMA), it was the first modern undecorated white porcelain service made in the United States and epitomizes the sophisticated organic styling that came to dominate post-war ceramic design.

Zeisel – who had worked as a ceramic designer in Germany and Russia, had been arrested and imprisoned for alleged involvement with an assassination attempt on Stalin, and had fled the Nazi regime in Austria – found herself in New York in 1938. There she established the first course in industrial ceramic design in the country and encountered Eliot Noyes, the director of MoMA's design department. Responding to the absence of ceramics in MoMA's 1940 exhibition *Organic Design in Home Furnishings*, the newly formed Castleton China Company asked the museum to recommend a designer to create a dinner service in the modern style. Noyes proposed Zeisel as designer for the service, which would be given MoMA's imprimatur and be launched there, subject to the museum's approval of the design.

Fundamental to the design of the service is Zeisel's belief in the expressive potential of forms, an approach that did not always sit comfortably with the museum's staunchly modernist agenda. Instead, Zeisel absorbed Emily Post's popular writings on American manners and attempted to find shapes that would echo such qualities as 'dignified', 'erect' and 'uplifted'. The forms she created did so admirably, rising elegantly from the table in lines that softened into curves. Though delayed by wartime restrictions, the service was finally launched in 1946. AG

Part of a tea set
Red earthenware, burnished
Made by Lucie Rie (1902–95)
Austria, Vienna
About 1936
Mark: 'L.R.G. WIEN',
painted in black
Teapot: height 18.8cm including handle
Given by Lucie Rie, C.34–1982

**Coffee pot, cup and saucer, and
cream jug from the 'Museum' service**
Porcelain
USA, Castleton China Company,
New Castle, Pennsylvania
Designed by Eva Zeisel (born 1906)
Designed about 1942–3; in production
from 1946
Marks: printed factory marks for
Castleton China
Coffee pot: height 25.7cm
Given by Castleton China Inc.,
Circ.161 to 163–1953

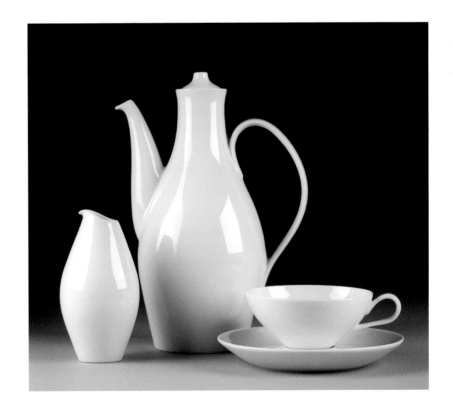

Vase: 'Artist at his Easel'

Vase

Picasso's work in clay has aroused a complex range of responses. Prejudice against the use of the material from those within the world of fine art, and against the idea of an untrained artist working in clay from factions within the studio pottery movement, led to what was in fact an extraordinary and significant part of his oeuvre being marginalized in some quarters. He first visited the Madoura pottery at Vallauris in the south of France in 1946 and went on to make over 4,000 works in clay, using forms produced for him as the basis for sculptural manipulation or as a three-dimensional surface for painting. The innovation and imagination inherent in these works – now fully recognized – had an important impact on ceramics in the 1950s, offering an alternative to the prevailing Orientalist canon and encouraging the use of painted tin-glaze decoration and the production of figurative work.

Produced in 1954, this particular vase is from a series of ceramics depicting the artist and his model. These follow a series of drawings on the same theme, in which Picasso parodied the effects of ageing, ultimately transforming himself into an 'Old Master' painter. The two scenes incorporated into the decoration of this vase continue this ploy: on one side, the artist as a young man works as a sculptor, modelling a figure before his standing female model, while on the other, the artist, now old and distinguished, is seen seated, painting at an easel. The shape of the vase, with its 'stirrup' spout, derives from South American pottery forms (compare p.28). AG

At the time this pot was made, Bernard Leach was probably 70 years old, having spent nearly half a century making pots and proselytizing about their manufacture. His work and example had altered the course of ceramics: the hand-making of pottery, once regarded as a rarefied and moderately eccentric activity, was now a widespread movement and a popular recreational pursuit. The acknowledged leader of the studio pottery movement, he was then producing some of the finest work of his career, and he had a further 15 years of potting before blindness finally forced an end.

Leach is, by any account, an extraordinary individual and a great artist. Having previously trained in etching, he first discovered pottery in 1911 while living in Japan. There, he encountered the progenitors of the fledgling Japanese folk-craft movement and became part of their circle, before returning to England in 1920 to found the Leach Pottery in St Ives. This relationship with Japan, which became part of his own mythology, fundamentally shaped his career.

This vase of about 1957 is characteristic of his best work. Rooted in the Orientalist canon that he himself had been instrumental in establishing – most particularly through his seminal *A Potter's Book*, published in 1940 – it draws particularly on the Song dynasty blackwares of northern China. A robust and vital thrown form, it exposes its stoneware body as a badge of honour, proclaiming the 'honesty' of its manufacture. Meanwhile, its energetic incised decoration demonstrates Leach's exceptional talent as a graphic artist. AG

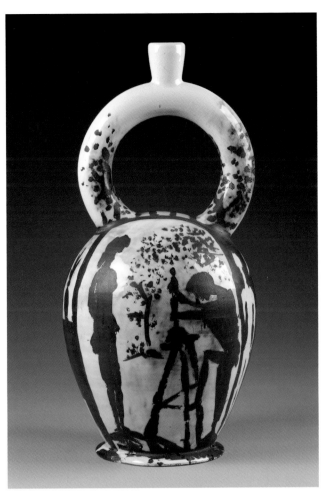

Vase: 'Artist at his Easel'
Tin-glazed white earthenware, with
wax resist and painted in oxides
Painted by Pablo Picasso (1881–1973)
France, Madoura Pottery, Vallauris
1954
Marks: 'MADOURA' impressed,
'2–89' painted in black and a further
impressed mark that has been
scratched out
Height 58.2cm, diameter 28.5cm
Allocated to the Museum in lieu of tax
by the Secretary of State for National
Heritage, C.109–1994

Vase
Stoneware, with tenmoku glaze and
incised decoration
Made by Bernard Leach (1887–1979)
England, Leach Pottery, St Ives,
Cornwall
About 1957
Marks: 'BL' and 'SI' in monogram,
impressed
Height 34cm, diameter 27.2cm
Circ.115–1958

Portrait plaque of Zhou Enlai (1898–1976)

Pot

Zhou Enlai was premier from the founding of the Chinese People's Republic in 1949 until his death in 1976. Although of photographic accuracy and reproducing the tonalities of a photograph, this portrait was actually painstakingly painted in enamels by the artist, Wu Kang.

The inscription reads: 'Jingdezhen Art Porcelain Factory, an attempt at portrait painting in the *fencai* style by Wu Kang', with the seal of Wu Kang reproduced at the bottom right. It is very rare for a Jingdezhen porcelain to be signed by the maker, the signature here being permissible because Wu Kang was considered an artist rather than a craftsman; he worked in the 'art porcelain factory' and featured in the *Register of Famous Porcelain Artists at Jingdezhen*, published about 1989. To be able to substitute the manual technique of painting for the mechanical process of photography is considered an 'art', and Wu Kang was praised for his ability to paint portraits that are very lifelike while at the same time bringing out the inner personality of the sitter. Implicit in such praise is an understanding that a photograph can depict only the appearance, not the spirit of a person. The 'fencai style' (literally 'powdered colours') mentioned in the inscription refers to a palette incorporating pink enamel, in this case only used subtly on the face of the sitter. Black is the predominant colour, which is in keeping with the austere style of life at that time. MW

Hans Coper is one of the most significant potters of the post-war period. More convincingly than any other, his work demonstrates that wheel-thrown clay can provide the basis for sculpture of the highest order. His tight and consistent vocabulary of forms − rigorously explored through working in series − radically extended the artistic scope of studio pottery. His own work represents a highly resolved solution to a particular problem, but also serves to indicate the apparently limitless possibilities of the medium, something that his influential teaching also reinforced.

Having first arrived in England as an émigré from Germany in 1939, Coper found work making ceramic buttons in Lucie Rie's London studio in 1946. With a background in engineering and no experience of clay, he nevertheless learned with remarkable speed and was soon making pottery alongside Rie. The originality of his work was quickly recognized. His influences, where they were evident, lay in archaic pottery, or in materials other than ceramics. Indeed, his highly textured surfaces, achieved through the layering and abrading of slips, recall stone or metal. This form of 'patination' adds further to the sculptural quality of his complex forms, assembled from thrown sections.

This handsome pedestal vase was bought from a major exhibition staged at the Museum in 1969 in which Coper was paired with the weaver Peter Collingwood. AG

**Portrait plaque of Zhou Enlai
(1898–1976)**
Porcelain, painted in enamels
China, Jingdezhen
Painted by Wu Kang (born 1914)
1965–75
Height 37.7cm, width 24.7cm
Simon Kwan Gift, FE.36–1990

Pot
White stoneware, with layers of
white and manganese slip
Made by Hans Coper (1920–81)
England, Frome, Somerset
1968
Mark: 'HC' in monogram, impressed
Height 30.4cm, width 22.2cm
Circ.208–1969

Pot

The work of Odundo demonstrates the ability of studio ceramics to reach beyond a single culture and period. Sensuous and elegant in its apparent simplicity, it is poised between the sophisticated and the elemental, seeming utterly of our own time and yet rooted in ancient traditions.

Born and raised in Kenya, Odundo came to pottery while studying in the United Kingdom. A meeting with Michael Cardew encouraged her to spend a period at the Pottery Training Centre, which he had established at Abuja in Nigeria. There she encountered Gwari traditions of hand-building, but also learned to throw. Her interest in hand-built work – including ancient American pottery – increased, and ultimately defined her mature style and choice of techniques. Odundo thus employs coiling and hand-building to create articulated forms, which are burnished and covered with fine slip to give them their gloss. The works are then left in their terracotta state or, as here, subjected to a further firing in a kiln starved of oxygen, which renders their surfaces a lustrous black.

The beauty and sensuality of Odundo's work are emphasized by its playful anthropomorphism. For while the work ultimately remains abstract and sculptural, the necks and bellies of her pots are frequently suggestive of their human equivalents, and their additional detailing recalls accessories, facial or bodily features, or other forms of adornment. **AG**

'Untitled Vessel'

The quotation and subversion of historic styles and forms – key elements in postmodern design – have been widely utilized by ceramic artists in the later twentieth century, most particularly in the USA. Such work has jettisoned the notion of tradition as something authentic, and has posed questions regarding the formation of taste and the role of objects as signifiers of wealth or status. In doing so, the artist has become a cultural commentator, using objects as vehicles with which to explore ideas of meaning. Among those working in this vein, the Californian ceramicist Adrian Saxe is pre-eminent.

Saxe has primarily focused his attention on the opulence and inventiveness of European court porcelain of the eighteenth century, work of a type that had hitherto been disregarded by studio potters for its apparent decadence and excessive ornamentation. Saxe does not seek to replicate these ceramics so much as to capture their essence through the introduction of exaggerated forms and rich surfaces. In this exuberant yet unsettling object, the standard components of a vessel have been subjected to a radical redesign, so that each part defies our expectations. The foot has the scale of a body, the body takes the form of a handle and the gilded cover is ornamented with a knuckle-duster and dagger-like finial rather than an easily grasped knob. For Saxe, these elements also take on symbolic qualities. The base represents the material source, clay, while the vessel stands for the refined and culturally determined object. **AG**

Pot
Red earthenware, burnished and
reduction-fired to black
Made by Magdalene Odundo
(born 1950)
England, Ripley, Hampshire
1983
Mark: 'Odundo 83'
Height 28.6cm, depth 23.8cm
Given by the Friends of the V&A,
C.78–1984

'Untitled Vessel'
Stoneware and porcelain
Made by Adrian Saxe (born 1943)
USA, Los Angeles
1985
Height 51cm, width 42.5cm,
depth 15cm
Given by Mark and Fredda Hindenburg,
Los Angeles, C.53&A–1986

Sculpture: 'Geological Age V' (*Chishitsu Jidai 5*)

Akiyama Yō's extraordinary earthenware sculpture exemplifies a major strand in ceramic practice today: the use of ceramic materials for the production of avant-garde works of art that make little or no reference to potters' traditional concerns.

An exponent of 'Black Fire' (a technique involving the introduction of large amounts of carbonizing materials during firing), Akiyama shares an interest in primitivism and the workings of time with many other Japanese ceramic artists of his generation. Inspired by minimalist forms, such as the spheres and rings found among European cave drawings, and by the approach to materials of the German conceptual artist Joseph Beuys, 'Geological Age V' is a metaphor for and an exploration of the primordiality of clay. It is formed of rings of clay that have been worked over with a blowtorch, further manipulated and partly polished after firing. The result, a dynamic, multi-layered rotational structure with a precise and regularly turned interior that contrasts with the jagged cusps and ragged fissures that surround it, is an arresting composition richly suggestive of the forms and forces of our geological past. Y-SC

'Siphoned Modernism'

The relationship between ceramics and other branches of art has been subject to constant change and revision. However, the tendency within ceramics to address broader themes has increased in recent decades. Much of the most successful work to do so has, nevertheless, retained and exploited the significance of the medium itself, either in terms of its material or through recognizable object types. The work of English artist Richard Slee exemplifies this, exploring humanistic and cultural themes in a tragi-comic fashion, and making much of the cosy homeliness of ceramic popular culture.

Like much of Slee's output, this work flirts with ideas of the uncanny and surreal. On first inspection it appears a straightforward, even archetypal object: a perfectly potted simple vessel form with an outlet pipe, effectively a cistern. Yet the polythene tube loops back to the interior, endlessly recycling its contents, if indeed there were any. As an art object, its simplicity and audacity recall the 'readymades' of the Dadaist Marcel Duchamp, and are perhaps equally perplexing. Yet its title – 'Siphoned Modernism' – offers a clue to its wry humour, and also indicates that it is not a blank object, but one that has been carefully 'styled'. Originally shown in Slee's winning Jerwood Applied Arts Prize exhibition in 2001, it offers the artist's personal critique of the revival of modernist design in contemporary ceramic craft, in which the 'recycling and siphoning of this original visionary movement and the revivalist creative desperation [are] alluded to by the symbolism of the bucket as receptacle and the medicinal piping'. AG

'Siphoned Modernism'
Earthenware, hand-built, with white glaze and polythene tube
Made by Richard Slee (born 1946)
England, Brighton
2001
Mark: 'RICHARD / SLEE' written in blue
Height 47cm, width 45.5cm, depth 28.5cm
Given by the artist, C.67–2005

Sculpture: 'Geological Age V'
(*Chishitsu Jidai 5*)
Carbon-impregnated earthenware, partly polished
Made by Akiyama Yō (born 1953)
Japan, Kyoto
1992
Height 44.2cm, width 95cm
FE.563–1992

Glossary

Art pottery
A category of largely non-utilitarian ceramics of the late nineteenth and early twentieth centuries made as a means of artistic expression.

Ash glaze
A stoneware or porcelain glaze created by the ash from a kiln's fuel settling on ceramics during firing, or by the deliberate application of wood, plant or similar ashes to these wares.

Biscuit
A term referring I) to fired but unglazed ceramics, or to unglazed parts of glazed and fired wares, and 2) to the first firing (if any) before a glaze firing.

Bocage
Hand-modelled flowers and vegetation applied to ceramic figures, especially British.

Bone china
A bright white porcellanous body developed in Staffordshire in the late eighteenth century and still in production today. It contains a high proportion of calcined animal bone ash (about 50 per cent by weight) in combination with china clay and china stone (the ingredients of many hard-paste porcelains). Bone ash was originally added to the composition of mid-eighteenth-century English soft-paste porcelains as a whitening and strengthening ingredient.

Celadon
A western term for a range of stonewares and porcelains – originally made in China but subsequently in Korea, South-East Asia and the West – with a distinctive olive-green or straw-coloured glaze achieved by reduction firing. The term is also used for the glaze itself, the colour of which derives from iron oxide.

Creamware
A type of tough, cream-coloured and lead-glazed earthenware – made from a combination of white-firing clays and ground calcined flint – which was developed in mid-eighteenth-century Staffordshire.

Delftware: see Tin glaze

Dip: see Jasper

Earthenware
Pottery made from clays that do not vitrify, or are fired at too low a temperature to vitrify them, and therefore require a glaze to make them impervious to liquids. Pre-twentieth-century earthenwares were usually fired at temperatures between 800 and I,000°C, and their colours ranged from white to dark brown.

Enamels
Opaque or translucent glassy pigments used for ceramic decoration, the colours of which are derived from metallic oxides. Enamels are usually painted or printed onto ceramics that have been glazed and fired, but they can also be applied to biscuit-fired wares. In either case they require a further firing (at a lower temperature than the earlier glaze or biscuit firing) to fuse them to the ware. Enamelled decoration is often used in combination with gilding, which is painted on and fired in much the same way.

Faience, *faïence*
These terms have been used for two completely different ceramic materials: I) for a body composed of crushed quartz, and with a blue or green glaze, which was made in the ancient Mediterranean and Middle East (notably Mesopotamia and pre-dynastic and dynastic Egypt); and 2) for tin-glazed earthenware, especially from French- and German-speaking lands and Scandinavia. In this book we have used faience for the quartz-bodied material and *faïence* for certain tin-glazed earthenwares.

Flambé, *flammée*
Flambé is a western term for the variegated copper-red glazes of certain eighteenth-century Chinese porcelains. In addition, like *flammée*, it is also used to describe similar glaze effects (inspired by these Chinese wares) achieved by European art potters in the late nineteenth and early twentieth centuries.

Fritware
A class of pottery, originating in the Middle East, made with a combination of powdered quartz with small amounts of white-firing clay and glass cullet. Fritwares are very similar in composition to certain European soft-paste porcelains.

Glue bat: see Transfer printing

Hard paste: see Porcelain

High-fired, high temperature
Terms with a number of related applications, including for ceramics and glazes that are fired at kiln temperatures greater than about I,150°C. Stonewares and hard-paste porcelain are high-fired; fritwares and pre-twentieth-century earthenwares are low-fired.

Incised slipware
Decoration achieved by incising or cutting through a layer of slip to reveal the contrasting colour of the underlying clay.

Jasper
A type of white porcellanous stoneware developed by the Staffordshire potter Josiah Wedgwood in the I770s. Jasper can be stained a range of colours, usually to create a contrasting background for applied relief decoration in white. 'Solid Jasper' is stained throughout, whereas a dip is a pigment applied to the surface only.

Lead glaze
A low-temperature glaze containing lead oxide as the main fluxing agent (i.e. an addition made to reduce the melting point of the glaze). Lead glazes are often clear or honey-toned, and can be stained a range of colours with metallic oxides.

Low-fired, low temperature: see High-fired, high temperature

Lustre decoration
Painted decoration in a microscopically thin

layer of metal, originally silver and copper. Lustre decoration is achieved by painting metal oxides mixed with a 'carrier', often red ochre, onto the glazed and fired surface of a pot. The pot is then fired again at a low temperature in a smoky kiln atmosphere. The smoke extracts the oxygen from the oxides, leaving a thin film of metal. Lustres derived from platinum and gold were introduced during the nineteenth century.

Luting: see Slip

Maiolica: see Tin glaze

Majolica

A type of nineteenth-century earthenware decorated with brightly coloured translucent glazes and pioneered by Minton & Co. Unlike the Italian maiolica it was named after (see Tin glaze), majolica's decorative effects were usually achieved by a combination of broad areas of coloured glazes in combination with moulded forms, rather than by painting (though exceptional pieces made for exhibitions were painted in this way).

Porcelain

A white, vitreous, high-fired ceramic body that is translucent when thinly potted. True or hard-paste porcelain is made from china stone and/or china clay (kaolin). European soft-paste porcelains were made in imitation of East Asian porcelains and contain white-firing clays and a variety of other materials, including glass, or its raw materials, and bone ash (the latter is also an ingredient of bone china). Porcelains are usually glazed, though some European porcelain figures are left unglazed (see Biscuit). In the West porcelains are usually fired to biscuit stage before glazing, whereas in China the glaze is usually applied to the unfired body.

Reducing atmosphere, reduction firing

In reduction firing the quantity of oxygen in a kiln is severely restricted (resulting in a reducing atmosphere). This creates carbon monoxide, which combines with the oxygen in oxides contained in clays and glazes, changing their chemical composition and very often their colour.

Reserved decoration

An area of surface decoration left unpainted, or without printing, when a ground colour is applied to a ceramic form. It is usually used as a background for figure, floral or other similar decoration.

Salt glaze

A stoneware glaze achieved by throwing salt into the kiln towards the end of a firing. The salt volatizes at the high temperatures required to fire stoneware and settles on the exterior surfaces of the wares, where it combines with silicates in the fired clay to form a tight-fitting glaze.

Slip, slip casting, slipware

Slip is a solution of potter's clay in water. It is used in the surface decoration of pottery and porcelain, as an adhesive when joining the unfired parts of ceramic figures or wares together (a process known as luting) and as a material for casting ceramics in plaster moulds (slip casting). Slipware is a term for pottery with painted, marbled, trailed or incised slips, often in contrasting colours. See also Incised slipware.

Soft paste: see Porcelain

Stoneware

A type of pottery made from refractory clays that vitrify at the high temperatures at which they are fired (usually above 1,200°C). They are opaque, unless made with porcelain clays or similar materials, and are impervious to liquids.

Studio pottery

A term for twentieth- and twenty-first-century ceramics made by artist craftsmen rather than factory workmen. They are hand-made and produced on a relatively small scale by a single potter or a small team.

Tenmoku

A black glaze used in studio pottery. It ultimately derives from the Song dynasty blackwares of southern China (for which the slightly different term 'temmoku' is sometimes used).

Tin glaze

A lead glaze that has been opacified and whitened with the addition of tin oxide. Such glazes are usually used on earthenwares. Tin-glazed earthenwares are variously named according to their country of origin: maiolica in Italy; *faience* in France, Germany and Scandinavia; Delftware (made at Delft) in the Netherlands; and delftware (without a capital D) in Britain and Ireland. In addition, the term maiolica is sometimes used for such pottery made outside Italy but decorated in the style of Italian maiolica. Tin-glazed pottery can be painted with in-glaze colours (applied onto the unfired and absorbent glaze), or decorated after the glaze firing with enamel colours or lustre pigments (both of which require a further firing).

Transfer printing

A method of decorating pottery by printing an engraved design onto a sheet of paper, or thin layer of animal glue (sometimes known as a glue bat), which is then laid onto the ware to transfer the design. There are several variations of the technique.

Underglaze

Decoration painted or printed onto ceramics before glazing and firing. Until recently, only a few pigments were known that could withstand the high temperatures of glaze firings, the one most widely used being a blue derived from cobalt. In the West, underglaze decoration was traditionally carried out on biscuit-fired wares, but on East Asian porcelains underglaze colours were painted onto the unfired clay.

Wax resist

A decorative effect achieved by painting a design in melted wax onto pottery or porcelain before glazing. The glaze then fails to adhere to the painted area and the wax burns away during the firing, leaving the design as an area devoid of pigment or glaze.

Select Bibliography

an asterisk (*) indicates a V&A publication

General

Caiger-Smith, Alan, *Tin-glaze Pottery in Europe and the Islamic World* (London, 1973)

— *Lustre Pottery: Technique, Tradition and Innovation in Islam and the Western World* (London and Boston, 1985)

Carswell, John, *Blue and White: Chinese Porcelain and Its Impact on the Western World* (Chicago, 1985)

Charleston, Robert J. (ed.), *World Ceramics: An Illustrated History* (London, 1968)

Freestone, Ian, and Gaimster, David (eds), *Pottery in the Making: World Ceramic Traditions* (London, 1997)

Jackson, Anna, and Jaffer, Amin (eds), *Encounters: The Meeting of Asia and Europe 1500–1800* (London, 2004)*

Kingery, W. David, and Vandivier, Pamela B., *Ceramic Masterpieces: Art, Structure and Technology* (London and New York, 1986)

Manners, Errol, *Ceramics Source Book* (London, 1990)

East and South-East Asia

Ayers, John, Impey, Oliver, and Mallet, J.V.G., *Porcelain for Palaces: The Fashion for Japan in Europe* (London, 1990)

Brown, Roxanna, *Ceramics of South-East Asia: Their Dating and Identification* (Singapore, second edition 1988)

Faulkner, Rupert, *Japanese Studio Crafts: Tradition and the Avant-garde* (London, 1995)

Guy, John, *Oriental Trade Ceramics in South-East Asia: Ninth to Sixteenth Centuries* (Singapore, 1986)

— *Ceramic Traditions of South-East Asia* (Singapore, 1989)

Impey, Oliver, *Japanese Export Porcelain: Catalogue of the Collection of the Ashmolean Museum, Oxford* (Amsterdam, 2002)

Itoh, Ikutarô, *Korean Ceramics from the Museum of Oriental Ceramics, Osaka* (New York, 2000)

Itoh, Ikutarô, and Mino, Yutaka, *The Radiance of Jade and the Clarity of Water: Korean Ceramics from the Ataka Collection* (Chicago and Hudson Hills, 1991)

Jahn, Gisela, *Meji Ceramics: The Art of Japanese Export Porcelain and Satsuma Ware 1868–1912* (Stuttgart, 2004)

Jörg, C.J.A., *Fine & Curious: Japanese Export Porcelain in Dutch Collections* (Leiden, 2003)

Kerr, Rose, *Chinese Ceramics: Porcelain of the Qing Dynasty 1644–1911* (London, 1986)*

— *Song Dynasty Ceramics* (London, 2004)*

Kerr, Rose, and Wood, Nigel, *Joseph Needham: Science and Civilisation in China*, Vol. 5, Chemistry and Chemical Technology. Part XII: Ceramic Technology (Cambridge, 2004)

Kim, Jae-yeol, *Handbook of Korean Art: White Porcelain and Punch'ŏng Ware* (Seoul, 2003)

Pak, Youngsook, and Whitfield, Roderick, *Handbook of Korean Art: Earthenware and Celadon* (Seoul, 2002)

Pierson, Stacey, *Earth, Fire and Water: Chinese Ceramic Technology. A Handbook for Non-specialists* (London, 1996)

Stevenson, John, and Guy, John, *Vietnamese Ceramics: A Separate Tradition* (Chicago, 1997)

Vainker, Shelagh, *Chinese Pottery and Porcelain* (London, 2005)

Wilson, Richard L., *Inside Japanese Ceramics: A Primer of Materials, Techniques and Traditions* (New York and Tokyo, 1995)

Wood, Nigel, *Chinese Glazes: Their Origins, Chemistry, and Recreation* (London and Philadelphia, 1999)

Middle East

Atasoy, Nurhan, and Raby, Julian, *Iznik: The Pottery of Ottoman Turkey* (London, 1989)

Crowe, Yolande, *Persia and China: Safavid Blue and White in the Victoria and Albert Museum, 1501–1738* (London, 2002)

Lane, Arthur, *Early Islamic Pottery: Mesopotamia, Egypt and Persia* (London, revised 1958)

— *Later Islamic Pottery: Persia, Syria, Egypt, Turkey* (London, revised 1971)

Stanley, Tim, Rosser-Owen, Mariam, and Vernoit, Stephen, *Palace and Mosque: Islamic Art from the Middle East* (London, 2004)*

Watson, Oliver, *Persian Lustre Pottery* (London, 1985)

— *Ceramics from Islamic Lands* (London, 2004)

Europe

Archer, Michael, *Delftware: The Tin-Glazed Earthenware of the British Isles. A Catalogue of the Collection in the Victoria and Albert Museum* (London, 1997)*

Benton, Charlotte, Benton, Tim, and Wood, Ghislaine, *Art Deco 1910–1939* (London, 2003)*

Cameron, Elisabeth, *Encyclopaedia of Pottery and Porcelain Manufacturers: The Nineteenth and Twentieth Centuries* (London, 1986)

Casey, Andrew, *20th Century Ceramic Designers in Britain* (Woodbridge, 2001)

Dawson, Aileen, *French Porcelain: A Catalogue of the British Museum Collection* (London, revised 2000)

de Waal, Edmund, *20th Century Ceramics* (London, 2003)

Espir, Helen, *European Decoration on Oriental Porcelain 1700–1830* (London, 2005)

Gaimster, David, *German Stoneware 1200–1900* (London, 1997)

Graves, Alun, *Tiles and Tilework of Europe* (London, 2002)*

Greenhalgh, Paul (ed.), *Art Nouveau: 1890–1914* (London, 2000)*

Harrod, Tanya, *The Crafts in Britain in the 20th Century* (London and New Haven, 1999)

Hawkins Opie, Jennifer, *Scandinavia: Ceramics & Glass in the Twentieth Century* (London, 1989)*

Hildyard, Robin, *European Ceramics* (London, 1999)*

— *English Pottery 1620–1840* (London, 2005)*

Musée national de céramique, Paris, *La Faïence européenne au XVIIe siècle: le triomphe de Delft* (Paris, 2003)

Rackham, Bernard, *Catalogue of Italian Maiolica [in the Victoria and Albert Museum]* (London, amended 1977)

Ray, Anthony, *Spanish Pottery 1248–1898 (with a catalogue of the collection in the Victoria and Albert Museum)* (London, 2000)*

Watson, Oliver, *Studio Pottery: Twentieth Century British Ceramics in the Victoria and Albert Museum Collection* (London, 1993)*

Wilk, Christopher (ed.), *Modernism, 1914–1939: Designing a New World* (London, 2006)*

Wilson, Timothy, *Ceramic Art of the Italian Renaissance* (London, 1987)

Young, Hilary, *English Porcelain, 1745–95* (London, 1999)*

Victoria and Albert Museum and its collections

Baker, Malcolm, and Richardson, Brenda (eds), *A Grand Design: The Art of the Victoria and Albert Museum* (New York and London, 1997)*

Burton, Anthony, *Vision and Accident: The Story of the Victoria and Albert Museum* (London, 1999)*